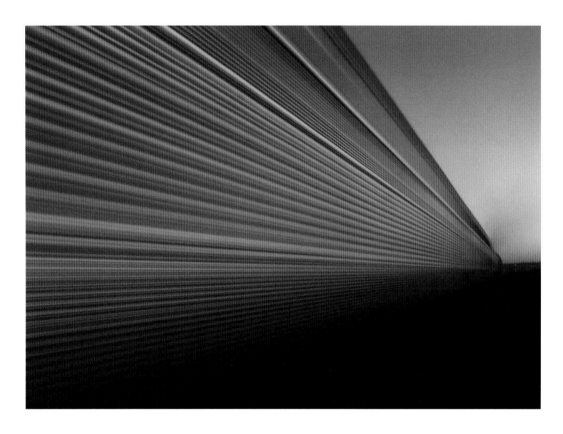

And I guess the sound of the outward bound
Made me a slave to its wanderin' ways.

"The Wayward Wind," Herb Newman and Stan Lebowsky, 1950

To my mother, Katy Boyd, who supplied transportation
for my early adventures and who remained remarkably calm
when I put her car in a ditch while chasing CB&Q 4-8-4 5632 out of Zearing.
When she entered the aviation industry and learned to fly, she admitted,
"I'm finally beginning to understand you and your darned trains!"

OUTBOUND TRAINS

IN THE ERA BEFORE THE MERGERS

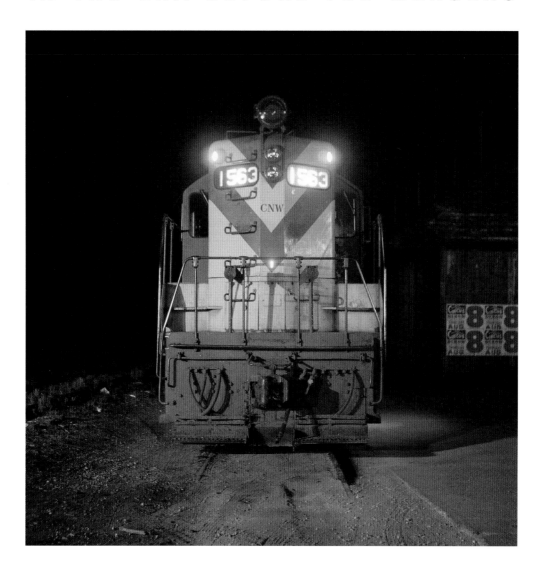

JIM BOYD

The BOSTON
MILLS PRESS

A BOSTON MILLS PRESS BOOK

First printing.

Library and Archives Canada Cataloguing in Publication

Boyd, Jim, 1941-
Outbound trains : in the era before the mergers / Jim Boyd.
Includes index.

ISBN 1-55046-403-5
1. Railroads--United States--History--20th century. I. Title.
HE2751.B69 2005 385'.0973 C2005-901526-8

Publisher Cataloging-in-Publication Data (U.S.)

Boyd, Jim, 1941-
Outbound trains : in the era before the mergers / Jim Boyd. —1st ed.
[192] p. : col. photos. ; cm.
Includes index.

Summary: Images and text of the first-generation diesel railroads from the early 1960s through the 1970s. A tour coast to coast with most major American railroads, and a sampling of interesting short lines, restored main lines, and museums.

ISBN 1-55046-403-5
1. Railroads--United States--History--20th century-- Pictorial works. I. Title.
385'.0973 dc22 HE2751.B69 2005

Published by Boston Mills Press
132 Main Street, Erin, Ontario, Canada N0B 1T0
Tel 519-833-2407 Fax 519-833-2195
e-mail: books@bostonmillspress.com
www.bostonmillspress.com

In Canada:
Distributed by Firefly Books Ltd.
66 Leek Crescent, Richmond Hill
Ontario, Canada L4B 1H1

In the United States:
Distributed by Firefly Books (U.S.) Inc.
P.O. Box 1338, Ellicott Station
Buffalo, New York, USA 14205

The publisher gratefully acknowledges the financial support for our publishing program by the Canada Council for the Arts, the Ontario Arts Council and the Government of Canada through the Book Publishing Industry Development Program.

Text and cover design by
Chris McCorkindale and Sue Breen
McCorkindale Advertising & Design

Printed in China

Photographs

Front cover
In September 1968, Louisville & Nashville No. 8, the *Pan American* from New Orleans to Cincinnati, was getting the headlights and windshields of its E7 washed off shortly after midnight at Mobile, Alabama.

Back cover
A cloud of coal dust all but obscures the caboose of an eastbound Norfolk & Western coal train on the former Virginian Railway bridge over the New River at Glen Lyn, Virginia, in September 1971. Within a year the old Virginian line will be abandoned and the bridge demolished shortly thereafter.

Page 1
The Santa Fe's *Super Chief* departs into the sunset at Chillicothe, Illinois, in July 1970.

Page 3
On a summer night in Dixon, Illinois, in 1963, C&NW GP7 1563 idles on the Hunter Lumber Company spur awaiting the return of the IC job switching the cement plant.

Page 5
Outbound train. The engineer of the Chicago-bound *Peoria Rocket* awaits the highball at Peoria, Illinois, in May 1965.

CONTENTS

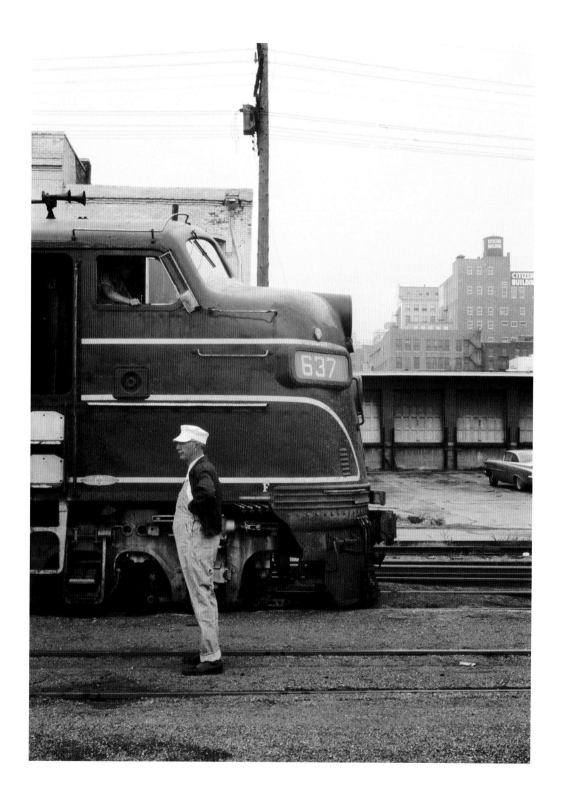

BORN TO THE RAILROAD

Foreword by Mike Del Vecchio

IT IS ALWAYS GRATIFYING TO SEE SOMEONE ENTHUSIASTICALLY doing in life exactly what he was born to do. Jim Boyd is such a person. This book is an appropriate volume, enshrining Jim with the all-time greats who have skillfully documented their life's vision of railroading. And it couldn't happen to a better man.

It strikes me now, thinking about it, that Jim is to railfandom what *Tonight Show* host Johnny Carson was to television. Both men have been similarly well known in their respective fields. For more than thirty years, Jim's style of finding, photographing and telling a story has inspired generations of railfans. As Johnny did in entertainment, Jim came to know just about everyone in railroading and would always give help and attention to a fresh face. Jim loves to laugh and has Johnny's knack for bringing out the best in people. Both are men who have helped define their genre to a point where the mention of their names needs no further explanation.

Formally retired as editor of *Railfan & Railroad* magazine, Jim will never really retire. He spends his time these days working on the books that he's always talked about producing, still writing articles and his regular *Camera Bag* column that began with the very first issue of *Railfan*, in winter 1974.

When he needs to get away from trains for a while, Jim's hobby is historical diving, using steam-era hard-hat diving gear. What started with a few individuals at a New Jersey scuba shop and a bunch of helmet collectors transplanted from the United Kingdom has grown into an NRHS-style organization, the Historical Diving Society, U.S.A. They put on dive rallies and exhibitions, and a group that Jim founded even dives heavy gear each year at the *Living Seas* aquarium at Walt Disney World in Florida. Much is due to Jim's dynamic personality and his experience with National Railway Historical Society chapters. He will certainly be as appreciated among the historical divers as he is among railfans.

I had the privilege of working with Jim at *R&R* as his first associate editor for a few months shy of ten years between 1987 and 1996, while our friendship goes back four years further. We met at meetings of the NRHS Tri-State Chapter in Morris Township, New Jersey, before I knew what he did for a living. He was knowledgeable and a great talker. I was getting more involved in the management of the Chapter and taking over as associate editor on the newsletter, *The Block Line*. I became one of his snoops on local rail happenings, and he became my window to the rest of the industry.

Through a strange chain of events, I purchased a defunct retail/wholesale electronic parts store where at least one night a month area railfans would show slides. Attendance grew to more than thirty some nights, and Jim was always among them, often cultivating new contributors and collecting news material for the magazine. We struck up a friendship. And I loved watching him work.

When *Railfan & Railroad* magazine was going from quarterly to monthly publication, Jim collected dozens of resumes for the new associate editor's position. The job remained unfilled until Jim asked and I sold the store.

My first day at *R&R*: The magazine was late, and Jim was frantically doing everything. We left together at 2 a.m., and those hours continued the rest of that week until the magazine was complete.

In the following months I began to really see Jim's depth and talents and his ability to recognize those qualities in others. During that time *Railfan & Railroad* was Jim Boyd and Jim Boyd was *Railfan & Railroad*. The ad department sold and plotted the advertising, but Jim designed and produced everything else.

Until that point, I had never seen anyone care so much about his work. It wasn't an ego thing—he genuinely wanted the magazine to be readable, enjoyable and, above all, useful and accurate. He insisted most on accuracy and spent hours digging and reading and looking through

books and articles checking author's work, especially locomotive rosters and company histories that needed to be told.

Jim would freely admit that much of his life isn't organized, but his reference material is very much so. He maintained indexes of everything he could, and those of locomotive newsmagazine *Extra 2200 South* were religiously kept with each volume. "Don't you dare let those get away from that binder!" were his first stern words to his new underling.

He has an uncanny knack for making sure that articles tell a complete story. If something didn't sit well, he'd dig and dig and come up with an answer that added a new dimension or direction to the work. He developed sources close to nearly every story.

As you'll see in these pages, Jim had photographed a great deal of railroading before the magazine began. It amazed me how often, while we were preparing a story for print, Jim would remember that he had a shot of a scene or locomotive that was needed to illustrate something in the feature. We never got paid for the use of our own photos at *R&R*. While contemporary coverage of events often included our own photos to justify the expense account for a trip, Jim's historic stuff was almost always there because it was needed and available.

Jim is also one hell of a photographer. Partly due to his education and influences, and more so because of his natural artistic sense of balance and lighting, his compositions are terrific. He lives for context and for appropriate elements, especially people, with which to frame his subjects.

And I'm the living embodiment of Jim's willingness to work with newbies. He would often spend many extra hours with new or inexperienced contributors, names that often grace the pages and mastheads of other magazines today. In my case, grammar was not stressed in my generation's high-school and college education. My writing was terrible. Jim worked with me over and above the call, and he also gave me a foundation of graphic design that I was able to build on after my time at *R&R*. My gratitude is immeasurable.

Always cheerful and ebullient, Jim writes like he talks. The words on these pages are indeed in Jim's voice. The photos are from Jim's canvas. And we readers are much richer for it.

Mike Del Vecchio
Dover, New Jersey
January 28, 2005

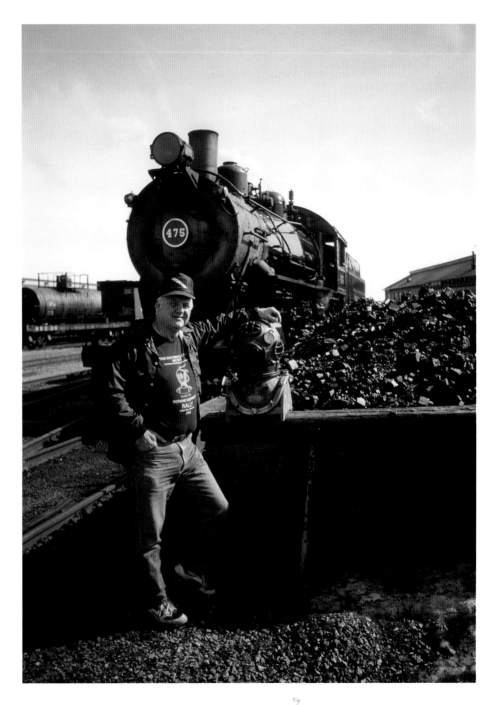

Jim Boyd at the Strasburg Rail Road on April 5, 1944, with ex-N&W 4-8-0 475 and Jim Folk's Desco U.S. Navy MkV diving helmet, built April 4, 1944, and dived the previous day, on its fiftieth birthday. *Jim Folk*

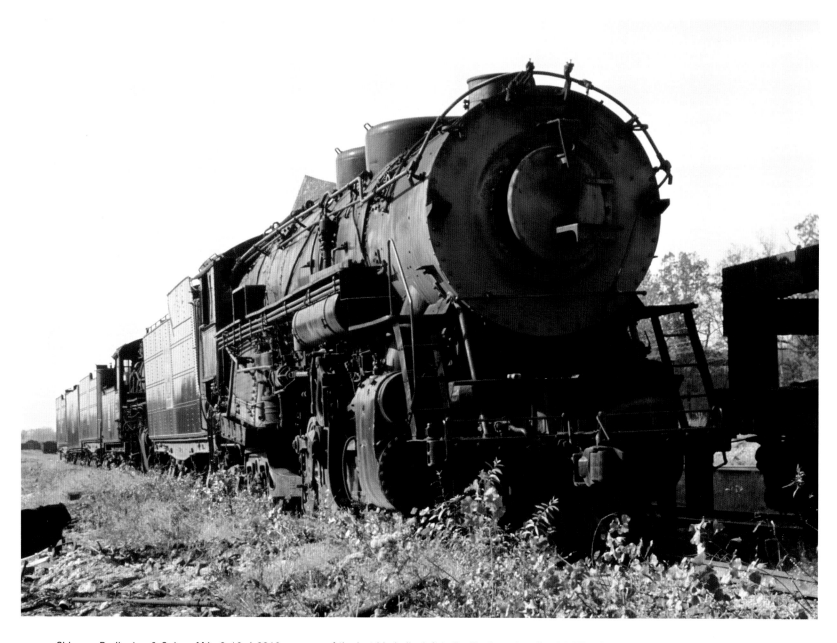

Chicago, Burlington & Quincy M4a 2-10-4 6319 was one of the last big hulks left in the Northwestern Steel & Wire Company scrap line at Sterling, Illinois, in the summer of 1963. Hundreds of locomotives, from C&NW 4-8-4s to New York Central Hudsons, were cut up here in the 1950s and 1960s. In April 1963, I was twenty-one. Russ Porter took a photograph of me (opposite) in the cab of derelict CB&Q 2-10-4 6327 in the NSW scrap line.

RUDE AWAKENING

Introduction

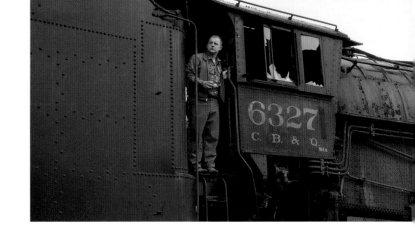

I THINK I KNEW WHAT A TRAIN WAS BEFORE I EVER SAW ONE. This is rather strange, since no one in my family had any interest in trains. As a toddler I had a long horizontal notebook in which I would draw a track line and an engine and pass it around at family gatherings to have each of the grownups add a car to my train. I got into trouble one Christmas when my Uncle Butch drew the tender on backwards, with the cistern next to the cab. I made such a fuss that my folks drove me up to the C&NW depot to prove me wrong. But of course, I was right. I think that set my destiny.

In 1949, when I was seven and a half years old, we moved into a new house on the north side of Dixon, Illinois, that had a perfect view of the Illinois Central tracks from the big dining room window. There were four or five trains a day in each direction, and the standard road engines were Mikados (though I didn't know that at the time), with a resident 0-6-0 switcher that made one early afternoon trip every day up to the north side and back.

The summer before I entered seventh grade I met Chet French, who was two years older than I was. He taught me wheel arrangements, engine numbers and railroad operations, as well as two-man backyard baseball. We put my newly acquired railroad knowledge into practice on my big American Flyer train layout.

It was the ultimate railfan's childhood, with a model railroad in the basement, a wise friend to learn from and steam engines passing in clear view a block away.

On January 17, 1955, when I'd just turned thirteen, it suddenly ended. The road jobs had begun to yield to black GP7s in 1953, but the noon locals still got Mikes, and the 0-6-0 still scampered up to "the Colony" (a state mental hospital) every afternoon with coal for its power plant. On that frigid January day, however, 0-6-0 275 was replaced with a GP9, and from then on, the only steam engines to pass the dining room window would be dead-in-tow. The beautiful big Iowa Division road engines, 4-8-2s and 2-10-2s, which almost never came through under steam, paraded south to Paducah, Kentucky, for reassignment or scrapping.

The Chicago & North Western, a long bike ride on the other side of town, dieselized shortly thereafter. Over in Sterling, 15 miles to the west, ex-C&NW and CB&Q 0-6-0s still worked the Northwestern Steel & Wire mill, while hundreds of main-line engines passed through its dead line to oblivion. I was still too young to drive, though, so I had a hard time getting to Sterling.

In January 1955, I was emotionally devastated that the most important thing in my life had been so abruptly ripped away. I would spend most of my adolescent and adult life trying to recapture the magic of steam. It became the driving force in my life. On August 11, 1957, I discovered the steam fantrip with a Railroad Club of Chicago excursion behind a Q3 2-8-2 over the Baltimore & Ohio Chicago Terminal. That put me on the Railroad Club of Chicago and Illini Railroad Club mailing lists and was the beginning of a lifelong pursuit of steam.

I had used just a simple camera before steam departed, and the best I could do were black-and-white "snapshots." As an avid reader of *Trains* and *Railroad* magazines, I was introduced to the best of rail photography, and handling a camera came naturally. I even took my first night photos of a street scene and Dixon's statue of Abe Lincoln in 1957 by bracing the Brownie Hawkeye camera and using the time-exposure "B" setting.

Serious railroad photography would soon dominate my life and help ease the loss of steam.

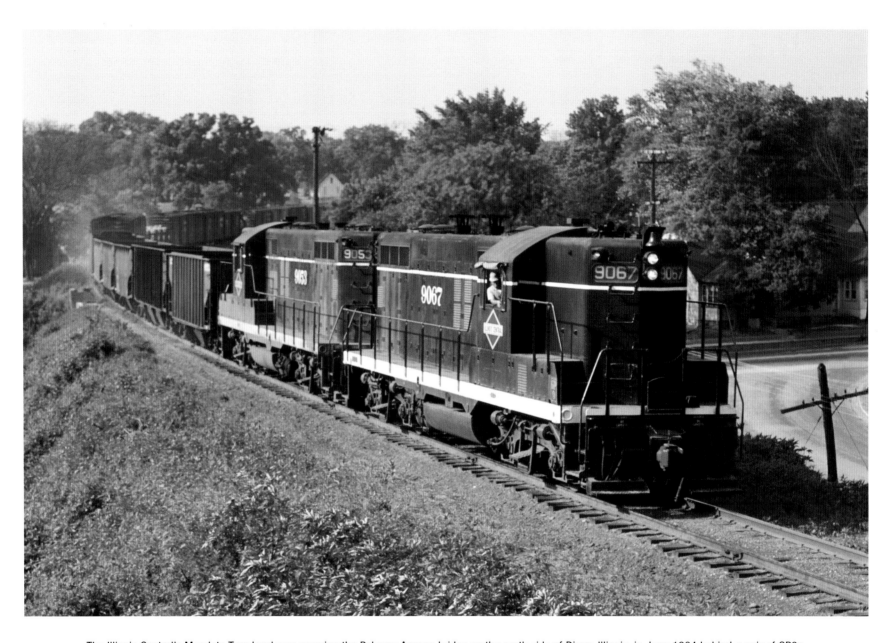

The Illinois Central's Mendota Turn local was crossing the Palmyra Avenue bridge on the north side of Dixon, Illinois, in June 1964 behind a pair of GP9s. The boxcars in the train could be viewed from my home on the hill about a block west of the tracks. Dick Stair (opposite), the daytime operator at the Illinois Central's tower in Champaign, Illinois, introduced me to other railfans at the University of illinois in the early 1960s.

HOMELAND SECURITY
Chapter One

I GREW UP IN THE CENTER OF THE UNIVERSE. AT LEAST that's what I thought Dixon, Illinois, was until I moved to New Jersey thirty years later and realized that New York City is the real center of the universe. Dixon is 100 miles due west of Chicago on the double-track main line of the Chicago & North Western. The Illinois Central's original north-south Charter Line (the Amboy District of the Springfield Division, known as the "Gruber") crossed the Rock River on an impressive deck girder trestle and ducked under the C&NW on the south side of town. I set out to explore the railroads within my universe even before kindergarten. During the first summer that I had a tricycle, when I was about five years old, we were living on the southwest side of town. I don't remember the incident, but my mother said that one afternoon I went missing, and she got so worried that she called the police. They found me about two miles away on the joint IC and C&NW industrial street trackage in River Street with my front wheel stuck in the flangeway and a big black 0-6-0 waiting patiently for the conductor to get me unstuck. It was an inauspicious beginning to a lifetime of train chasing.

In the summer of 1949 my family moved into a new house they had built on the north side of the river. It sat on a hillside and had a superb view of the IC tracks, and the IC immediately became my home road.

A bicycle was sufficient mobility to get around Dixon, but it also got me into trouble again. One day I was hanging out at the 7th Street crossing in the middle of the IC yard and got curious about what was in the South Yard beyond the C&NW underpass. I wandered almost a mile down into the four-track storage yard, and on the trek back to 7th Street I encountered a grumpy railroad cop, who chewed me out for trespassing. He took my name and address and sent letters to my parents and the Jefferson Grade School principal, who then obligingly busted my chops for my foolish interest in trains.

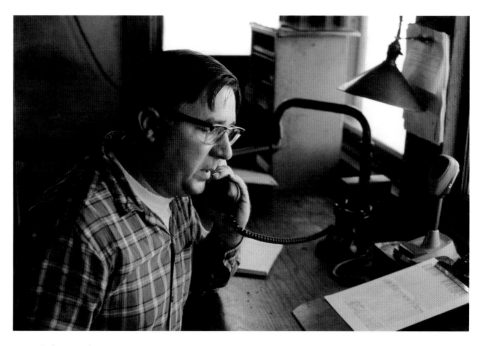

"If I catch you here again, I'll throw you in jail," the cinder dick had threatened, and that kept me away from 7th Street for many years. The worst part of the incident, though, was that as he was interrogating me, the only 2-10-2 I'd ever seen close up eased into town on a south-bound Dunbar ore train. Even in my adolescence, I had my priorities.

As a typical Midwestern teenager, I got my driver's license when I turned sixteen in November 1957. Browbeating my mother out of her car whenever I could, I began to explore the other nearby rail lines, including the Milwaukee Road, the Chicago Great Western and two main lines of the Chicago, Burlington & Quincy. My photography was still elementary, but my enthusiasm for exploration was not.

I did quite well in high school but spent three disastrous semesters flunking out of Engineering at the University of Illinois because I was

totally disinterested in math and the overall subject matter. Nobody (including me, at the time) understood that my interest in trains was more artistic than mechanical, but this was the post-Sputnik era when America was in a panic to produce more engineers. Unfortunately, I was not one of them.

But my year and a half at the U of I actually did just what college is supposed to do. It set me on the path for my future career, though the direction came from an unexpected source. I got to know Dick Stair, the operator at the IC's busy Champaign interlocking tower. Dick was an unabashed railfan, and the spacious tower was the social gathering place for other fans. Dick introduced me to upperclassmen Bruce Meyer, Phil Weibler and J. Parker Lamb. It was Parker who took me out train chasing and taught me the basics of real photography. From him I learned f-stops and shutter speeds and the basics of night photography. I even bought my first good camera from him, a medium-format Kodak Chevron rangefinder, which was his preferred camera at the time (he had three or four of 'em). I got my first journalism experience when I put my newfound photography skills to use on the *Daily Illini* campus newspaper. I was the future Professor Lamb's first graduate student—in railfanning, not engineering.

Following my academic fiasco at the U of I, I entered the two-year photography course at the Layton School of Art in Milwaukee in the fall of 1961. My instructor, a delightful Dutchman named Gerhard Bakker, was a veteran art director as well as a photographer, and he taught not only camera techniques but also the basics of publication, layout and advertising graphics. I did my final photo thesis on the Chicago North Shore & Milwaukee, and that gave me the opportunity to duck out of classes to photograph the interurbans in their last weeks before abandonment. Fortunately, Mr. Bakker was not a railfan and never saw John Gruber's little softcover book *Trolleys to Milwaukee*, or he might have interpreted my "inspiration" as "plagiarism"!

Another important part of my education resulted from the "Monday Night Slide Group What Meets on Tuesdays" hosted by Russ Porter in West Allis. I would ride the Route 10 trolleybus out to the west side from my lakefront apartment for an evening with other railfans operating Russ's HO scale model railroad and having a slide session of everyone's latest rail adventures. The Monday Night Slide Session had been moved to Tuesday so that the weekend's slides could be processed on Monday and returned on Tuesday for immediate presentation.

Russ was also an author for Hal Carstens' *Railroad Model Craftsman* magazine, doing both model and prototype oriented features. My railfan photography was becoming an expensive obsession, costing both time and money, and I realized that doing magazine articles might be a good way to get something in return. I asked Russ, "What does a magazine article look like?" He just happened to have one he was about to submit, and showed me a typewritten manuscript and photos with captions taped to the back. Hmm, I figured, I could do that. My first contribution to Carstens, however, was a photo of my kitbashed IC 2600 class 4-8-2 on Russ's layout, and it made the cover of the December 1962 issue of *Railroad Model Craftsman*. I was hooked!

Hal had been doing a series of prototype roster and rolling stock photo features that had long irritated me; they were almost exclusively devoted to what I thought of as "those stupid Eastern railroads"—like the NYO&W, L&NE and Susquehanna. I was in a position to fix that, and began sending him features on the Chicago & Illinois Midland, Wabash, Nickel Plate and Santa Fe passenger diesels. Every one of them got published immediately. My part-time journalism career was off and rolling.

I put my Layton education to use when I got a job at television station WTVO in Rockford, Illinois. It was about that time I began to seriously pursue both black-and-white and color photography, since I had the use of the film department's well-equipped darkroom. Not surprisingly, my early efforts reflected what Parker Lamb and John Gruber's book had taught me. I refined my photography on the local railroads while making numerous trips to other parts of the country, shooting two cameras, black and white in the Chevron and color in a Pentax 35 mm SLR.

By 1965, I had my life on track with a fun job at the television station, a car, friends and an entire realm of colorful railroads within daytrip range. I had a strong sense of home, and I felt secure there.

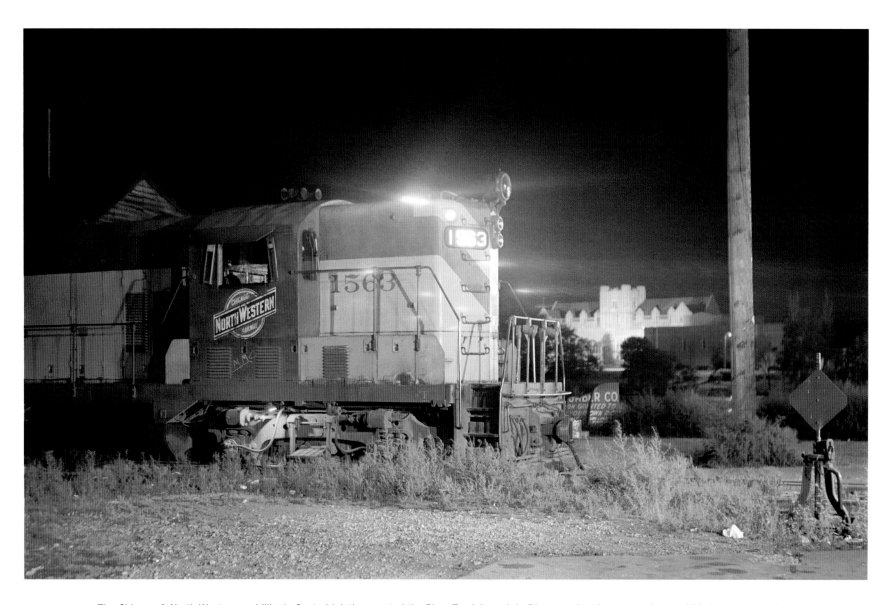

The Chicago & North Western and Illinois Central jointly operated the River Track branch in Dixon serving the power plant and Medusa cement plant on the south bank of the river. On a summer night in 1963, C&NW GP7 1563 was idling on the Hunter Lumber Company spur waiting for the IC job to return from the cement plant. Across the river is Dixon High School, where study halls 201 and 211 provided me with a fine view of the River Track.

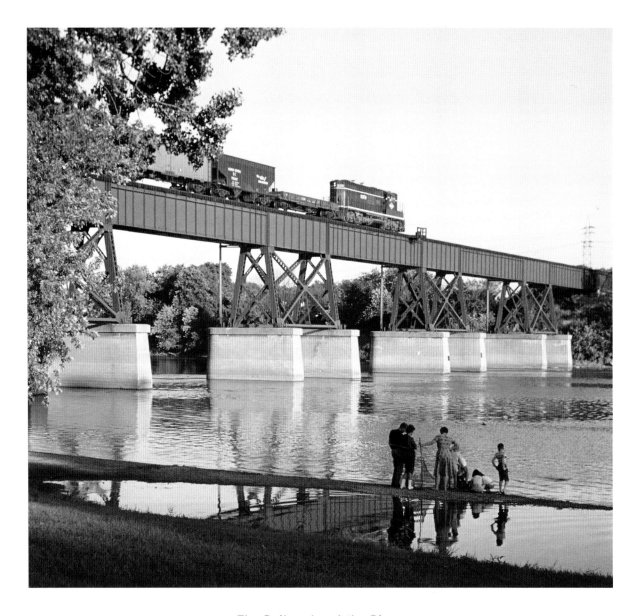

The Railroad and the River

The Illinois Central's steel trestle over the Rock River was the most prominent railroad structure in Dixon, Illinois. A family was fishing on the north bank of the river in the summer of 1963 as the Dixon switch job paused for conductor Louie Scott to line the switch after pulling out of the Borden candy factory siding. The yard and freight house were on the south side of the river. (Right) The view looking west from the Peoria Avenue bridge in October 1963 shows a southbound freight and the smokestacks of the coal-fired Illinois Northern Utilities power plant that was served by the IC and C&NW.

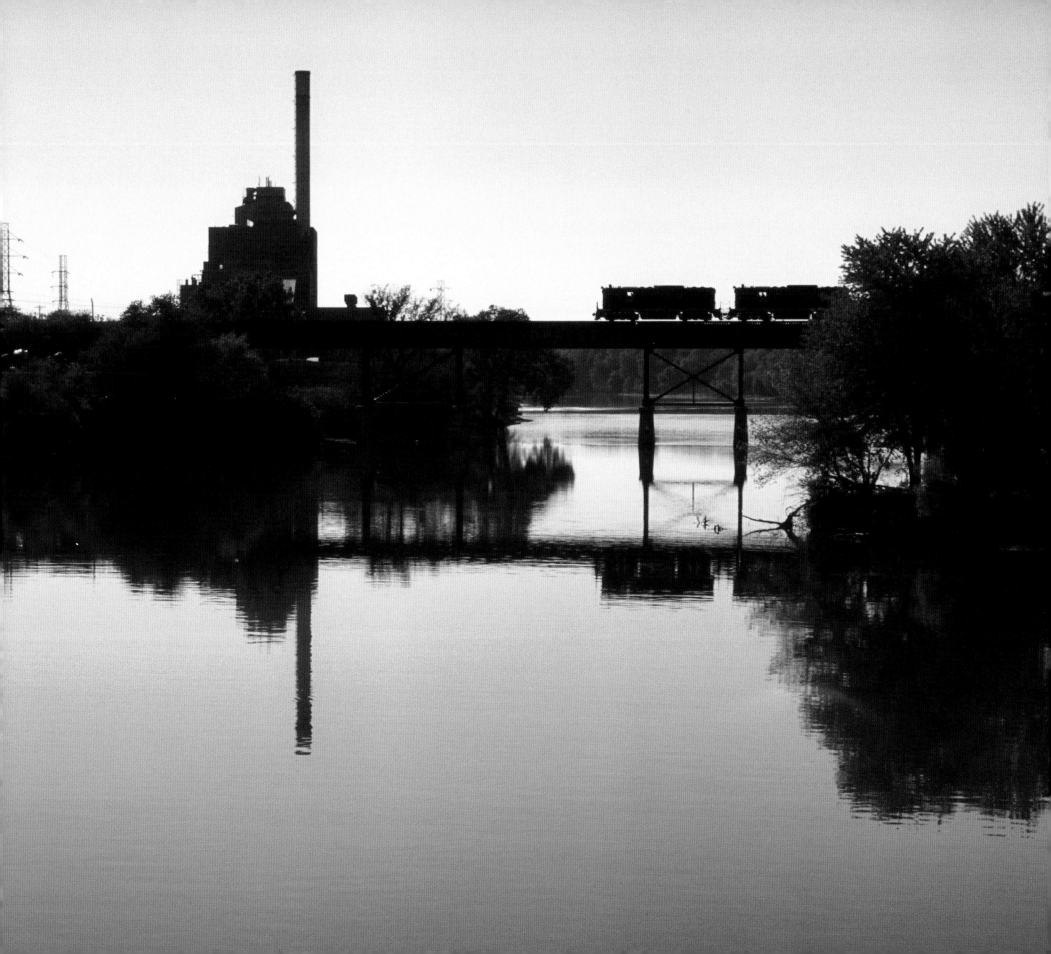

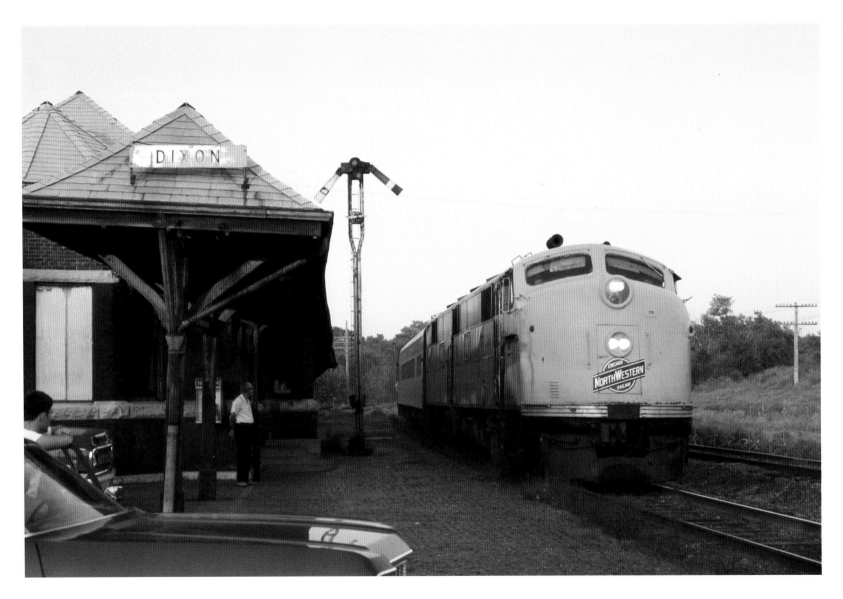

The North Western

My hometown, Dixon, Illinois, is 100 miles due west of Chicago on the main line of the Chicago & North Western. The *Kate Shelly 400* was on a long-distance commuter schedule 137 miles between Clinton, Iowa, and Chicago, running into the city in the morning and out in the evening. In September 1970, an E7 had the westbound *Kate*, No. 1, making its 7:02 p.m. stop at Dixon's handsome brick and stone depot.

High-nosed Geeps, like this westbound set crossing over the IC just east of the depot in April 1964, replaced the F-units in the early 1960s. Brand-new GP30s and GP35s were big news when they brought the first low noses into Dixon in early 1963 and 1964. Four new units had freight 249 (left) dropping down Dixon Hill on July 21, 1964.

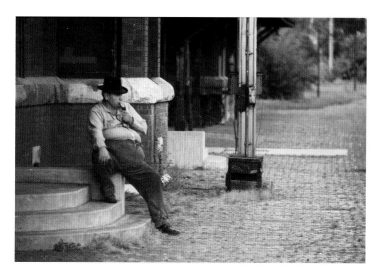

Clyde Shoemaker, a wealthy retired fuel dealer, was a fixture at the Dixon depot in the 1960s. He'd been watching trains there since the 1940s and would fondly recall the 4-8-4 "H-engines" fighting the steep hill eastward through town.

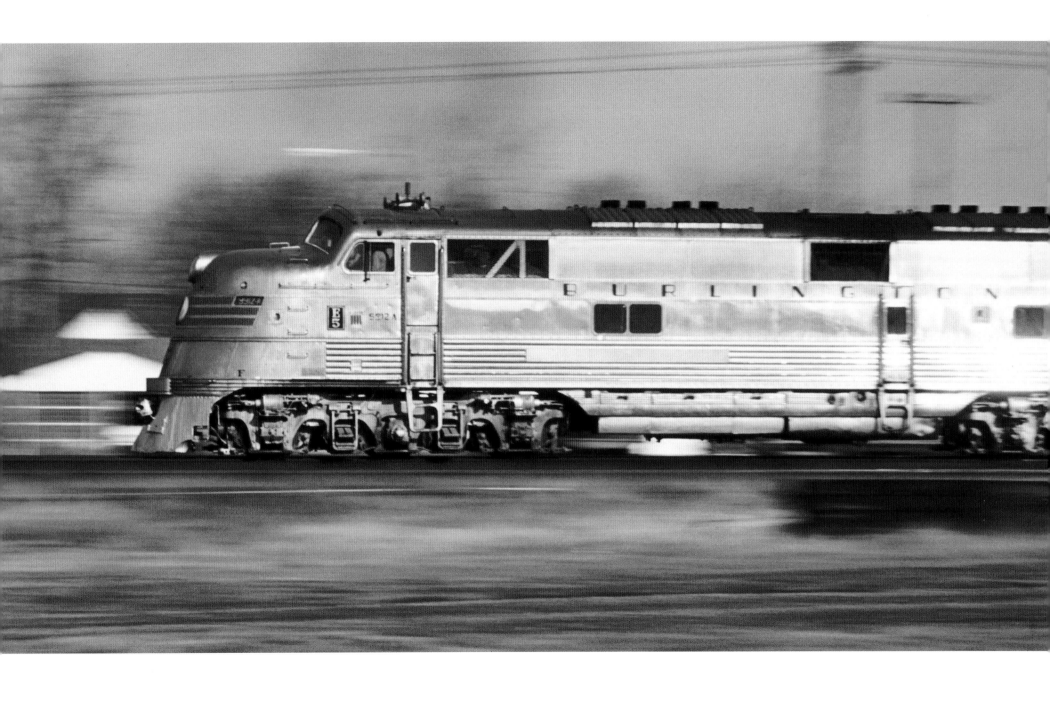

Up to Oregon

The nearest "foreign" railroad to Dixon was the Chicago, Burlington & Quincy's hot single-track main line from Aurora to the Twin Cities. It was a 14-mile ride up Route 2 to Oregon, where silver domeliners paused in their 100-mph sprints across northern Illinois. Operator Ed Miller (right) always had a friendly greeting and interesting things on the lineup. In December 1964 the westbound *Morning Zephyr* was regularly assigned E5 9912-A, built in March 1940. The slant-nosed, stainless-steel-clad unit, formerly named *Silver Meteor*, was mated to an E5 booster of similar vintage. The only flaw in the perfect consist was the front dome obs, positioned backwards for rapid turnaround in Minneapolois.

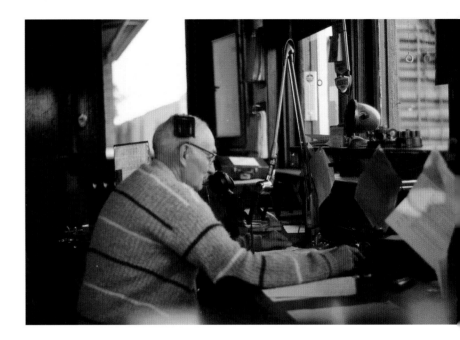

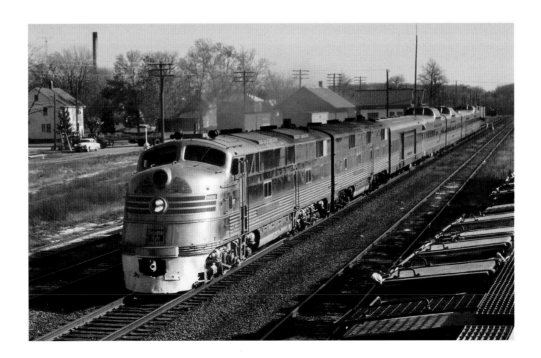

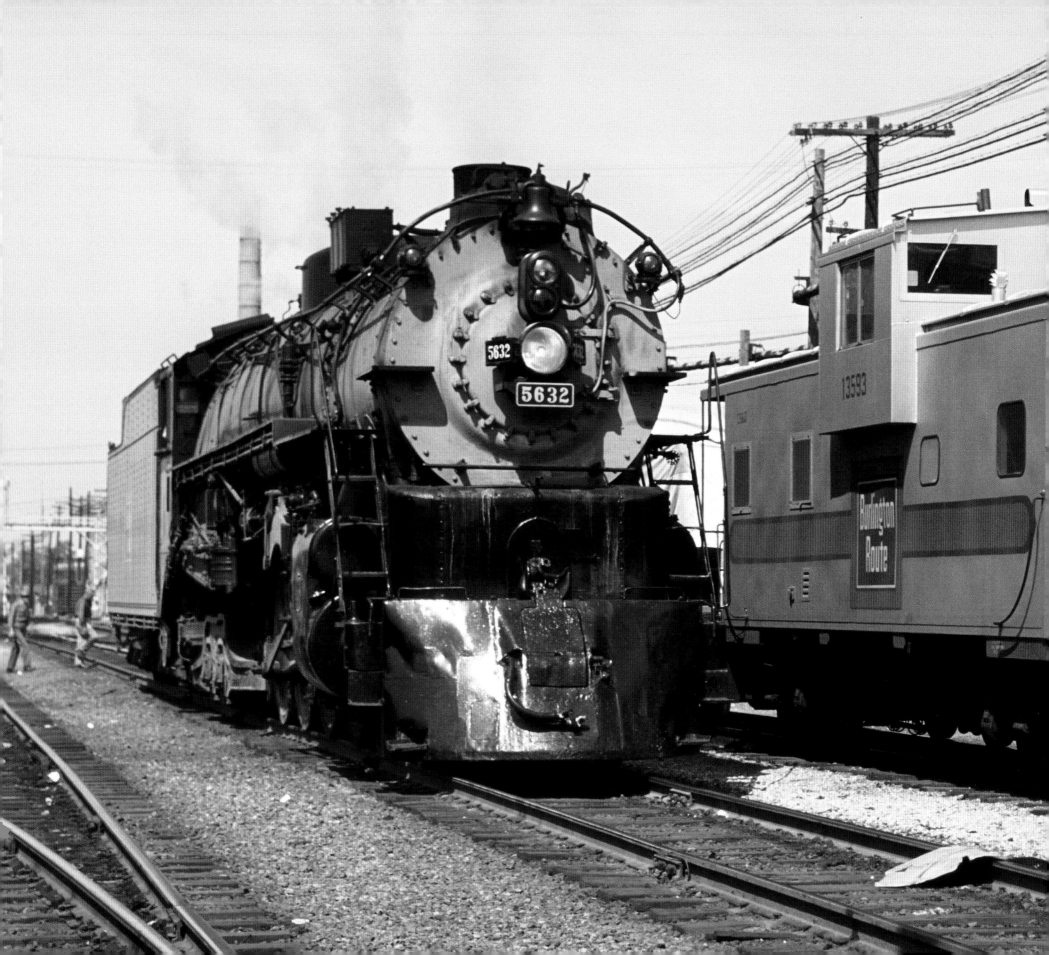

"My" 4-8-4

The 5632 wasn't the first CB&Q 4-8-4 I rode behind, but the brawny O5b became "my" engine a few days before my seventeenth birthday when it made its first railfan trip to Galesburg in November 1958 and was then kept in excursion service for the next six years by CB&Q President Harry Murphy. They refrained from fancy paint and maintained the 5632 in its "in service" appearance. It looked very much at home (below) at Mendota on June 1, 1963; taking water (right) at Galesburg on September 29, 1963, and letting the CDGI's caboose pass at Galesburg (left) on May 17, 1964.

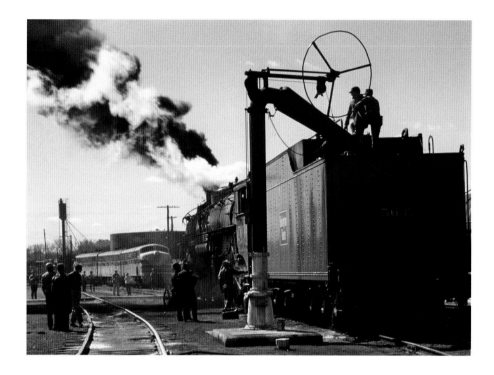

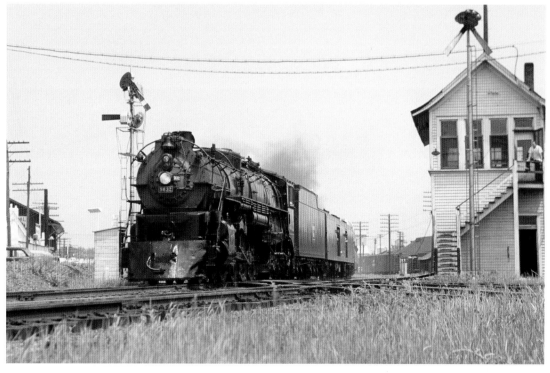

The Unappreciated 4960

On December 28, 1958, the CB&Q fired up 01a 2-8-2 4960 for an excursion from Chicago down the branch to Ottawa, Illinois. For the next six years the Mikado partnered with 05b 5632 in the Burlington's wide-ranging excursion program. Since I was so enthralled with the big 4-8-4, a trip with the pug-ugly Mike was always a bit of a disappointment. When Baldwin cranked out the 4960 in July 1923, it was definitely no beauty contest winner, and a collision in Wyoming that mashed its CB&Q headlight bracket left it with an oddball makeshift Colorado & Southern style bracket that always annoyed me. But its perform-ance was impressive, with a sharp exhaust and 65-mph galloping on the main line. On October 4, 1964, the 4960 had just been turned (below) on the turntable at Rockford for its return to Chicago. President Louis Menk killed the CB&Q steam program on July 17, 1966, with a run out the branch from Mendota to Denrock. It passed over a stream (opposite) near Walnut and made a photo run in the middle of Prophetstown. That sign behind the front of the engine (left) says "A.J. Boyd Casket Co., Inc." I had an upstairs apartment in that building, and this was the only steam fantrip run-past that I ever saw from my house.

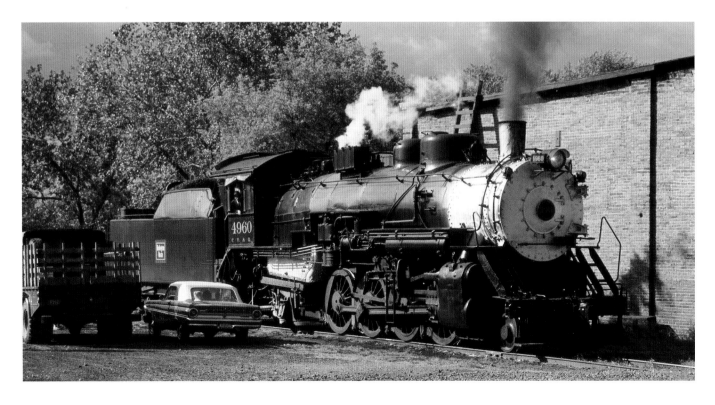

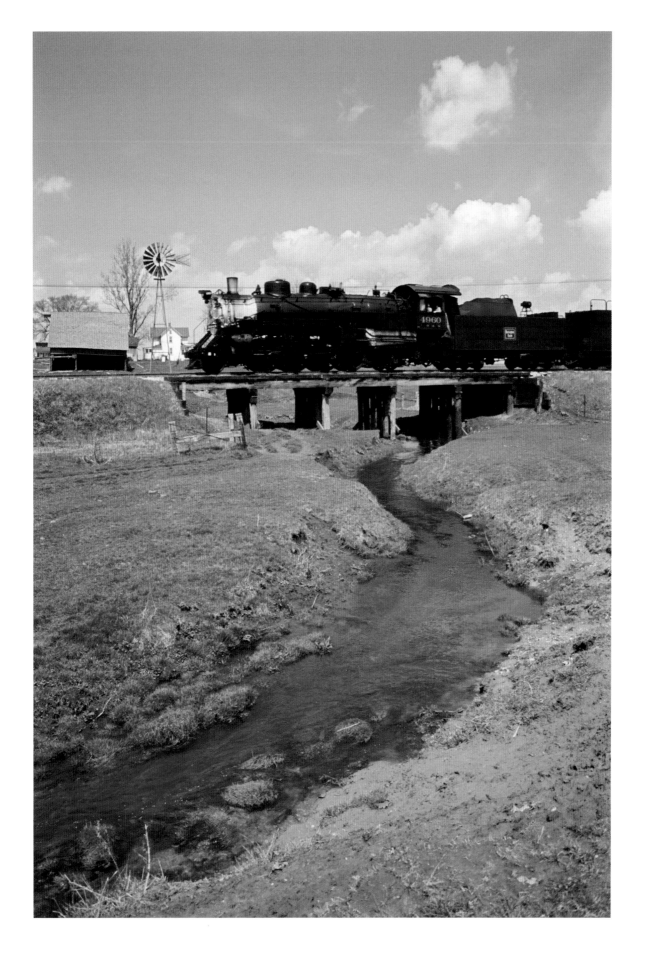

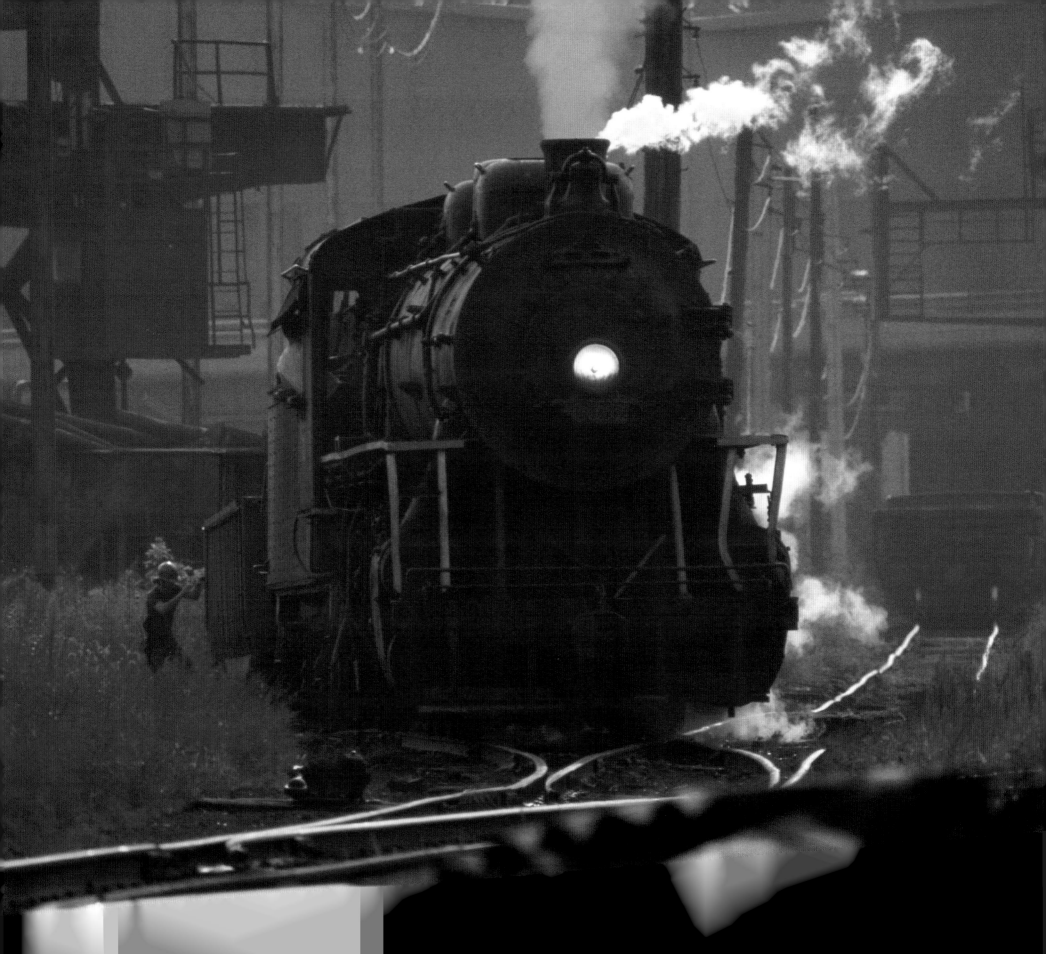

The Mill

Twelve miles west of Dixon was the Northwestern Steel & Wire mill in Sterling, Illinois. In the mid-1950s, there were rows of road engines in the half-mile-long scrap line. I remember C&NW Class H 4-8-4s, a Milwaukee 2-6-2, Illinois Central Mikes and even New York Central Hudsons. Former C&NW 0-6-0s did the in-plant switching. By 1960 the exotic stuff had been turned into nails and reels of wire, but the scrap line was replenished with the last of the Grand Trunk Western and CB&Q fleets. Mill owner P.W. Dillon took a liking to the brawny GTW 0-8-0s, and instead of scrapping them, he replaced the 0-6-0s with fourteen of them. In 1964, NSW 06 (ex-GTW 8306) was switching at night (right) in front of the spectacular electric furnace beneath the new Avenue G bridge. Ex-GTW 8315 (below right) was passing under the bridge in September 1965, and the 30 (ex-GTW 8330) was working east of the furnace (opposite) in mid-1973. In 1970 the engines were converted to oil-firing, for one-man operation, and the 25 (below) got a KCS Vanderbilt tender coupled on backwards, while the 15 got a tender off a CB&Q O1a 2-8-2. Steam lasted at Sterling until December 3, 1980, not long after Mr. Dillon died at age ninety-six.

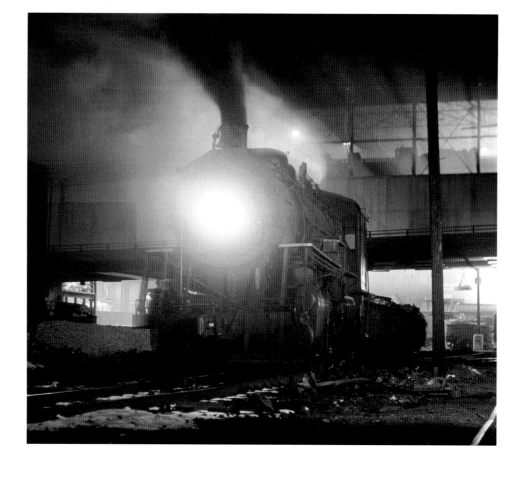

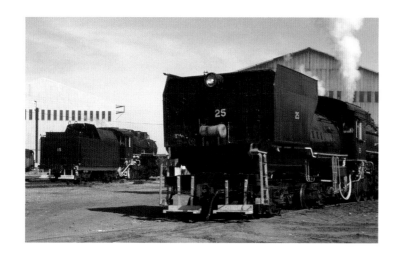

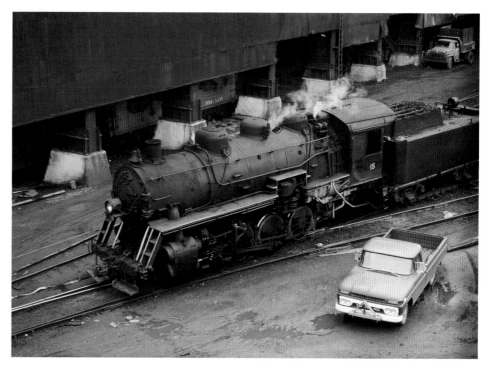

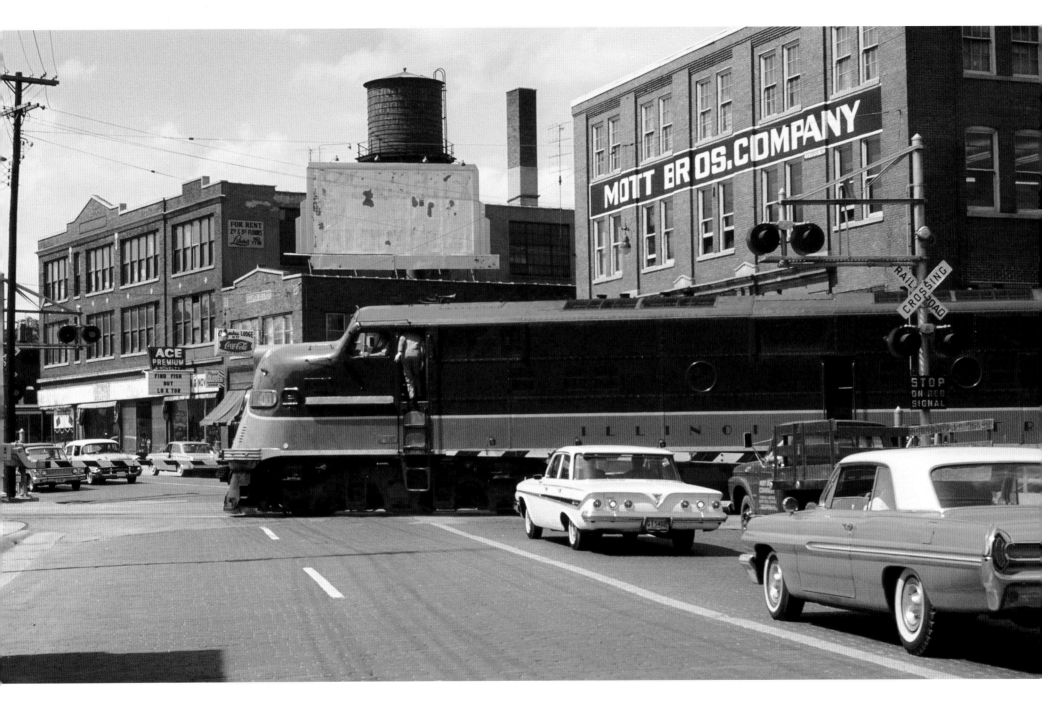

The Can o' Corn

My favorite IC units were the two slant-nosed E6s, 4001 and 4003, that frequently worked No. 14, the *Land o' Corn*.
The 4001 was easing out across Main Street departing the Rockford depot in June 1965. The fireman, climbing into the cab,
had just keyed down the crossing gates. Rockford was also served by the overnight *Hawkeye* to Sioux City.

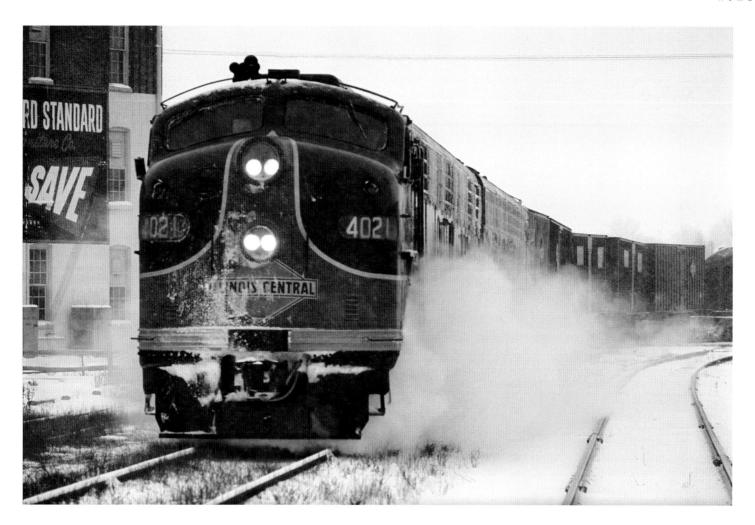

In 1964, I moved to Rockford, Illinois, and went to work for television station WTVO. My 3-to-11-p.m. workday gave me time to photograph Illinois Central No. 14 at 10:35 in the morning. The Waterloo, Iowa, to Chicago streamliner *Land o' Corn*, complete with E-units, head-end Flexi-Vans, coaches and a cafe-lounge, became fondly known as the "Can o' Corn." The most unusual units to show up on 14 were Central of Georgia E8s 811 and 812 in full IC colors but with the CofG name spelled out in the diamond herald. The 811 was dropping downhill west of Rockford (below) in June 1965. Frosty E8 4021 (right) was showing the effects of the northern Illinois winter in January 1966.

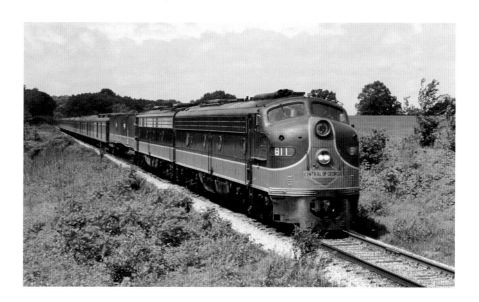

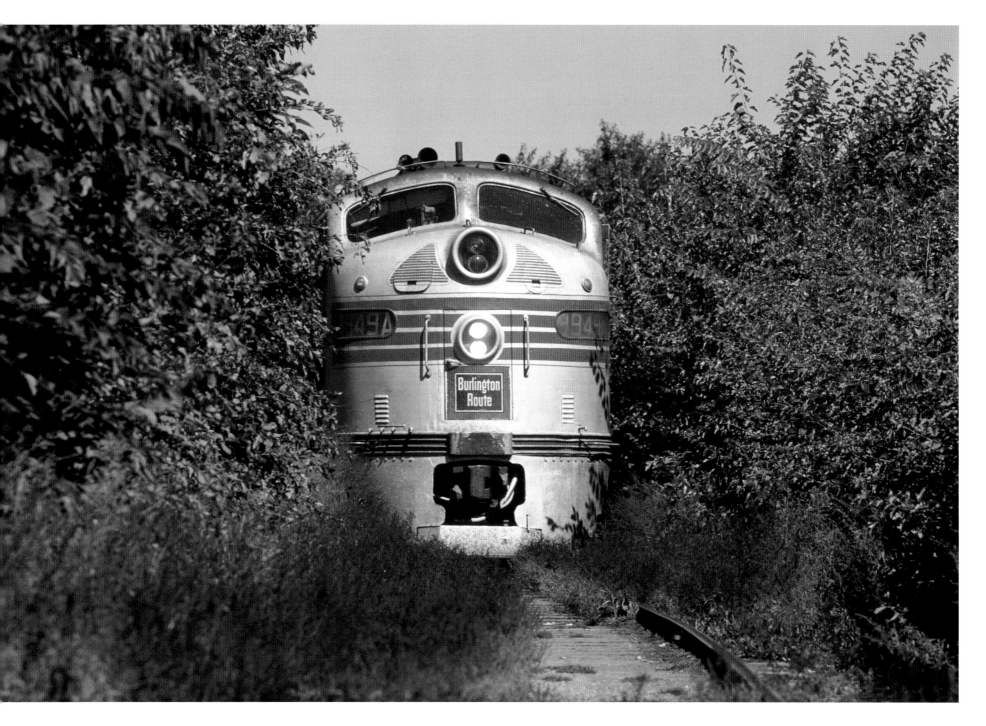

Way of the Zephyrs?

A damaged bridge on the CB&Q's Twin Cities main line between East Dubuque and Savannah in August 1967 caused four days of passenger train detours over the IC from East Dubuque to Rockford, where they could go onto the CB&Q's branch down to Flagg Center. "The Worm" connection between the IC and CB&Q, however, involved a mile of industrial trackage that included this "tree tunnel" crowding E8 9949-A on the *Empire Builder*.

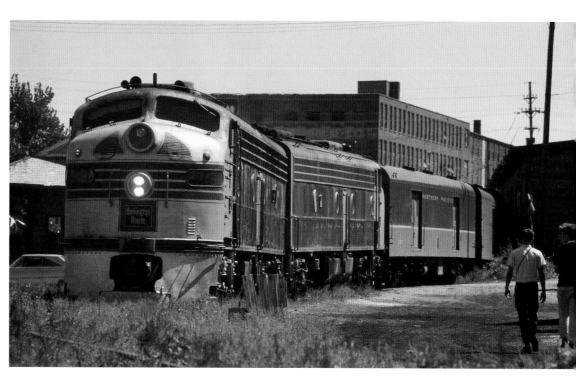

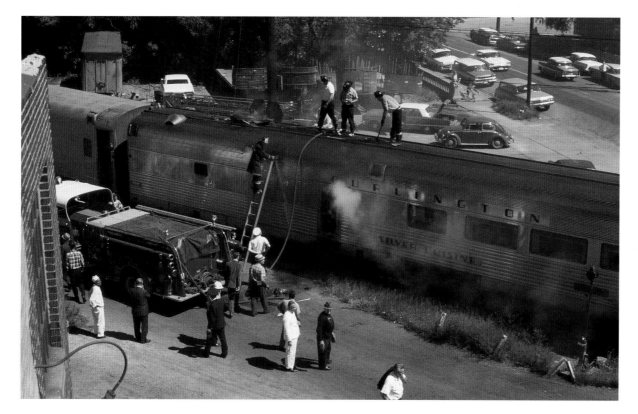

The westbound combined *Empire Builder* and *North Coast Limited* was nearing the end of its back-up detour over "The Worm" industrial trackage (above) from the CB&Q Flagg Center branch onto the IC's Buckbee Siding as railfans Mike Schafer (white shirt) and John Carey walked alongside. A short while earlier on that train, the fire department (below) had been chopping through the roof of the diner *Silver Cuisine* to put out a smoky grease-trap fire. Another westbound on the IC (above left) eased past my ground-floor apartment at 1125 9th Street.

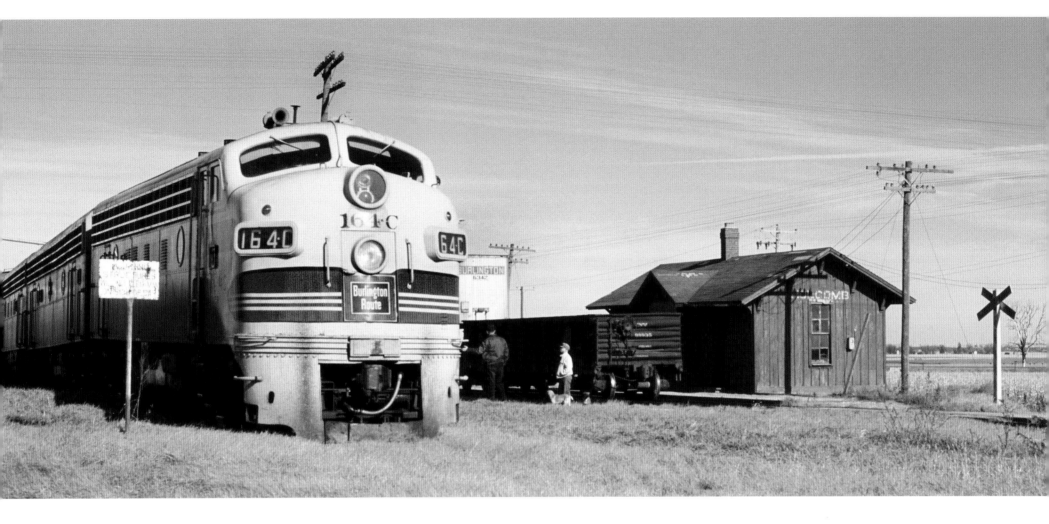

Graybacks and a Hotbox

Detouring *Zephyrs* were not the usual traffic on the 24-mile
CB&Q spur from the Twin Cities main line at Flagg Center north
to Rockford. Every predawn Monday, however, main-line freight 81
out of Chicago would venture up the branch behind an A-B-B-A
set of "Grayback" F-units and turn back at Rockford. "Chicken
wire" F3 124-D (right) was idling in the morning light at Rockford
in November 1965, while the 164-C (above) and sister F7s
made a pick-up at Holcomb a few weeks earlier. The Graybacks
were particularly classy with their Mars lights and passenger-style
pilots. The head brakeman on a Twin Cities line local (opposite)
was hooking burning waste out of a hotbox at Big Rock, Illinois,
on May 3, 1964.

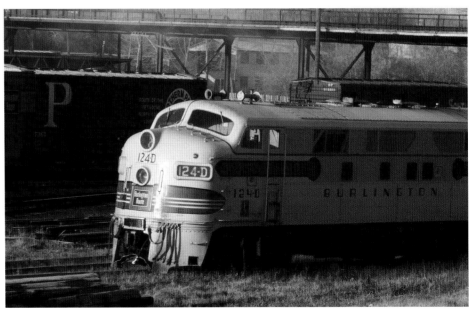

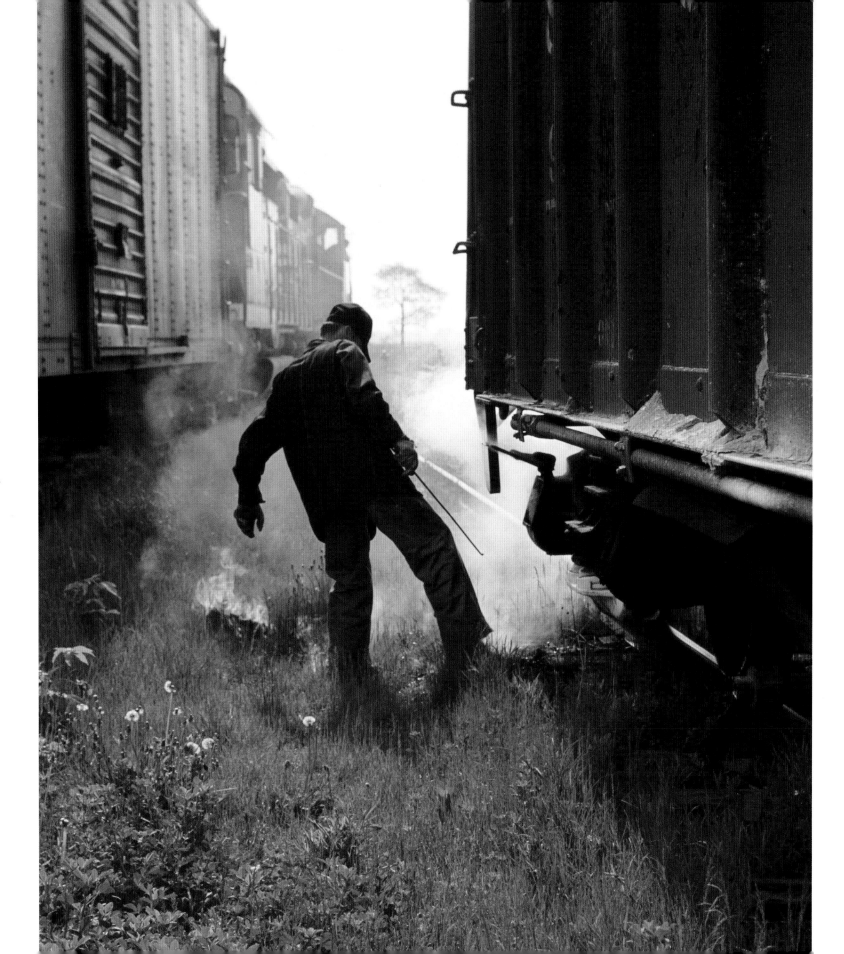

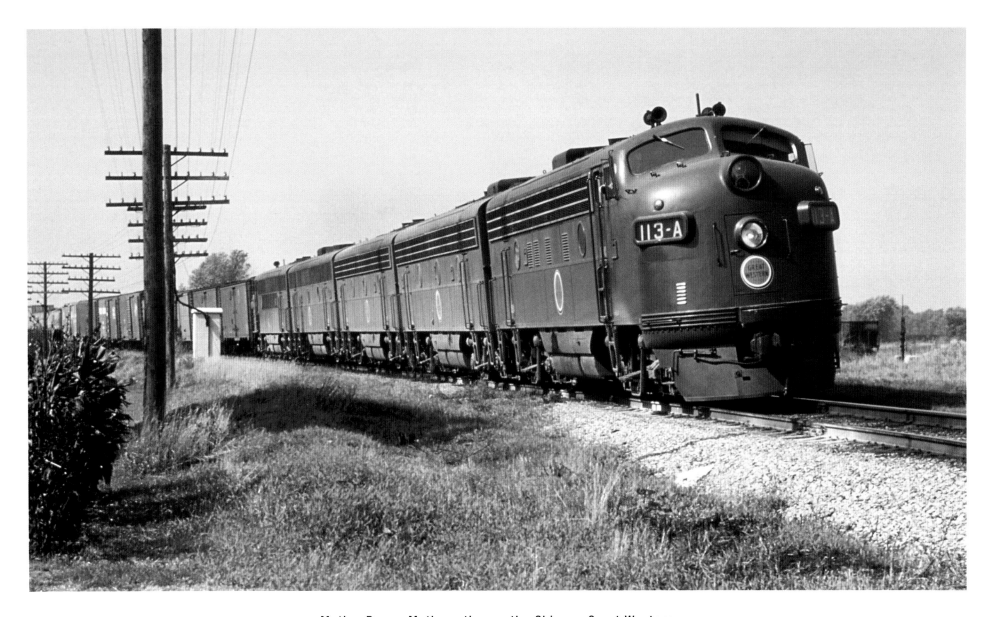

Motive Power Mathematics on the Chicago Great Western

The Chicago Great Western began replacing its 2-10-4s in 1947 with a dozen A-B-A sets of F3s and rapidly expanding its diesel fleet with F5s and F7s.
The CGW adopted a "one big train" philosophy, and the midday eastbound freight 192 from Oelwein, Iowa, to Chicago would regularly get
five or six 1500-h.p. F-units, such as the perfect A-B-B-B-A set led by F5 113-A (above) at South Freeport, Illinois, on October 17, 1964.
The unit-reduction economies of modern power were evident in three SD40s (opposite) working tonnage through Byron, Illinois, in September 1968.

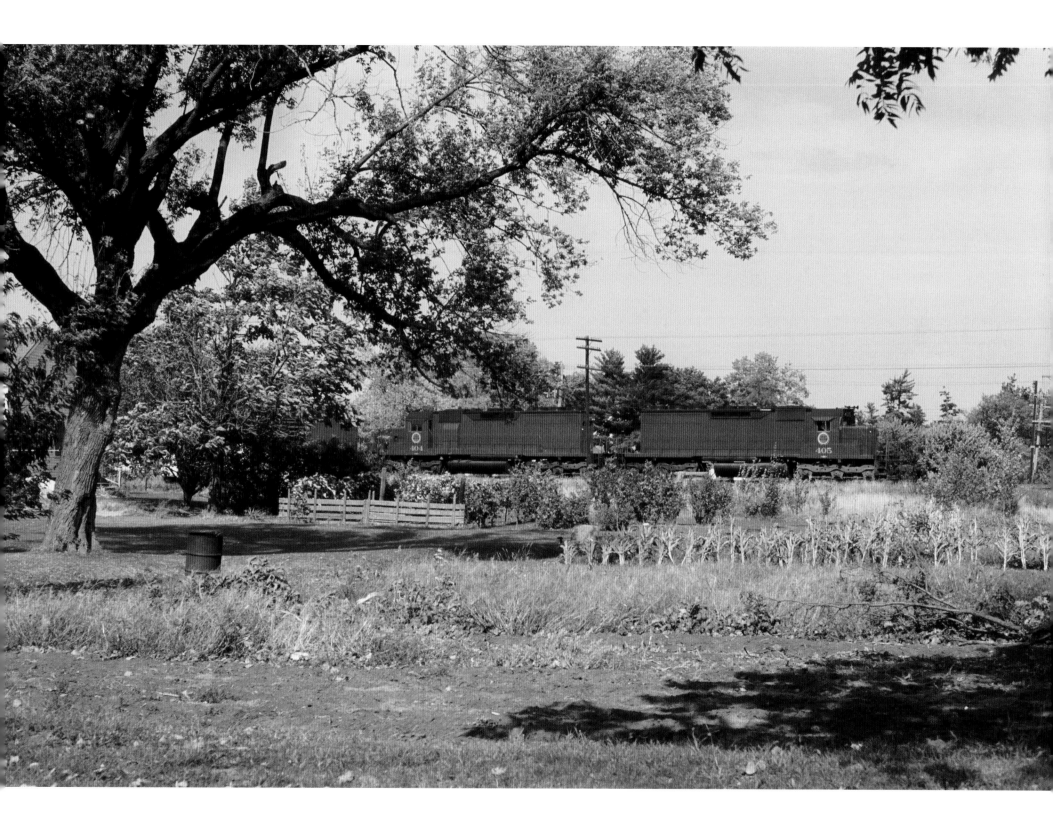

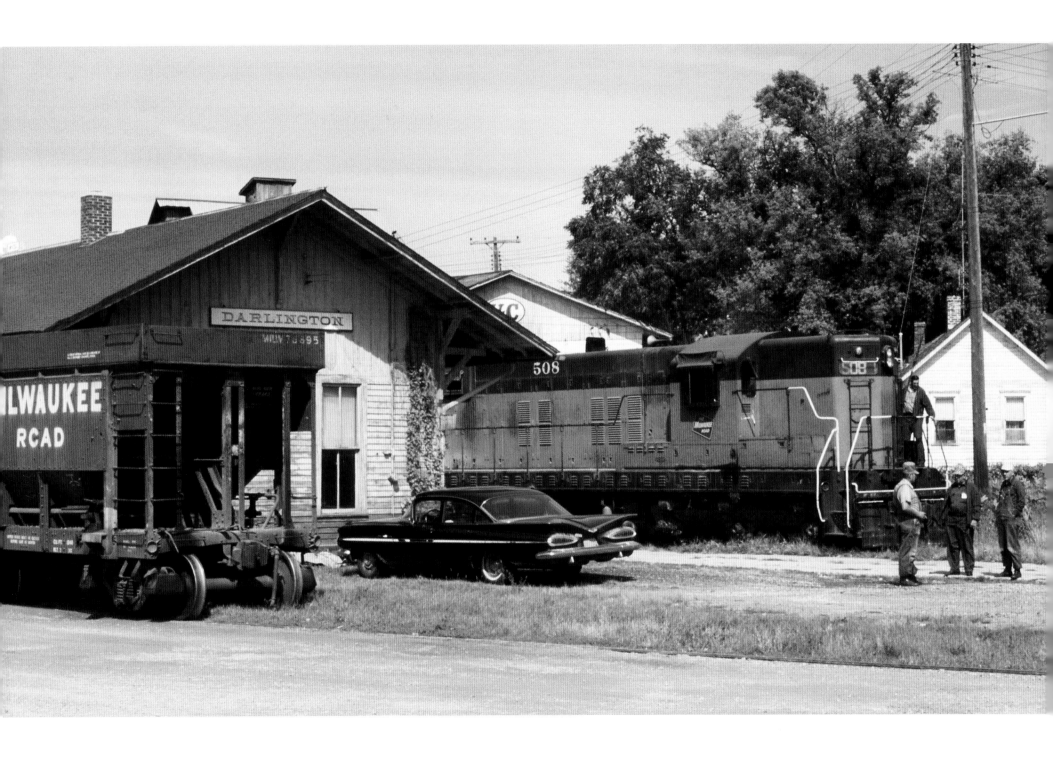

Cheeseheads

A fascinating network of branch lines served the dairyland of southwestern Wisconsin. The Milwaukee Road's "Limburger Limited"
worked the branches from Mineral Point and New Glarus to Janesville. Lightweight SD7 508 (left) was at Darlington,
returning from Mineral Point, in September 1971. A Chicago & North Western GP30 (above) was working the "Ridge Runner"
on the Cuba City branches west of Madison in September 1970.

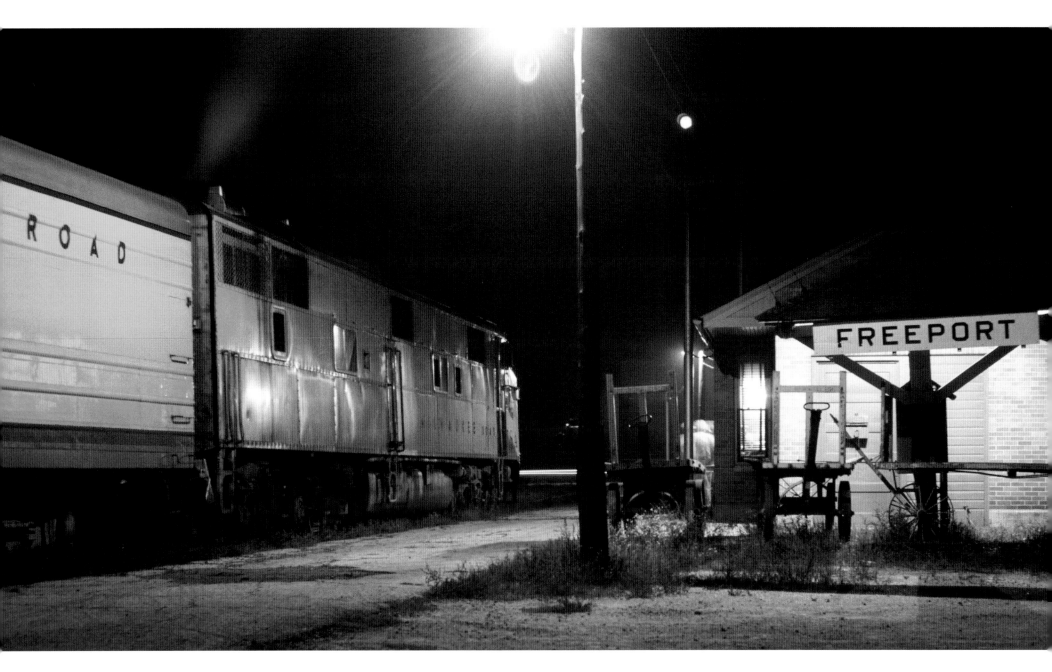

The Milwaukee Road

In contrast to the speedy *Hiawathas* and *Cities* streamliners on the main lines, the remnant of the old Milwaukee–Kansas City *Southwest Limited* rambled the branch across southeastern Wisconsin and northwestern Illinois from Milwaukee to Savannah, where it connected with the overnight *Arrow* to and from Omaha and Sioux Falls. With an E7 for power, westbound No. 25 paused at Freeport, Illinois, in October 1965 during its last week of service.

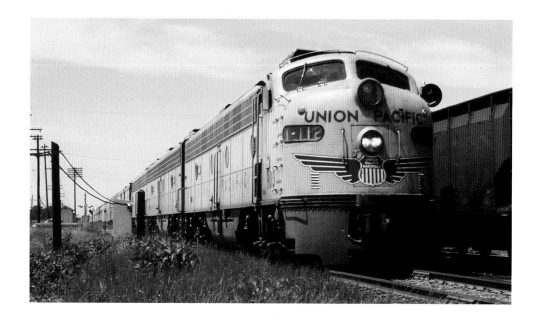

The CB&Q line from Rockford to Flagg Center was shared with the Milwaukee Road's branch from Janesville, Wisconsin, to Ladd, Illinois. In 1965, the standard units on the Ladd run were Fairbanks-Morse H16-44 road switchers such as the 428 and 434 (below) switching at Davis Junction. In 1955, the Union Pacific's *Cities* streamliners moved from the C&NW to the Milwaukee Road's Omaha–Chicago main that crossed the Rockford–Flagg Center line at Davis Junction. In June 1965, First 112 (right), the eastbound *City of Denver*, was departing "D.J." in midmorning behind a set of UP E9s.

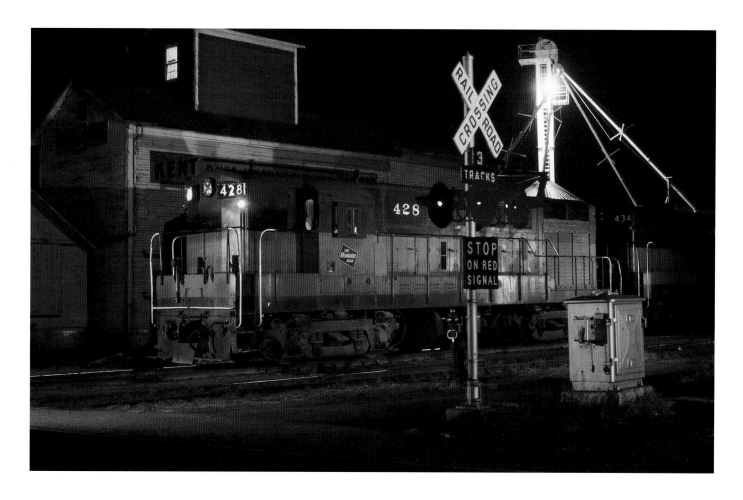

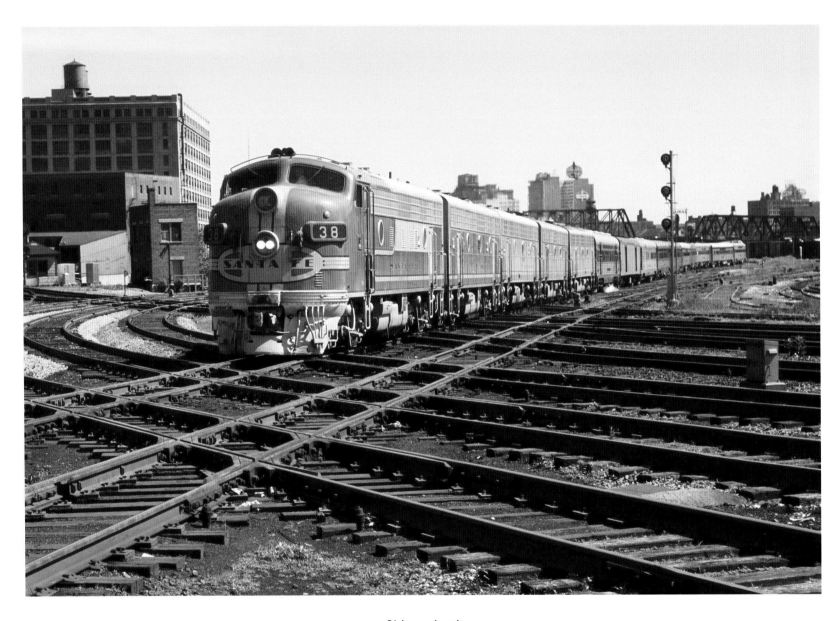

Chicagoland

The defining location in Chicago was 21st Street Interlocking, where the tracks out of Dearborn Station crossed the tracks out of Union Station and split into main lines to the east, west and south. On June 16, 1964, Santa Fe No. 19, *The Chief* to Los Angeles, was heading west behind a perfect A-B-B-B-B set led by F7 38L.

CHICAGOLAND

Chapter Two

CHICAGO IN THE MID-1960s WAS THE MOST WONDERFUL
playground any young railfan could imagine. It was literally
"The Railroad Capital," where east met west and north met
south. Into six major passenger terminals came America's finest
passenger trains and hordes of nameless locals and mail trains. Its
freight yards were too numerous to fathom, and an amazing spider-
web of belt lines and terminal companies worked endlessly to make
order out of hopeless chaos. Vintage roundhouses and spartan new
diesel facilities were home to the finest and weirdest of American
motive power.

It was my quest for steam that got me into Chicago for the first
time, on August 11, 1957, for a B&OCT steam fantrip. My folks gave
me a predawn ride up to Oregon, Illinois, to catch Burlington No. 48,
the *Black Hawk–Mainstreeter–Western Star* into Chicago. I took along a
notebook in which I logged every locomotive I observed on the trip,
and with precise teenage logic, I put the steam engines and diesels
on separate pages. In retrospect, my diesel-spotting was approximate
at best, but I could tell Alcos from Baldwins and EMDs. Those colorful
diesels might be fun someday when I didn't have more important
steam things on my mind.

In December 1959, I got black-and-white snapshots and 8 mm
color movies of an ex-B&OCT 0-8-0 working the coal dumper on the
Indian Hill & Iron Range. It was Chicago's last operating steam
locomotive, and I could kick myself for never going back to shoot
the ex-TP&W Lima switcher that replaced it.

When I got a job in Rockford in the summer of 1963 and my
own car, I began to team up with Mike Schafer and other local fans
for frequent forays into Chicagoland, seeking out the scheduled and
easily predictable passenger trains (thanks to Mike's mastery of
timetables) and the more elusive freights. Being a motive power nut,

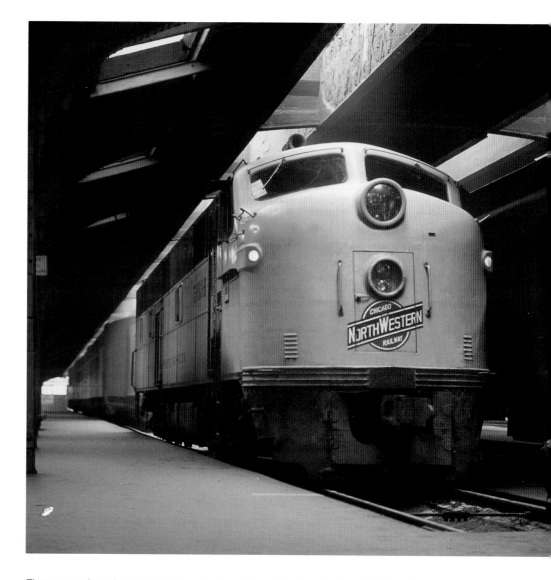

There were six major passenger terminals on the west and south side of Chicago's
downtown "Loop." The farthest north and west was North Western Station, where in
1964 a switcher was removing the consist from behind the E7 that had brought the
C&NW's *Kate Shelley 400* in from Clinton, Iowa.

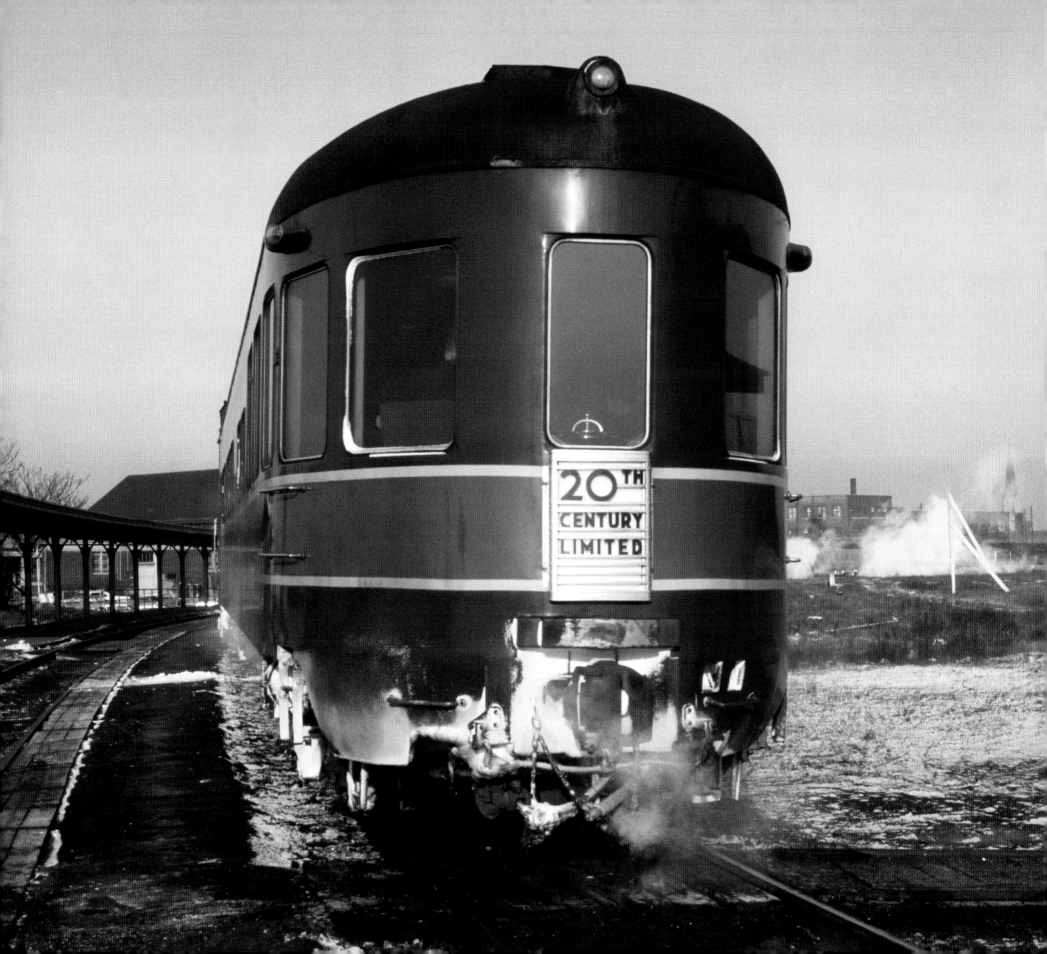

I loved all the engine terminals, with their variety of colorful diesels and the occasional surprises in the form of a rare old unit or a shiny brand-new one.

My skills at diesel-spotting were rapidly improving, along with my photography, and I put more and more emphasis on color slides. As the 1960s moved along, the color transparency film was improving. I never liked the brassy look of the old, slow Kodachromes and preferred the look of Ektachromes. Unfortunately, the "best sounding" film, Professional Ektachrome, proved to have an extremely short lifespan, and after twenty-five years it was already beginning to frazz out into a pool of red. In 1964, I got my first 35 mm Pentax single-lens reflex with 55 mm normal, 28 mm wide and 180 mm telephoto lenses. The new camera gave me greatly improved flexibility over the 2 1/4 x 2 1/4 fixed-lens Kodak Chevron I'd gotten from Parker Lamb.

Chicago had so much to offer that it was almost too much to handle, and we often got lazy and just hit the usual spots and failed to seek out the more elusive and exotic subjects. We were regularly reading the magazines and knew which railroads were getting new units or retiring old ones, and that news would often determine where we would go on any given weekend. The Sy Reich rosters in *Railroad* magazine were gold mines for their listings of rare diesels that we could go looking for.

My favorite quest was for the slant-nosed EMD E-units. The IC had a pair of E6s in the handsome *Panama Limited* scheme, and the CB&Q had its elegant stainless-steel-clad E5s. The Rock Island and B&O frequently produced E3s and E6s, and we even got Atlantic Coast Line E6s in on the Pennsy's *South Wind* out of Florida. The Santa Fe had its E6s and lone E3 and rare E8ms on No. 12 from Kansas City, arriving right around dusk and departing the next morning. And the Santa Fe often had Alco PAs on the *Texas Chief* and *Grand Canyon*. We made a lot of trips to Hammond, Indiana, when the Erie

Lackawanna had transferred its entire fourteen-unit PA fleet to the west end for freight service. On rare occasions, a PA set would get hijacked for passenger duty.

By the late 1960s, however, we were becoming aware that some diesels had already disappeared. On one of my first trips into Chicago on the CB&Q, I remember stepping off the *Morning Zephyr* and coming face to face with a set of awesome Pennsy Baldwin passenger Sharks in Union Station, but I never saw them again. I'd already missed Nickel Plate and New York Central PAs and the Milwaukee and North Western slant-nosed E-units. Maybe it was the threat of loss, so intensely experienced with steam, that made diesels more desirable and gave a sense of urgency to my diesel photography.

The only thing that could ruin a trip into Chicago was the weather, and it often did. I've got a lot of crappy weather shots in my "culls" boxes. But I had learned quickly that the same low clouds, mist and moisture that made daytime photography so dreary could turn night photography into pure magic. Mike Schafer and I got very good at open flash night photography and spent almost a decade in and around Chicago as sleep-deprived twenty-somethings!

At Englewood in March 1964, the elegant observation-lounge *Hickory Creek* was bringing up the markers on the New York Central's overnight *20th Century Limited* from New York City, making its last station stop before terminating at LaSalle Street Station in downtown Chicago.

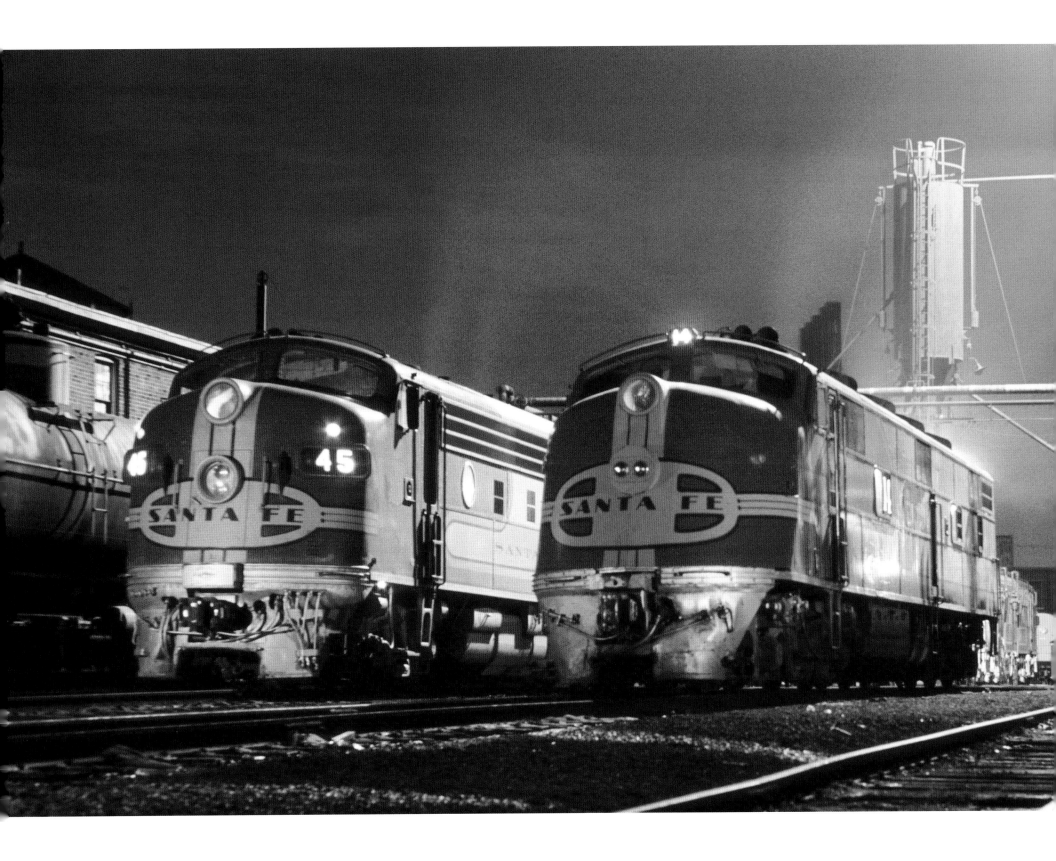

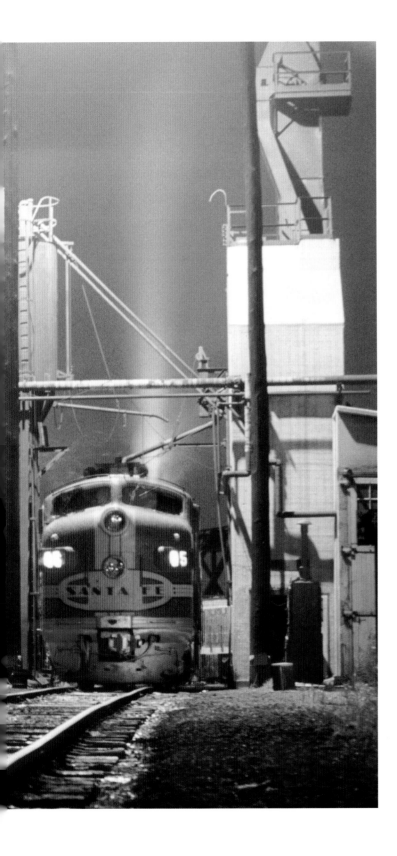

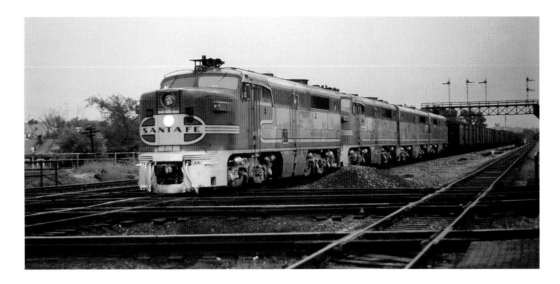

The East End of the Santa Fe

The modern Santa Fe Trail began at the bumping post of Dearborn Station, and the nearby 18th Street engine terminal was the staging area for the passenger power. In July 1965 the units lined up there included F7 45, E6 14 and E8m 85. The Santa Fe rostered only thirteen cab and eight booster E-units. Not all the Warbonnets were in passenger service, however, as evidenced by the A-A-B-A set of Alco PAs hitting the Rock Island diamonds at Joliet (above) with a "Green Fruit Express" strawberry train on a rainy summer evening in 1965 and the A-B-B F7 set (below) on westbound freezers at McCook in June 1966.

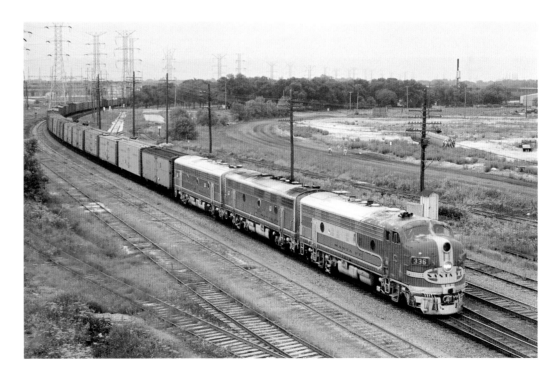

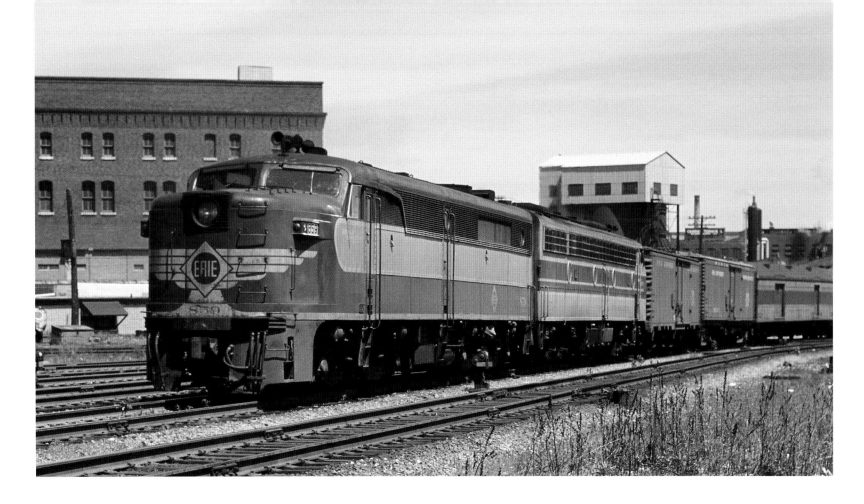

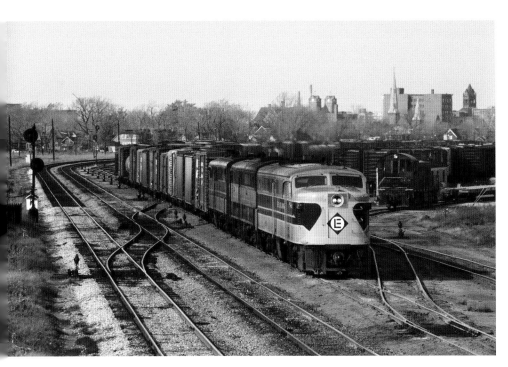

Chicago's Own PAs

The Santa Fe Alco PAs always seemed like outlanders, sneaking in at night on a mail train and escaping the next afternoon on the *Texas Chief*. But over at the Chicago & Western Indiana's 47th Street engine terminal, you'd usually find a set of Erie Lackawanna PAs. The entire fleet of fourteen former Erie PA1s (850–861) and PA2s (862–863) had been transferred in the early 1960s to work the flatlands between Chicago and Marion, Ohio. The 856 was still in full Erie livery (above) at 21st Street on the *Lake Cities*, outbound to Hoboken, New Jersey, on June 16, 1964. The 850, 859 and 853 (left) were on an eastbound freight at Hammond, Indiana, in November 1965.

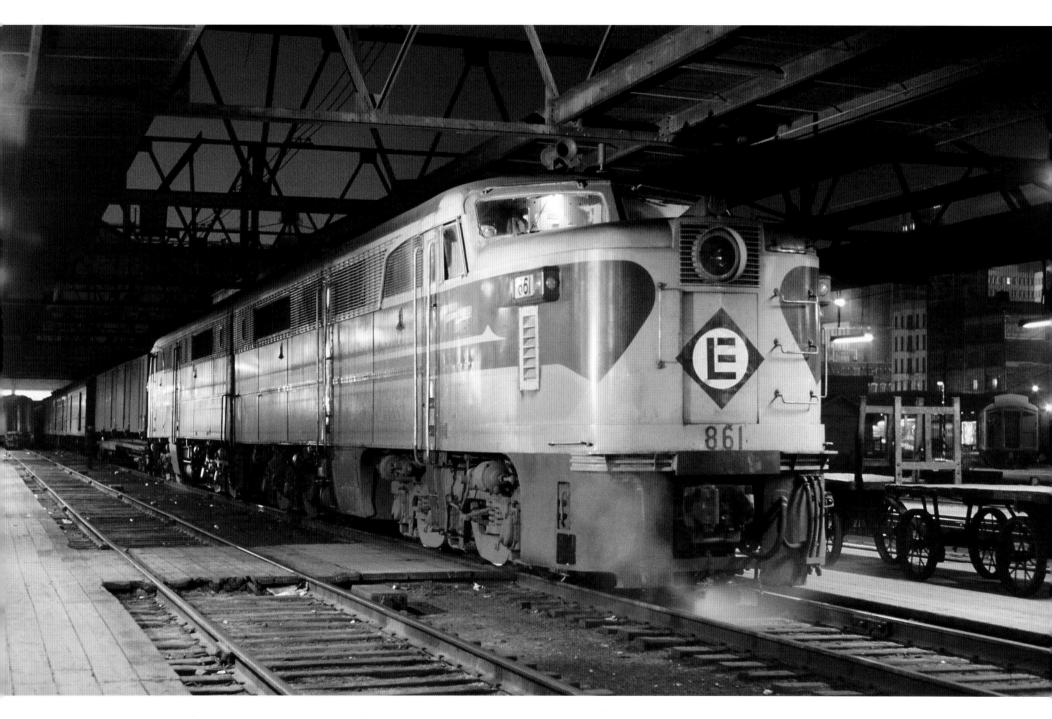

The last regular passenger assignment for the EL PAs was the *Atlantic Express*, an overnight mail train. The 861 was on No. 8, awaiting its 10 p.m. departure at Dearborn Station, in November 1965. Joining us taking this photo was Californian Richard Steinheimer (opposite), who was en route to photograph Pennsy GG1s in New Jersey for a *Trains* magazine feature article.

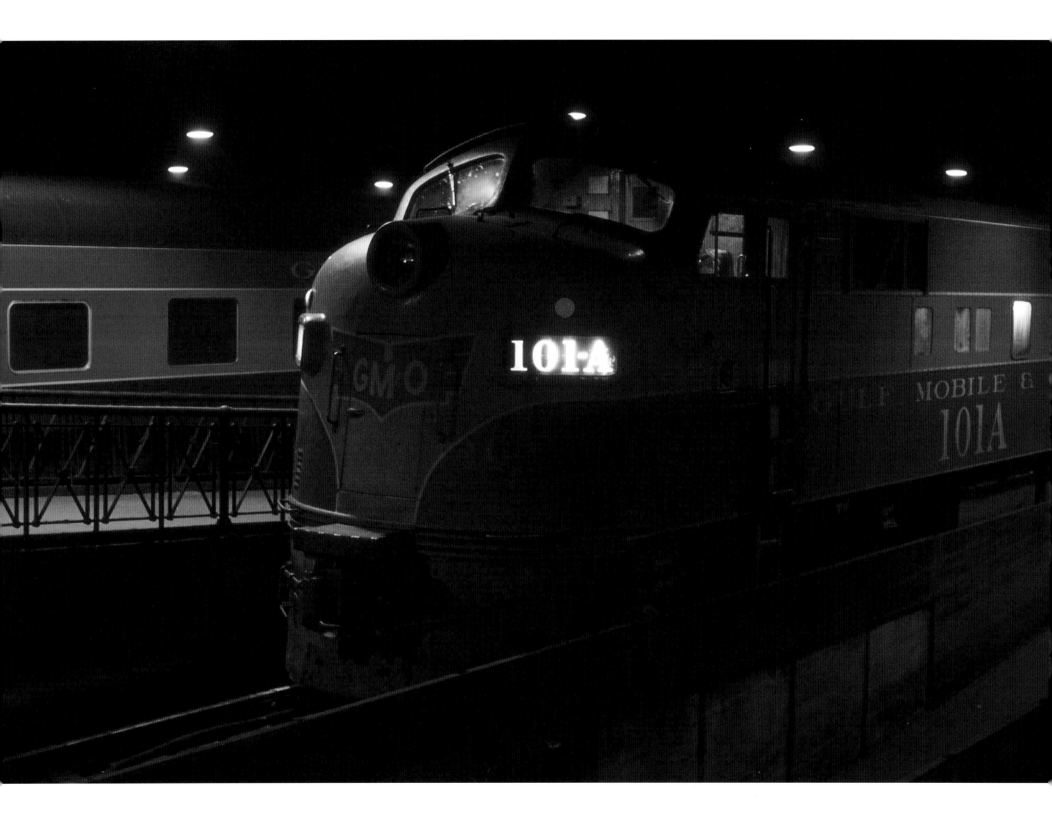

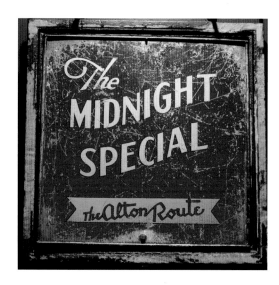

The Midnight Special

The supreme irony of Chicago railroading was
"The Rebel Route" Gulf, Mobile & Ohio running the
Abraham Lincoln to and from St. Louis. This was,
of course, the result of the 1947 merger with the
Chicago & Alton. The *Abe* had arrived in Chicago
Union Station in November 1965 behind E7 101A
(opposite) and pulled up across the platform from
the *Midnight Special*, awaiting its 11:25 p.m.
departure. Two months earlier, the Pullman porter
(right) was ready to usher me to my open section
lower berth in the four-section, eight-roomette,
one-compartment, three-double bedroom 1950
ACF sleeper *Culver White*.

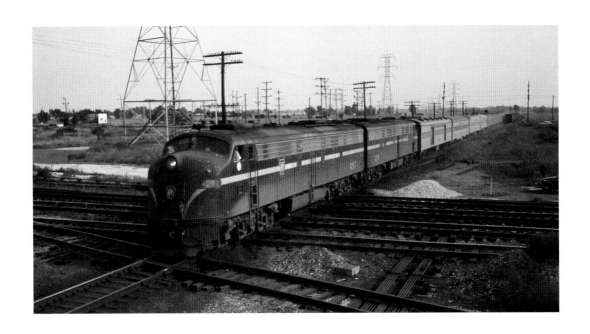

The South Wind

My wall calendar in the mid-1960s had every fourth day circled so I could see at a glance what power would be on the Pennsy's every-other-day *South Wind* from Florida, which would alternate between Pennsy and Atlantic Coast Line run-through units. Pennsy E8s had the inbound *South Wind* banging the Nickel Plate and B&OCT diamonds (left) at Burnham Tower in 1965. ACL E7s had the train departing Union Station (below) on a different day. A slant-nosed ACL E6 was idling overnight (opposite) in the Pennsy's 18th Street engine facility in December 1965.

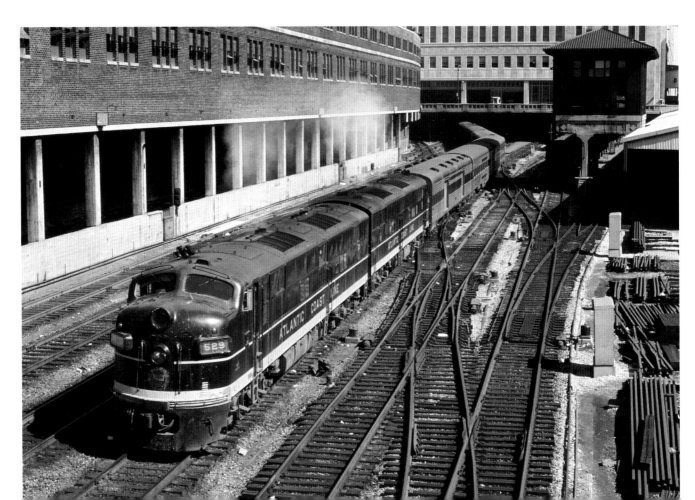

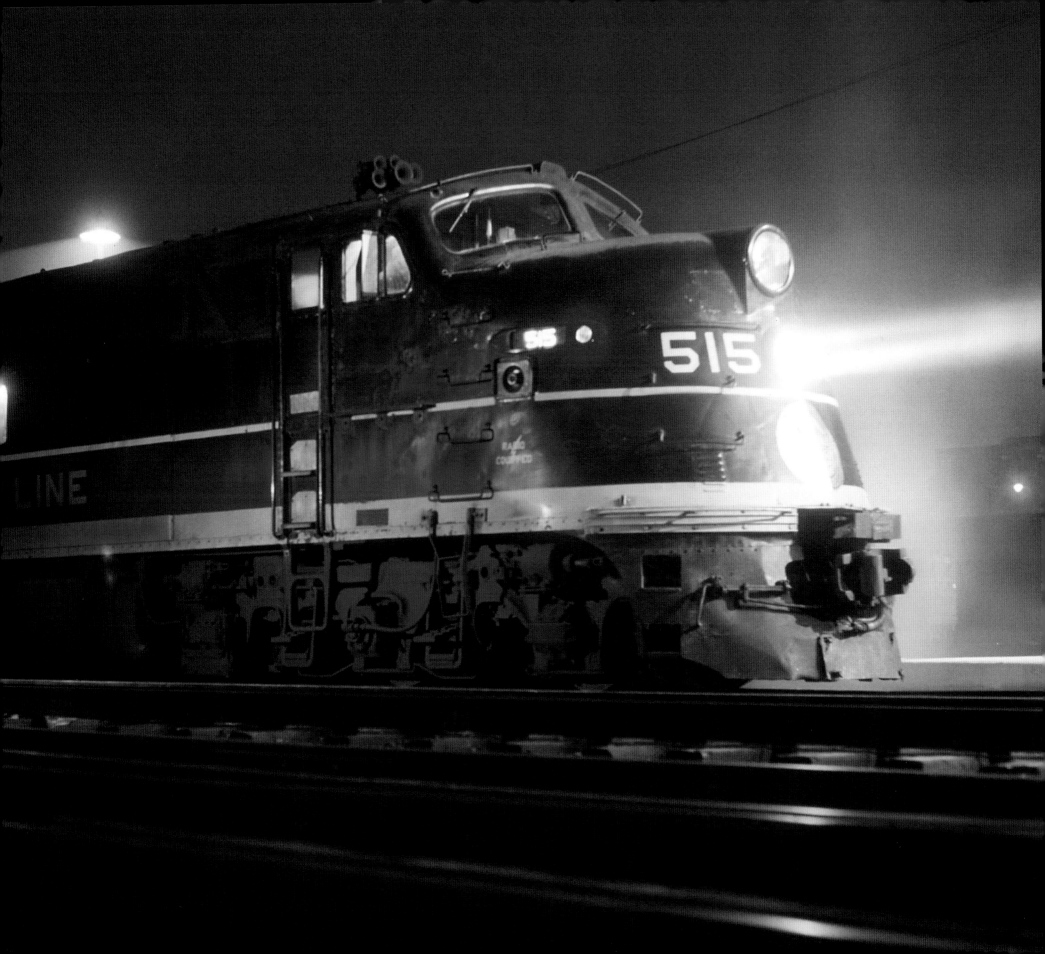

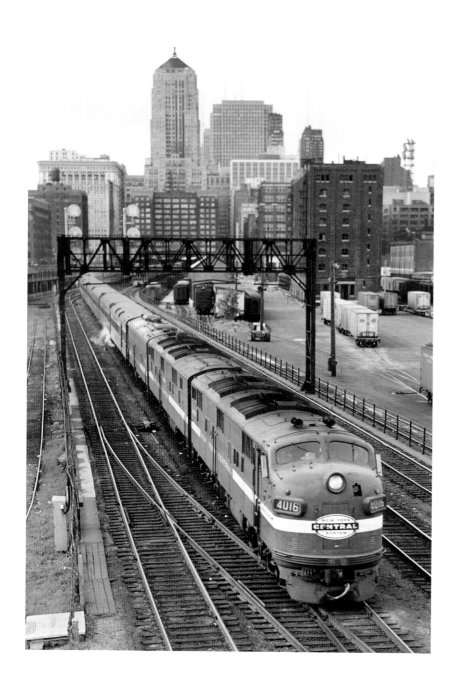

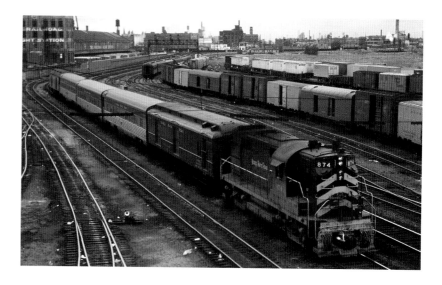

The Railroad Capital

The Board of Trade Building (left) towered over the otherwise unassuming LaSalle Street Station as the New York Central's legendary *20th Century Limited* was outbound at Roosevelt Road in 1964. The Rock Island's unique repowered Alco DL109 621, "Christine"(below), was at the same location on July 12, 1964. A "pure" Alco, RS11 874, was arriving at Roosevelt Road (above) in 1964 with the Nickel Plate's overnight *City of Chicago* from Buffalo.

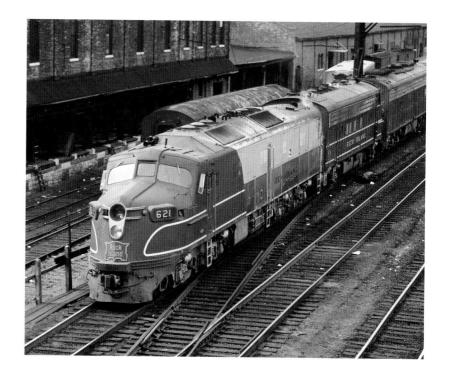

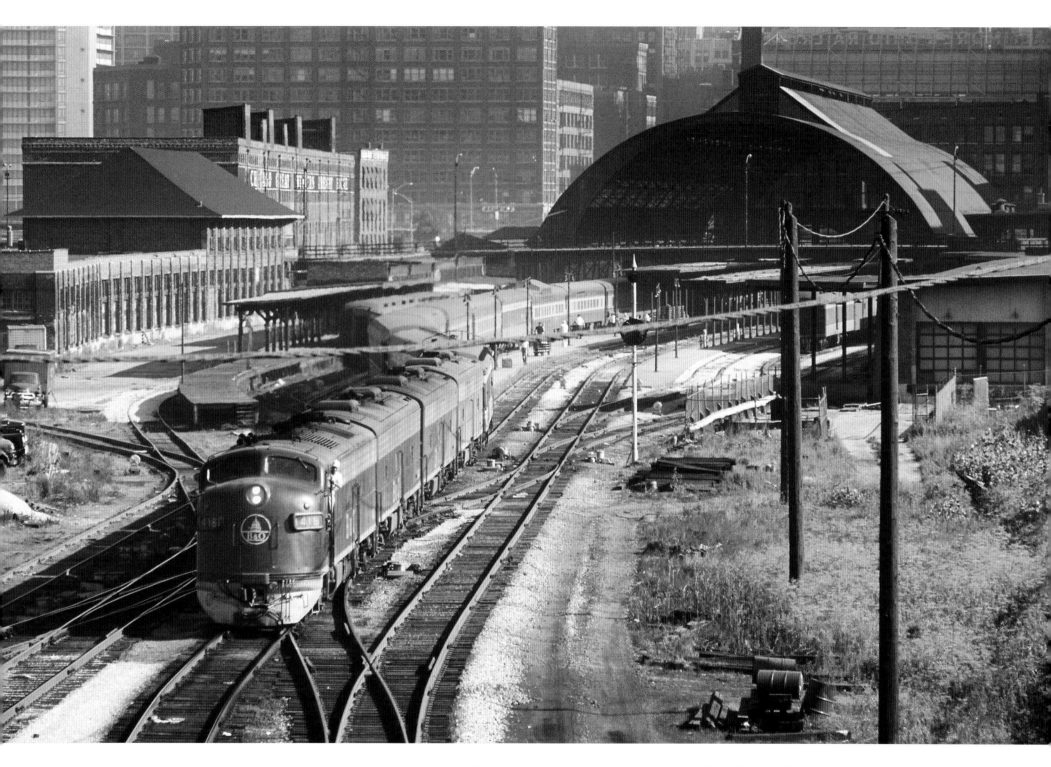

Chicago's most picturesque terminal was Grand Central Station, with its clock tower and arched trainshed. The Baltimore & Ohio's *Capitol Limited* was shoving in backwards (above) as it arrived from Baltimore and Washington, D.C., on a summer morning in 1965.

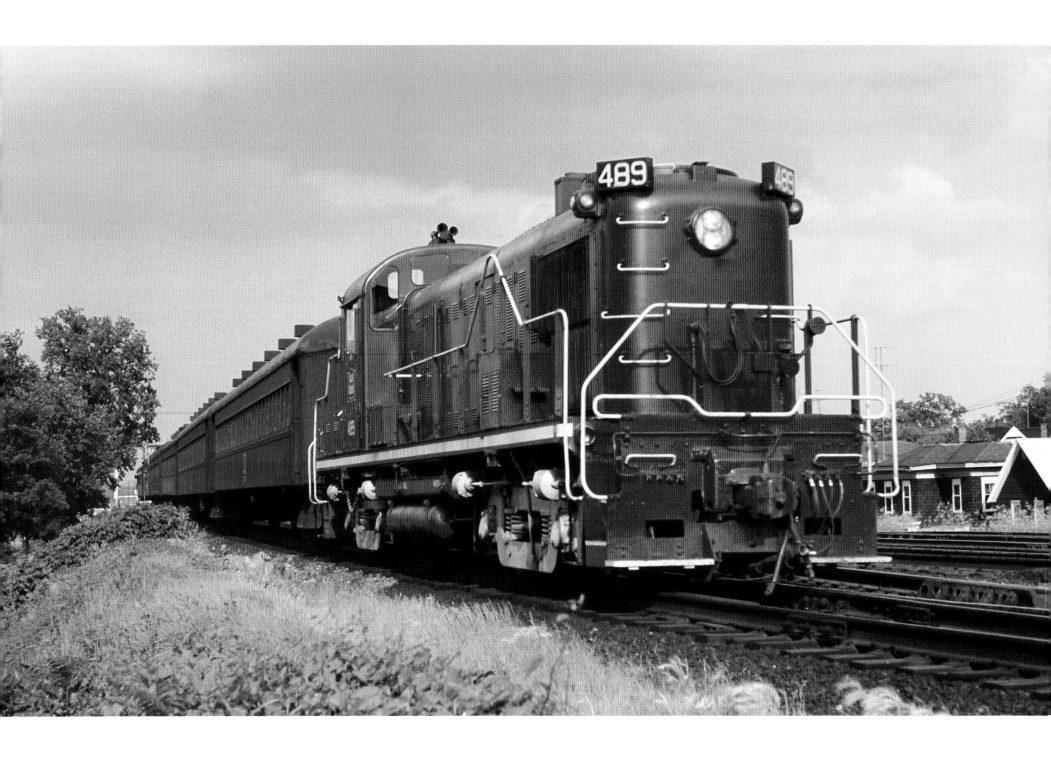

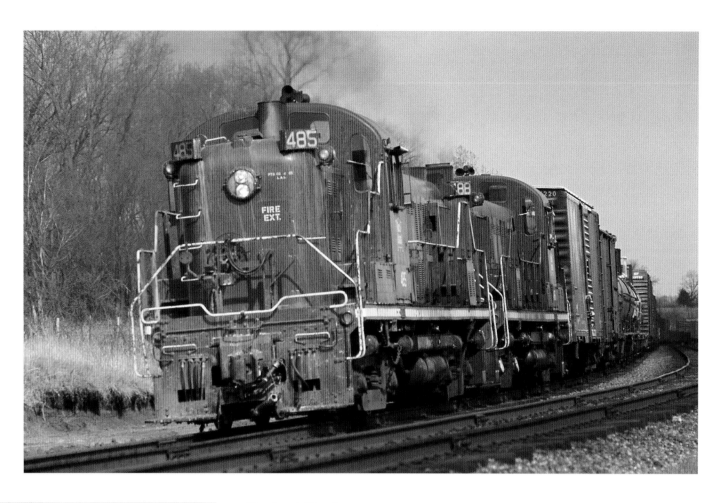

Weekend Warriors

The Rock Island operated its commuter service out of LaSalle Street Station to Joliet with a diesel fleet that included fifteen dual-control RS3s (485–499) equipped with head-end-power generators mounted on their running boards. The 489 was on a typical commuter run (opposite) in June 1965. When they were scheduled for inspection, the RS3s would be put on weekend freights and sent 177 miles west to the locomotive shop at Silvis. One of our favorite photo locations in western Illinois was Wyanet, where the Rock crossed under the CB&Q main line. Saturday mornings would find the RS3s working westward, like the 485 and 488 (above) and 492 and 488 (left) on different weekends in 1965.

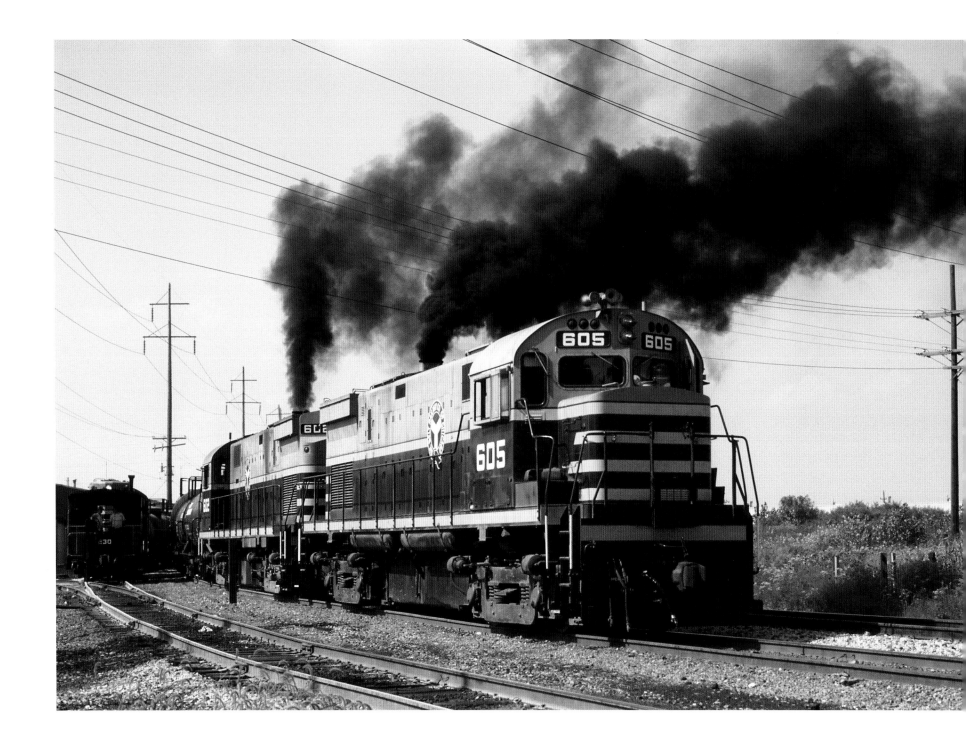

Belts: Inner, Outer and Otherwise

The Chicago terminal region is defined by the Elgin, Joliet & Eastern, the 129-mile "Outer Belt" surrounding the city from Waukegan on the north to Joliet on the west and Porter, Indiana, on the east. The "J" was famous for EMD-repowered center-cab Baldwins, such as the 916 crossing the C&O, Erie and GTW (above) at Griffith, Indiana, in August 1965. The "Inner Belt," Belt Railway of Chicago, was known for the six Alco Century 424s it bought in 1965. The 605 and 602 were putting on a classic Alco show (opposite) at Clearing Yard in September 1987. The Chicago River & Indiana used Lima switchers such as the 8410 at Western Avenue Junction (right) on June 16, 1964.

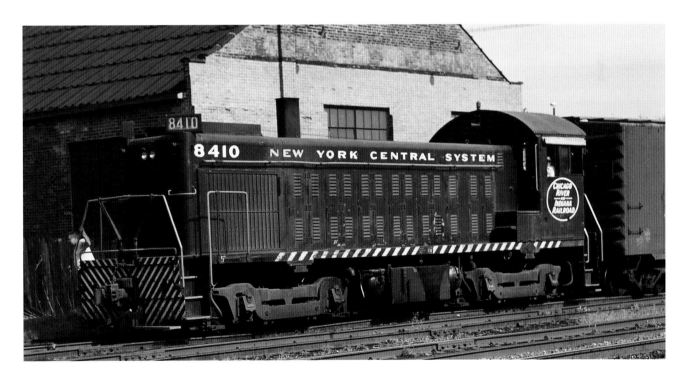

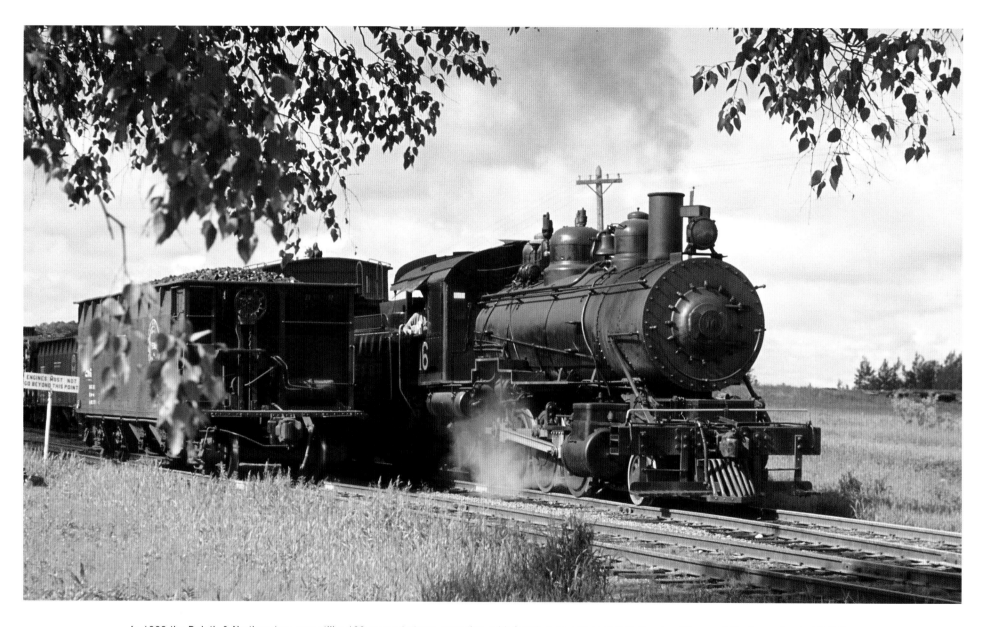

In 1963 the Duluth & Northeastern was still a 100-percent steam operation, with four 2-8-0s and an 0-6-0. Number 16, one of the two saturated 2-8-0s, was simmering at the DM&IR interchange at Saginaw while the crew took its lunch break. On June 14, after three days of getting my fill of regular service steam, I ventured into Superior, Wisconsin, to see the diesels, including the pair of Duluth, Winnipeg & Pacific RS11s (opposite) delivering a transfer to the Great Northern's yard. It was this day that convinced me that diesels were worth photographing.

EXPANDING HORIZONS

Chapter Three

M Y FIRST LONG-DISTANCE VENTURE WAS PART OF MY continuing quest for steam. It was an Illini Railroad Club fantrip to the Duluth, Missabe & Iron Range on the Fourth of July weekend of 1958 with CB&Q O5a 4-8-4 5618 hitting 100 miles per hour up the Mississippi River and DM&IR 2-8-8-4 222 rambling around the Iron Range, where we spotted Mikados still in regular service. A year later, I made a trip to the Colorado narrow gauge with CB&Q O5bs 5632 and 5626 relaying the train from Chicago to Denver and Rio Grande diesels over La Veta Pass to Alamosa. I shot rather crude 8 mm movies and some not-too-bad black-and-white snapshots with my dad's Zeiss-Ikon folding camera. A group of us rented a car and drove up to Cheyenne, Wyoming, during our free day in Denver on the return trip. There were fourteen cold Big Boys in the Union Pacific roundhouse and all sorts of big stuff in the outdoor dead line, but the highlight of the trip was on the Colorado & Southern. In the roundhouse was live 2-8-2 803, an ugly bucket that was essentially a CB&Q O1a like 4960, but with an Elesco feedwater heater. It was called for the afternoon Loveland Turn, and we almost missed the departure of our train from Denver by waiting for the C&S to move the 803 out onto the turntable and ready track. Unfortunately, we couldn't wait for its departure. The 803 turned out to be the last regular service steam I would ever see on a Class One railroad.

I can pin down the date and almost exact moment that my photography came of age. In the second week of June 1963 I made a trip to the Duluth & Northeastern shortline at Cloquet, Minnesota, and it was still running steam. En route to Minnesota in Bruce Bailey's brand new Corvair, we had a classic Ralph Nader "unsafe at any speed" end-for-end spinout, doing donuts on a curve (fortunately with no damage or injuries or class-action lawsuits). My photography was about to do a similar turnaround. After three days of chasing the fleet

of 2-8-0s and a clattering and gassy Army 0-6-0, we took a day to check out some dead Great Northern steam in Superior, Wisconsin, but got distracted by the diesels. The big steam hulks that had been there six months earlier in the gloom of winter were gone, but nearby Soo Line F-units and ex-DSS&A Baldwins, a Northern Pacific Budd car and Duluth, Winnipeg & Pacific Alcos caused me to realize that diesels were almost as worthy of my attention as steam. It was likely a function of

three days on the D&NE "getting my fill" of regular-service steam for the first time in my life! It was the night photo session at the Soo Line roundhouse that got me hooked on diesels.

After the Duluth trip, I began pursuing my newfound interest in diesels with dozens of trips into Chicago and around the upper Midwest. I had to learn to shoot locomotives that didn't make smoke

in countryside that most people consider as fascinating as the surface of a pool table. In addition to being exposed to editor David P. Morgan's exquisite taste in photography in *Trains* magazine, I learned how to shoot the "vast flatland" from black-and-white books by Bob Olmsted, who could make a corn stalk, crossbuck, grain elevator or lineside tree as compelling a photo element as a snow-capped mountain or desert cactus.

Because of the influences of masters of black and white such as Lamb, Olmsted and Gruber, and the monochrome magazines and books of the time, I learned to think in black and white. I would mentally compose a picture in black and white, using the light contrast to carry the composition, with the color being just a delightful additional effect. I didn't realize until decades later what a valuable skill this was, as I began to see the work of railfans who had learned on color and had no understanding of how to see light, a skill that was a natural part of my photography. To this day I compose in black and white and shoot in color.

Now that I had a car and a good-paying job at the television station in Rockford, and a gaggle of railfan friends, I began to explore railroads that required a bit more travel to reach. The Rock Island always yielded good action at Silvis and LaSalle-Peru, and the mighty Santa Fe put on a great show on Edelstein Hill, just west of Chillicothe. And there was no resisting the colorful Chicago & Illinois Midland further south at Peoria and Springfield (the subject of my first photo feature in the November 1965 *Railroad Model Craftsman*). Among our earlier overnighters were trips to Omaha, Kansas City, St. Louis, Minneapolis, Louisville and Cincinnati.

I was still chasing steam whenever possible, and Canadian National 4-8-4 6218 tempted me into a "foreign" country for the first time. It was a time-warp venture into London, Ontario. While the 6218 was everything I could have dreamed of, an unexpected bonus was the flock of Fairbanks Morse CPA16-5s that dominated the Windsor–Toronto passenger trains that ran through there. After shooting freight F-M C-Liners in the CN yard at Sarnia, Ontario, we drove across the bridge into Port Huron, Michigan, where my traveling companion, Joe Swenson, asked, "Isn't this where we're supposed to get out and kiss the ground of our homeland?"

In July 1966, I was at Northtown Yard in Minneapolis photographing the Northern Pacific's first two brand new SD45s. On hand was an EMD Field Instructor. I knew what the job was, since Bruce Meyer from the U of I was now doing the same work. Knowing Bruce had an electrical engineering degree, I asked the guy at Northtown what kind of a degree he had, and he replied, much to my amazement, "English literature."

He explained that the job's only requirements were that you be twenty-one years old and willing to travel. I qualified on both counts, and so he told me how to apply for the job. As soon as I got back home to Rockford, I fired off my application to Shorty Rogers at EMD and just as quickly got back a reply, "We have no openings for someone with your qualifications at this time…" So much for that idea. Back to reality.

In September 1968, I got a phone call at the TV station: "Mr. Boyd, this is Mr. Rogers at EMD. Are you still interested in a position as a Field Instructor?"

A month later I was delivering SW1500s to the Great Northern at Minneapolis Junction and a month after that was riding GP38s in three directions out of Cumberland, Maryland, on the Baltimore & Ohio. It was the beginning of an incredible three years on the road, living out of a suitcase but carrying passes "Good On Locomotives and Freight Trains."

It was the railfan's dream job. My duties involved going to railroad shops all over the country where new diesels were being delivered and put into service. Though the job title, Field Instructor, was an outdated reference to the steam era, the actual work involved inspecting and riding the new units on their first runs and reporting on their performance for warranty protection. I carried my cameras everywhere I went while working on the GN, B&O, C&O, Western Maryland, Cotton Belt, Georgia Railroad and even Illinois Central, as well as a variety of short lines and industrial operations from Sandersville Railroad in rural Georgia to the River Terminal in the midst of Cleveland's Cuyahoga Valley steel mills.

Back in the summer of 1967 my soul was still solidly planted in northern Illinois, but that took a dramatic change with the EMD job. I saw many sights and made new friends in different regions. I realized that Americans were pretty much Americans, regardless of geography.

My horizons were rapidly expanding.

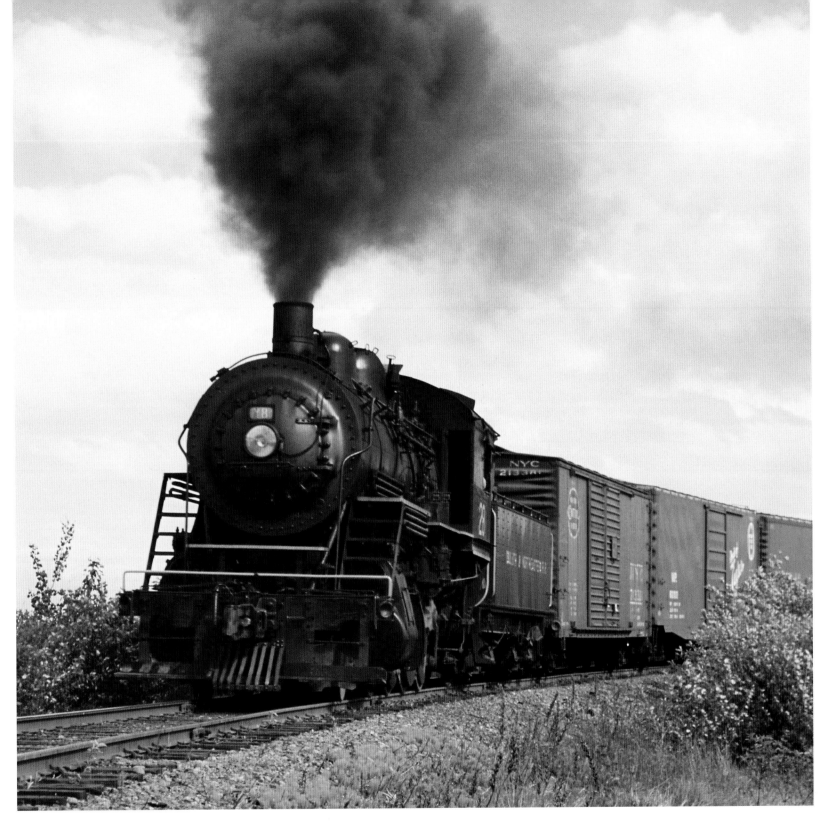

On June 15, 1963, superheated 2-8-0 No. 28 was departing Cloquet on the 12-mile afternoon run to the DM&IR interchange at Saginaw.

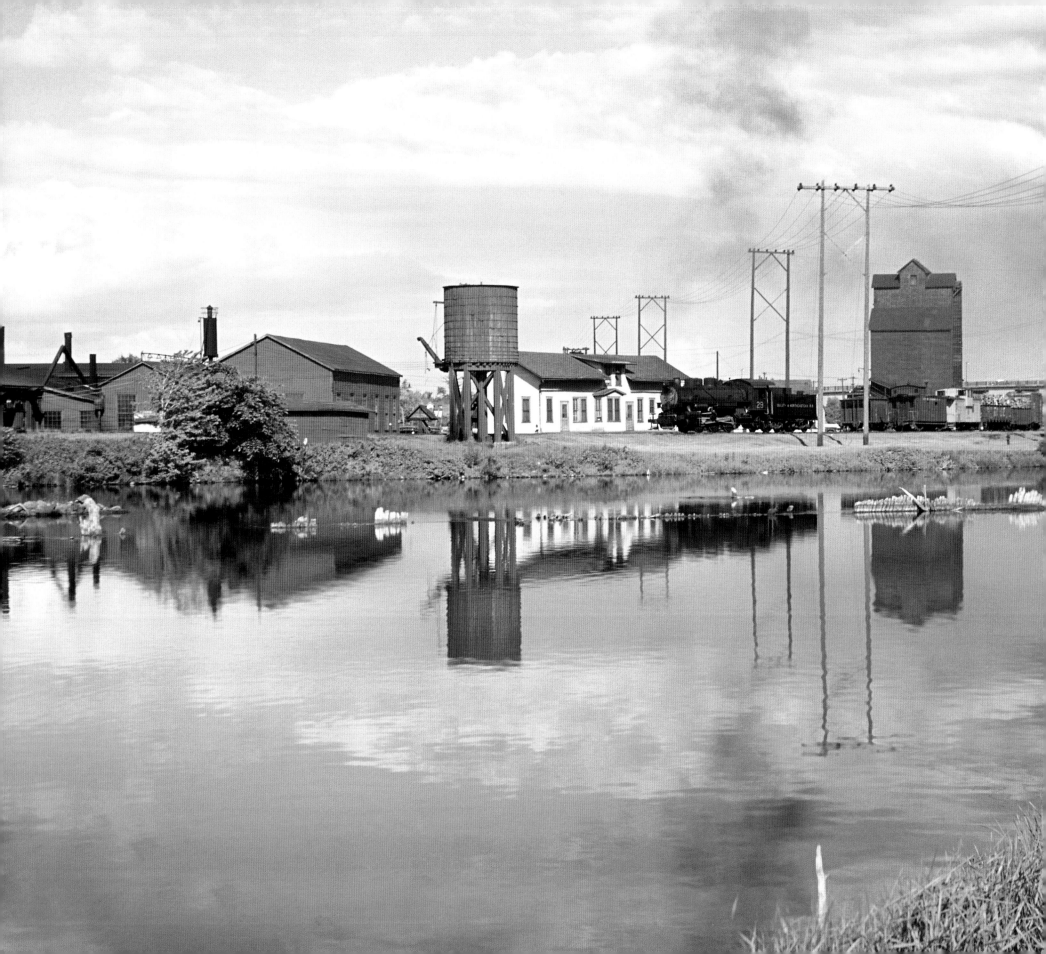

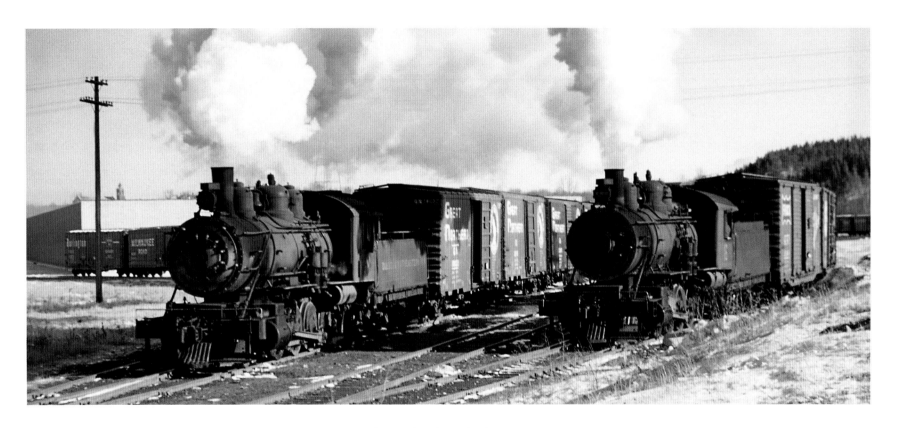

Consolidations in Cloquet

It had been eight frustrating years since steam had departed from Dixon, Illinois. But in Cloquet, Minnesota, the Duluth & Northeastern
was still running steam in revenue freight service without a single diesel on the property. On a cold but sunny March 8, 1963,
saturated 2-8-0s 14 and 16 (above) were working side by side in the Wood Conversion Company yard. Ex-Army 0-6-0 29 (left)
was reflected in the St. Louis River in front of the Cloquet office on June 17, 1963.

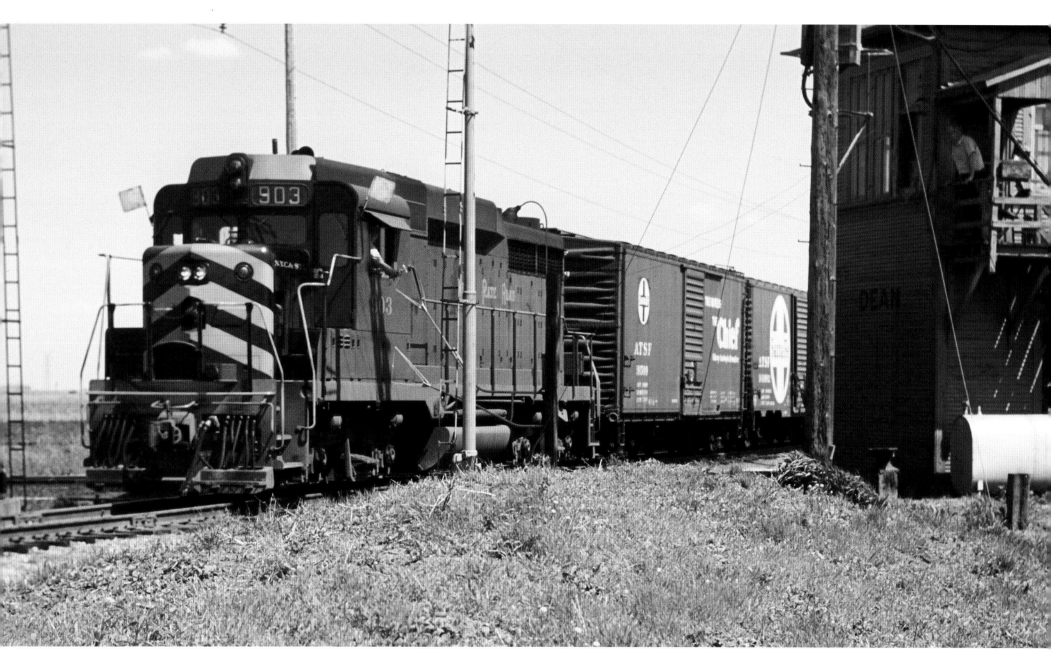

Encounters at Dean Tower

The first action I encountered at Dean Tower in Bloomington, Illinois, on March 3, 1964, was a westbound local on the Nickel Plate's old Lake Erie & Western line from Frankfort, Indiana, to Peoria, Illinois. GP30 903 was making a long double into the yard east of the tower (above) as the fireman snagged the train orders while the operator watched from the tower. The IC's Gruber line crossed the NKP and the New York Central's Peoria & Eastern on the east side of the tower. While the Nickel Plate was still working, a P&E job rolled westward (opposite top) behind three Geeps.

In 1949, the Nickel Plate bought its only GE 44-tonner, No. 90, for the yard just east of Dean Tower, where it was idling (below left) on May 3, 1963. Within six months, the "Mighty 90" was sold and "disappeared." In 1969, railfan Tom Lawson told me it had been sold by Birmingham Rail to Weston & Brooker Sand & Gravel at Grays, Georgia. In January 1970, I drove down there and found the elusive 90 still in NKP colors (below right). Passing by en route to Macon in 1968, I had gone looking for a railroad at that pit, but I did not see the tracks and turned back just 100 yards before I would have spotted the tracks and the 90!

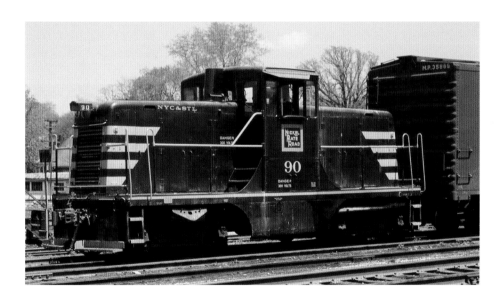

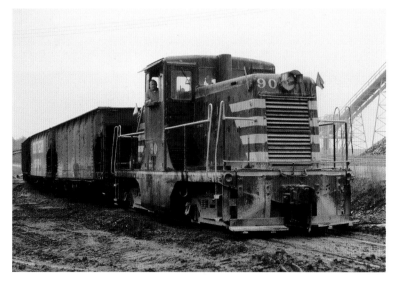

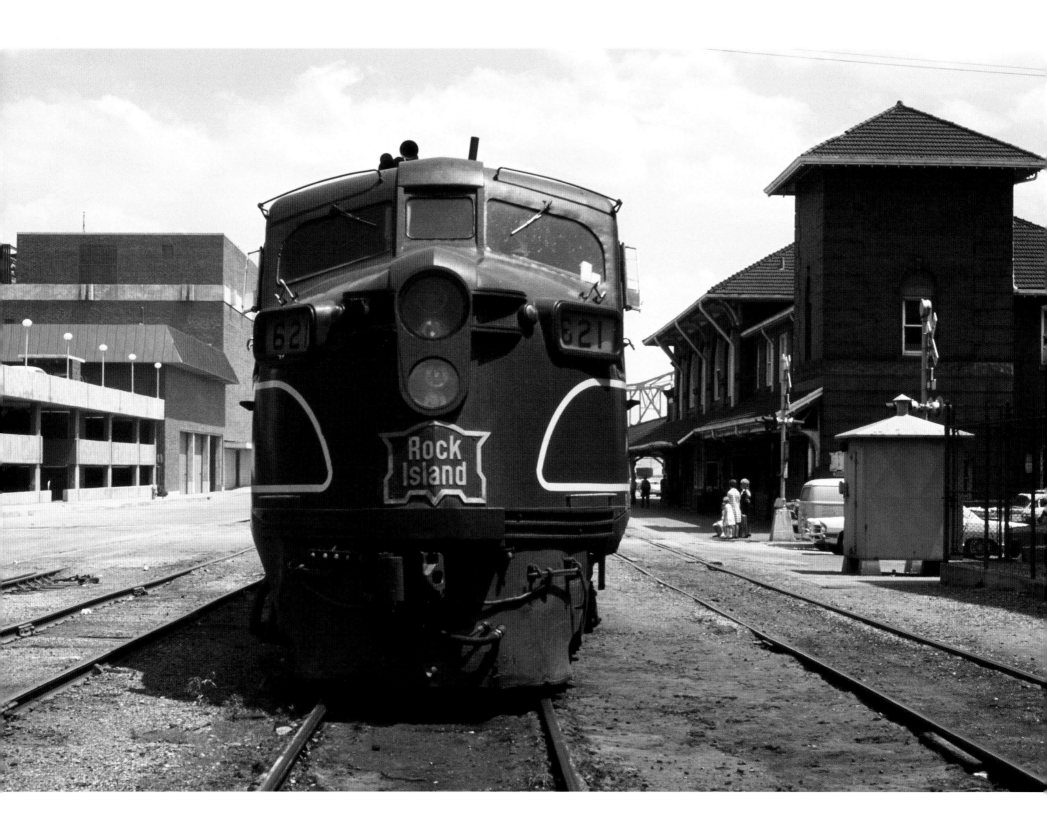

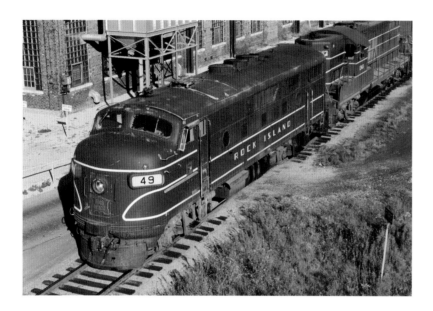

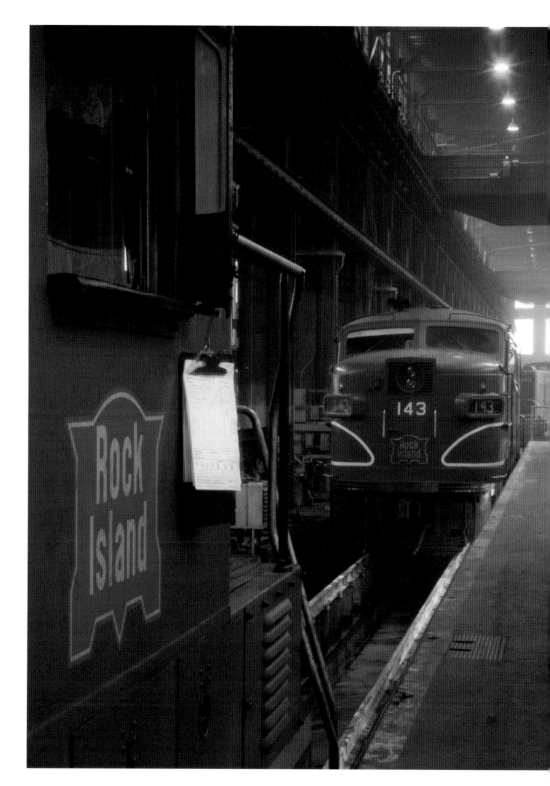

Rocketry

The Rock Island was always interesting, in spite of having abandoned its colorful red, black and silver *Rocket* scheme for the lifeless maroon. Star of the fleet was "Christine," the only Alco DL109 repowered by EMD. The 621 (opposite) had just brought the *Peoria Rocket* into Peoria, Illinois, in June 1967. The Rock Island had gotten a dozen 1350-h.p. F2s (38–49) in July 1946, and the most unusual one was No. 49, the "Bond-O Rocket," which had lost its upper headlight casing to a minor mishap. It was alongside the Silvis Shop (top right) in October 1966. Inside the shop (right) on January 24, 1965, was 143, the first Rock Island FA1 to be repowered by EMD, and the two-year-old U25B 206. Seeing the first new U-boats, Phil Weibler observed, "It's a shame to paint new units weathered maroon."

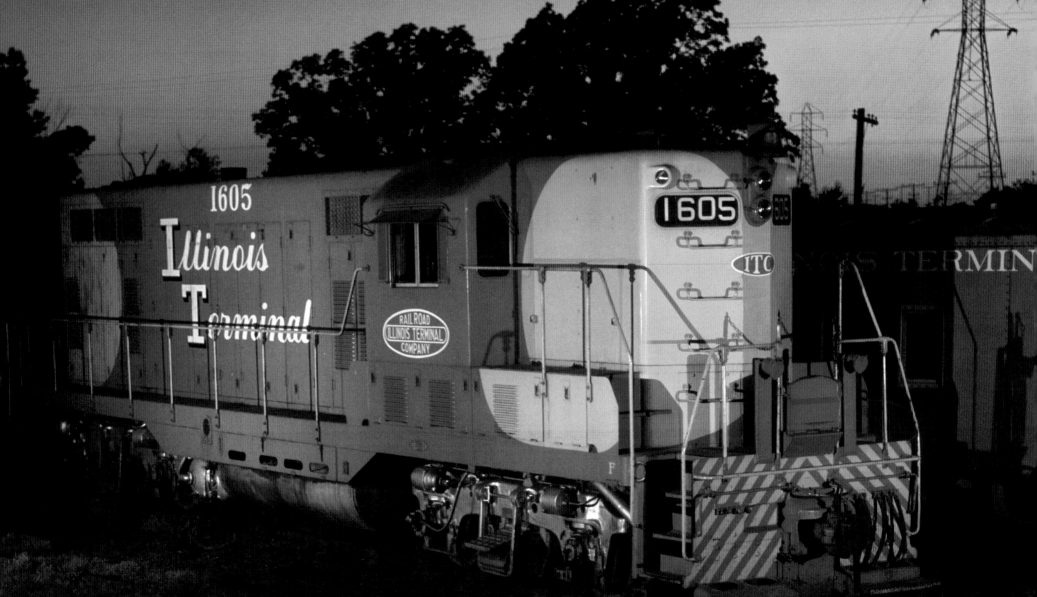

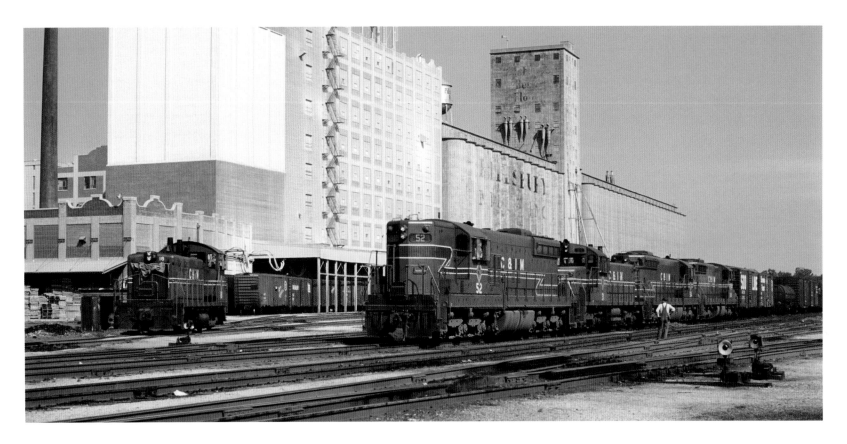

Peoria Greens

Peoria, Illinois, in 1964 was served by thirteen different railroads, but not a single significant main line. It was the home to the Toledo, Peoria & Western, where Alco RS2 203 (right) was working the East Peoria yard in the summer of 1965. Peoria was the northern terminal of the Chicago & Illinois Midland, which had its home facility 84 miles south at Springfield, where the Pillsbury flour mill (above) provided a dramatic backdrop for the Shops Yard. The Midland rostered only eighteen diesels, and one of each of its four models is in this June 1965 photo: SW1200 18, SD9s 52 and 54, SD18 61 and RS1325 31, one of only two ever built. The former interurban Illinois Terminal linked Peoria and St. Louis and was all diesel by August 1964, when GP7 1605 (opposite) was idling in Edwardsville at sundown.

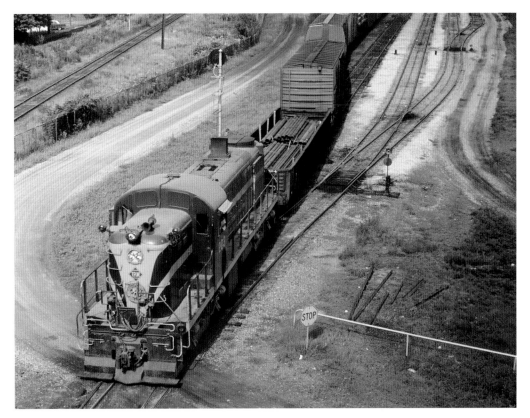

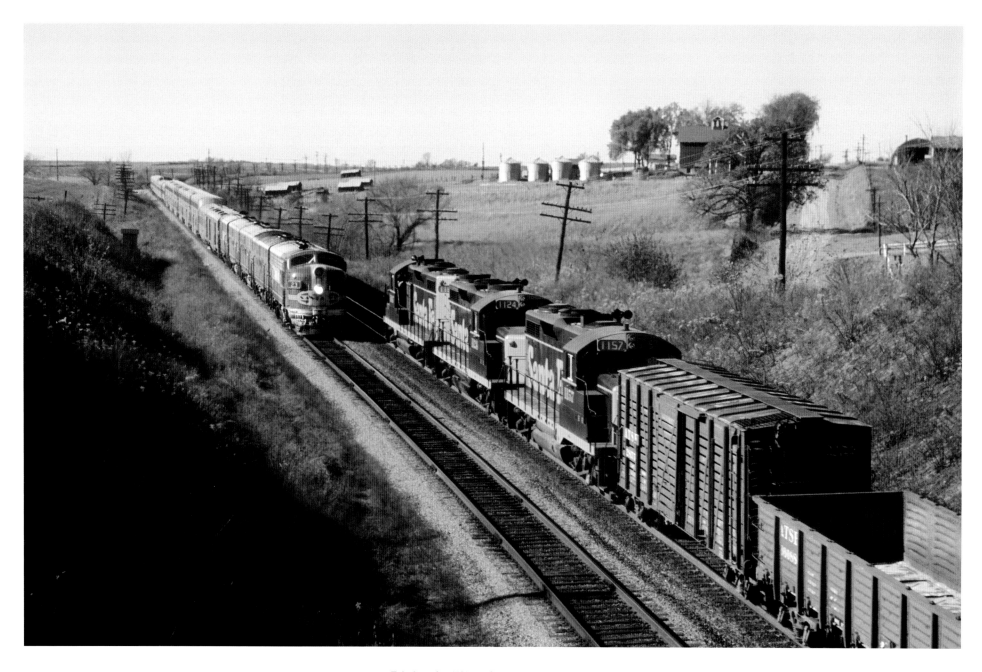

Edelstein Hill—October 11, 1963

Edelstein Hill, just west of Chillicothe, Illinois, is the steepest grade on the Santa Fe main line east of the Rocky Mountains. The one-percent climb out of the Illinois River Valley once demanded 2-10-2 helpers for the westbound shove. On a beautiful autumn day, October 13, 1963, three GP20s (opposite) were rounding Houlihan's Curve coming off the floodplain out of Chillicothe. Three miles up the hill (above) at 10:45 a.m., the GP20s and their wooden stock car met No. 18, the eastbound combined *Super Chief* and *El Capitan*, beneath the Santa Fe Road overpass.

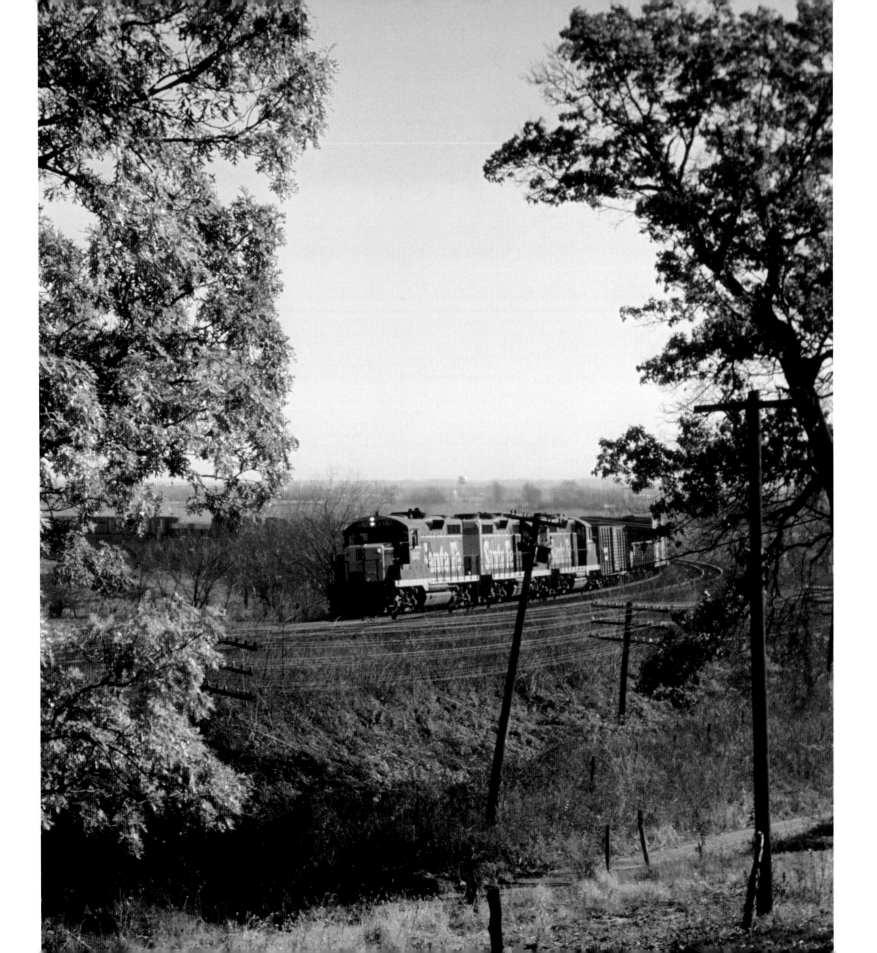

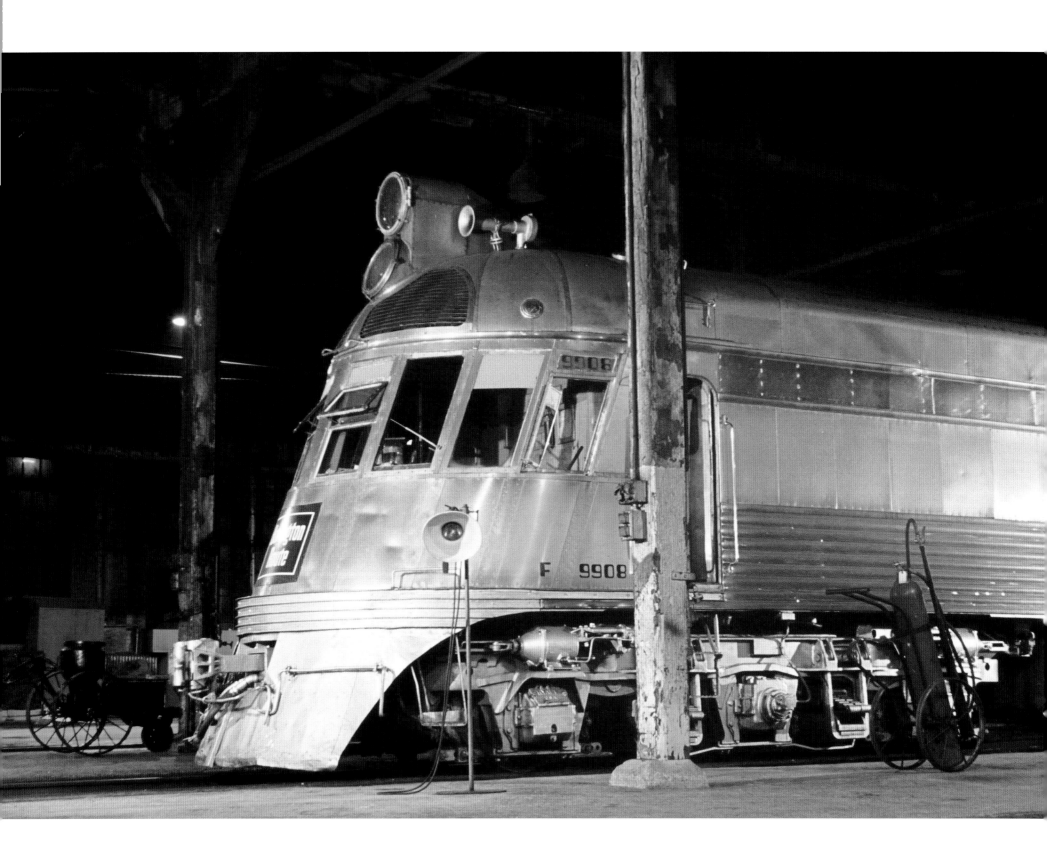

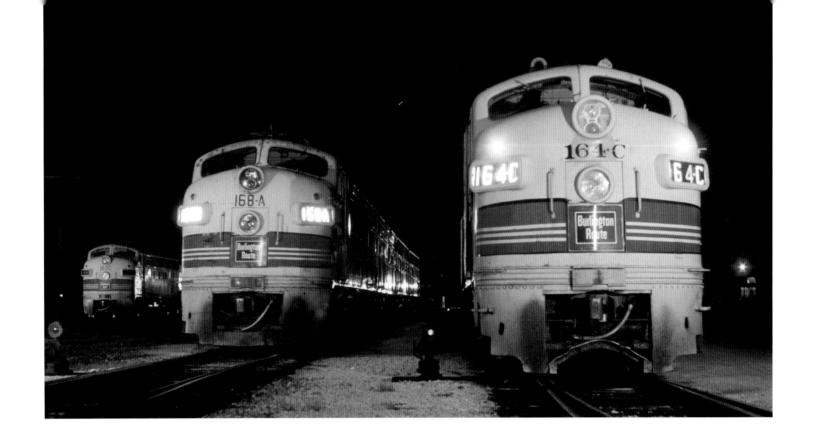

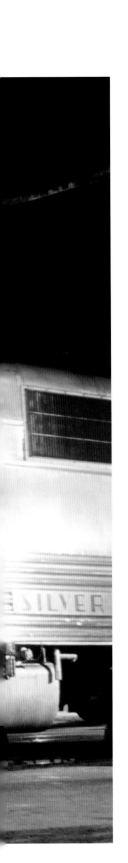

Galesburg

Galesburg, Illinois, was a popular destination for steam fantrips, but it had attractions of its own. In the spring of 1965 (left), the last shovel-nose *Zephyr* unit, 9908 *Silver Charger*, was in the Galesburg roundhouse, while outside (above) three sets of F7 Graybacks were lined up on the ready tracks. A few months later, in October 1965, a CB&Q U25B (right) and a set of Union Pacific GP30s were on the service tracks adjacent to the huge concrete coaling tower.

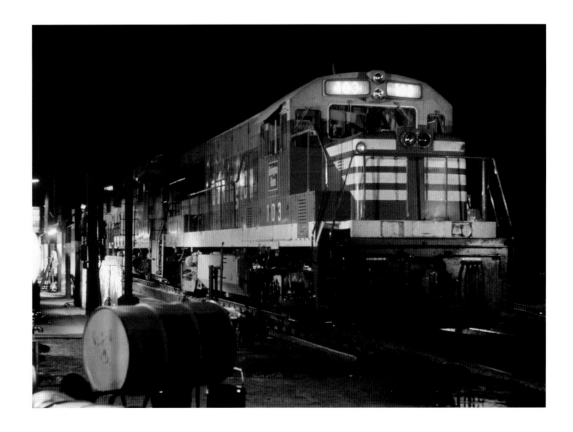

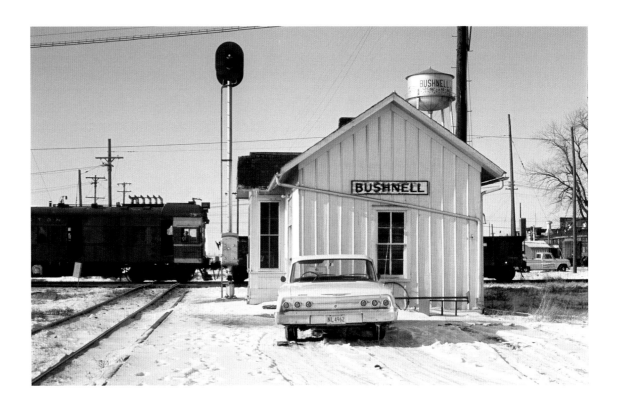

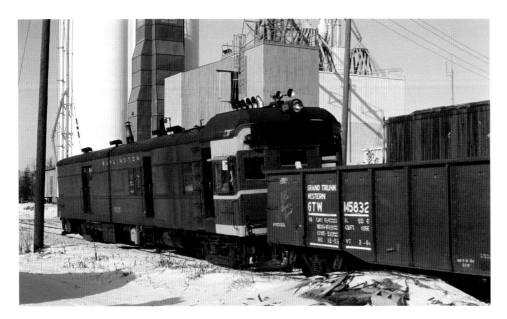

The Bushnell Bug

On New Years Eve Day 1966, CB&Q motor car 9735 was working as a switch engine at Busnell, Illinois. The Burlington had made extensive use of these gas-electric "doodlebugs" for branch-line passenger service since the 1920s. The 9735 had been built in 1929 by the Electro-Motive Company and Pullman with a 400-h.p. Winton 148 gasoline engine. It was a 65-foot Railway Post Office and baggage combine, intended to pull a coach for passengers. It was the last gas motor car in CB&Q service, and that was because the regular engineer (top left) liked it and maintained the car on his own time to keep it running. The 9735 was crossing the TP&W diamond (above) after picking up an empty gon from a siding (left). With the depot baggage wagon (opposite), it created a perfect steam-era scene.

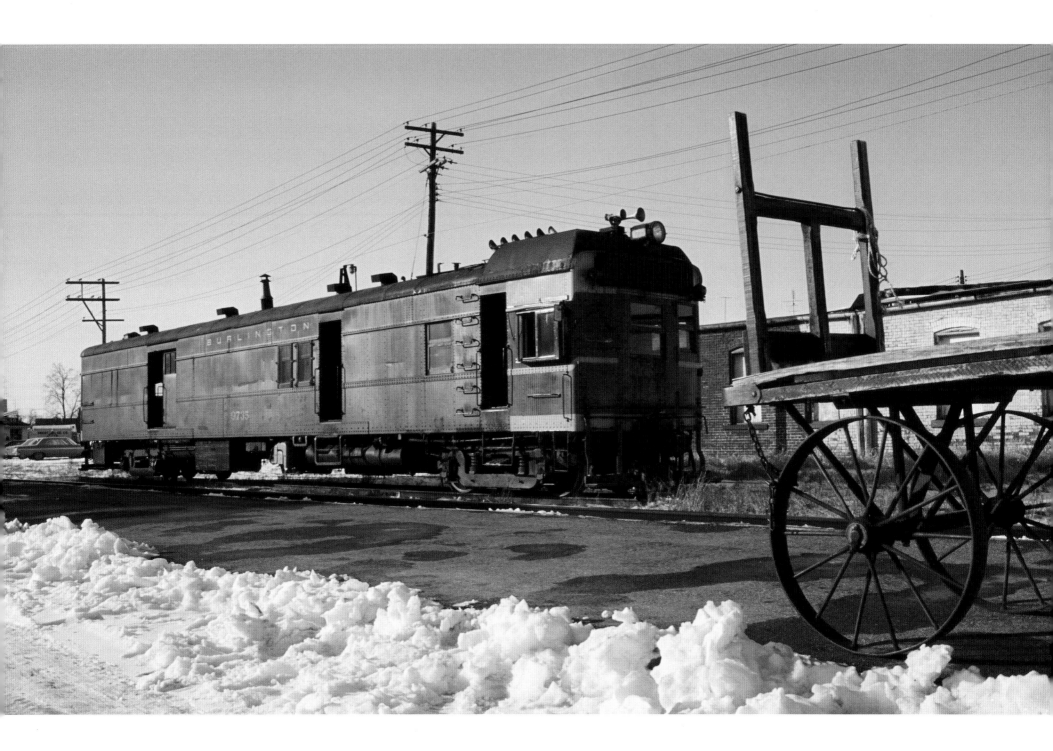

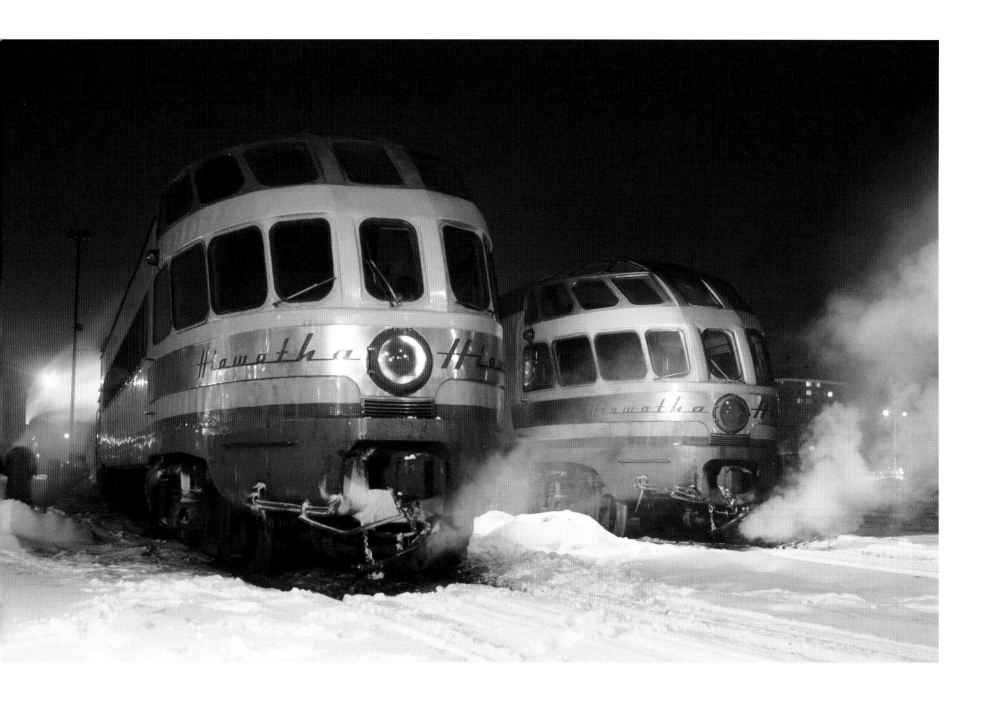

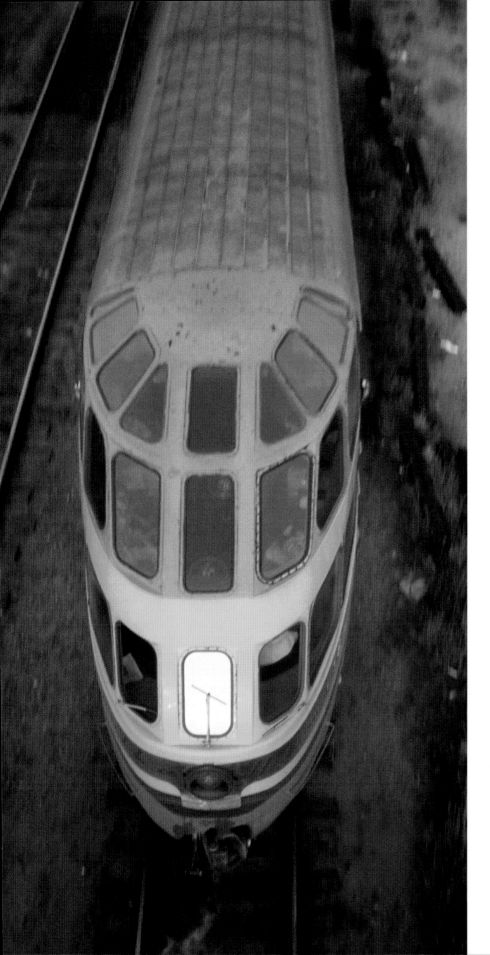

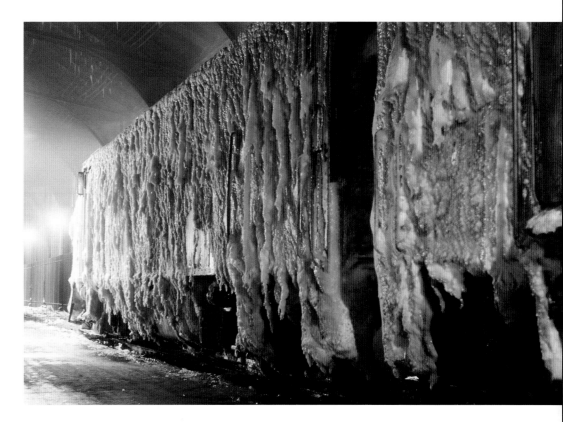

Skytops

In 1947, Milwaukee-based stylist Brooks Stevens designed spectacular Skytop observation cars for the Milwaukee Road's *Olympian Hiawatha* and *Twin Cities Hiawathas*. The six Pullman-built *Creek*-series cars for the *Olympian* were eight-bedroom sleepers with the lounge under glass, while the four Milwaukee-built *Rapids*-series day-train Twin Cities cars had a dozen solarium seats, twenty-four parlor seats and a drawing room. The six sleepers were sold to the Canadian National in 1964, but the four *Rapids* cars remained until 1970 on their *Morning* and *Afternoon Hiawatha* assignments between Chicago and Minneapolis. In 1966, one of the *Rapids* cars (left) caught a glint of skylight in its lower center window as it passed the West Milwaukee Shops, where it had been built in 1948. On a frigid February night in 1969, two of the *Rapids* cars (opposite) were on house steam at the coach yard west of the Minneapolis passenger station. That same night, unnamed No. 16 from Aberdeen, South Dakota, arrived in Minneapolis encrusted in ice (above) and fourteen hours late on the 290-mile run.

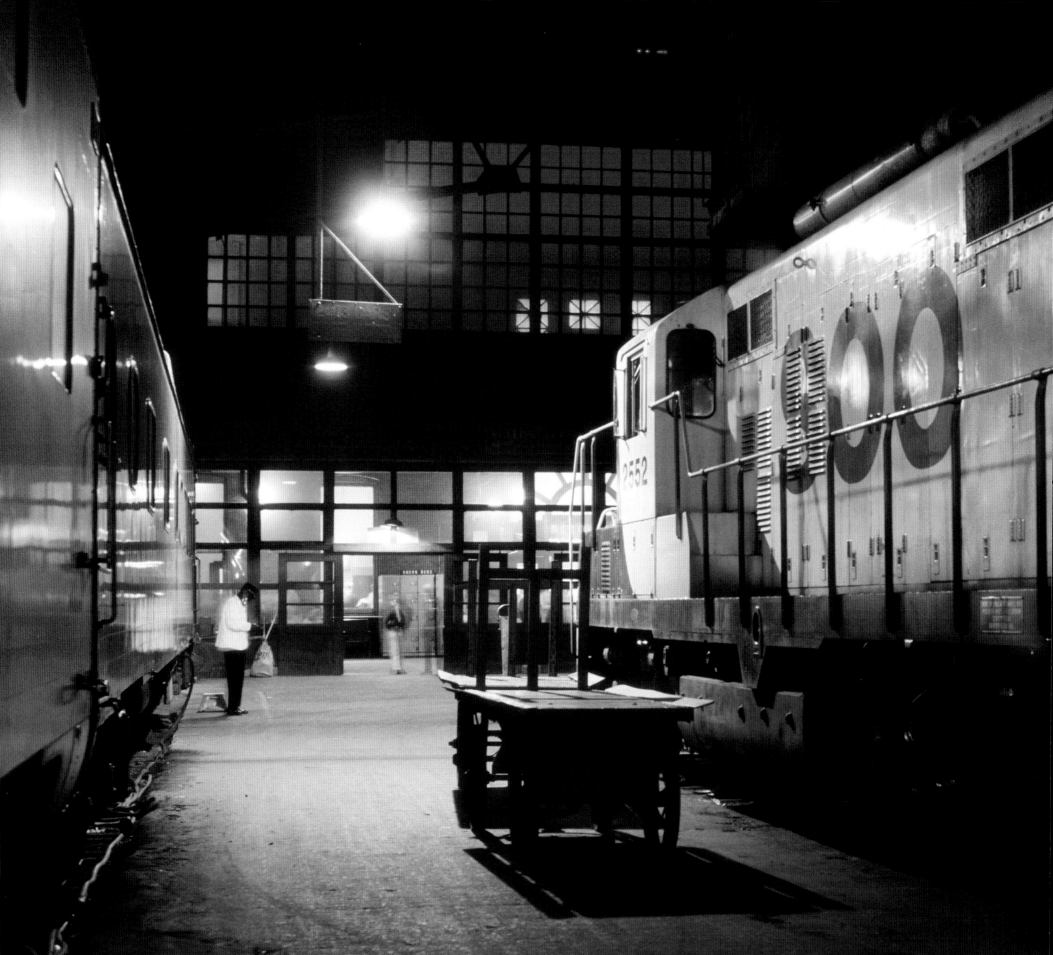

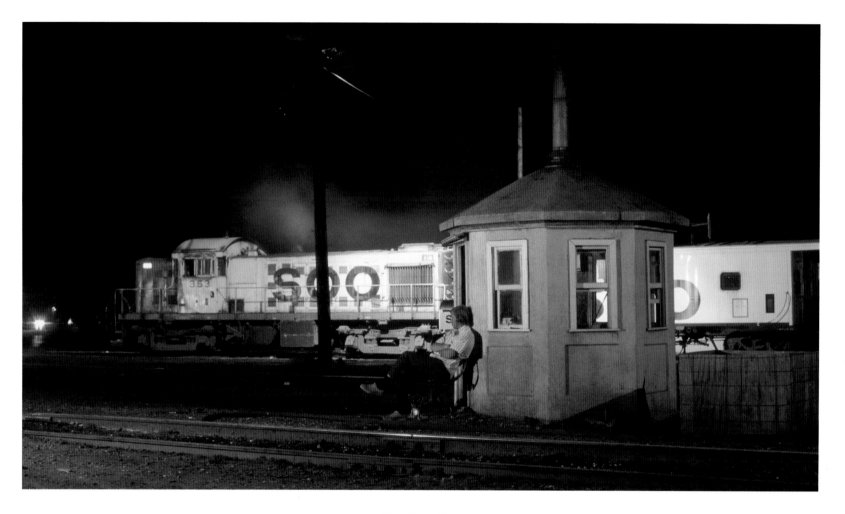

The Soo Line

The Pullman porter on the Milwaukee Road's overnight *Pioneer Limited* to Chicago (opposite) was at his post at the sleeper steps in the
Minneapolis Milwaukee Road passenger station in August 1966, while alongside idled the GP9 on the Soo Line's *Winnipegger*.
The '*Pegger* had arrived from St. Paul at 8:20 p.m. and would shove backward out of the station at 8:45 to resume its northward trek to Canada.
The *Pioneer* would pull directly out for Chicago at 9:40. In North Fond du Lac, Wisconsin, busy Lakeshore Drive crosses the throat tracks of the
Soo Line yard, and in August 1973 a watchman was employed to keep everyone safe and the traffic moving, in spite of yard engines
such as the RS1 parked "on the circuit" of what would have otherwise been automatic crossing gates.

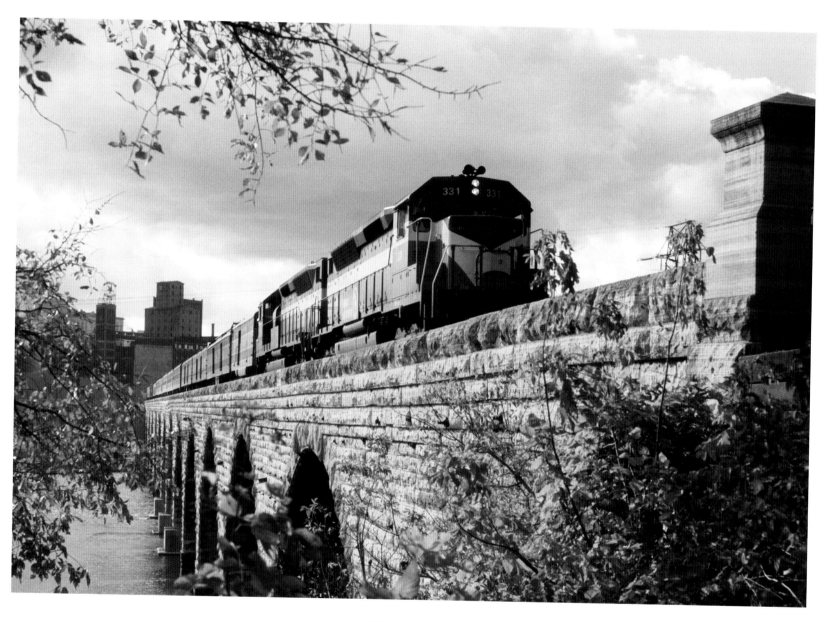

Big Sky Blue

In 1967 the Great Northern abandoned its traditional colors of Omaha orange and Pullman green, introduced on its FTs in 1941, in favor of a new "Big Sky Blue" livery. The first Big Sky Blue units were 3600-h.p. passenger SDP45s (326–333), delivered in the summer of 1967. The 331 and 326 were only a few months old (above) when they led the eastbound *Western Star* across the stone arch Mississippi River bridge just south of the Minneapolis GN Station in October 1967. Later that day, the duo was idling in the St. Paul engine terminal (opposite) in the middle of the wye east of St. Paul Union Depot in the company of an F3 and other units in the simplified orange.

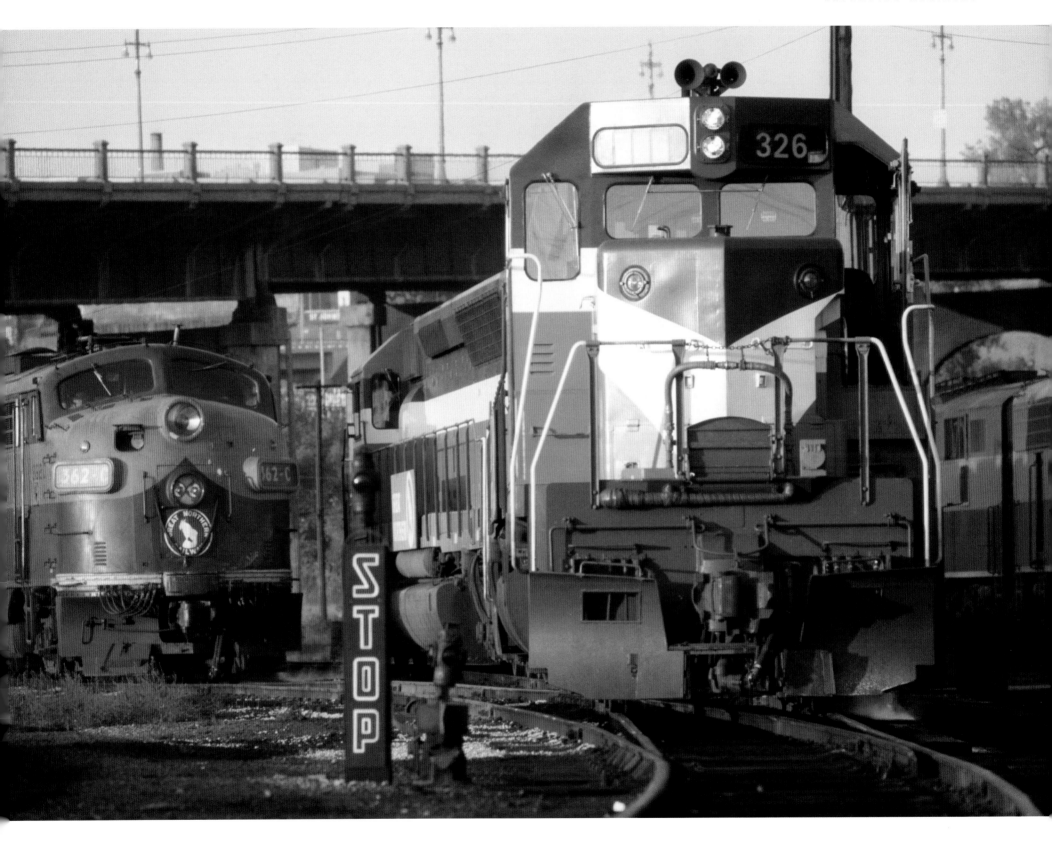

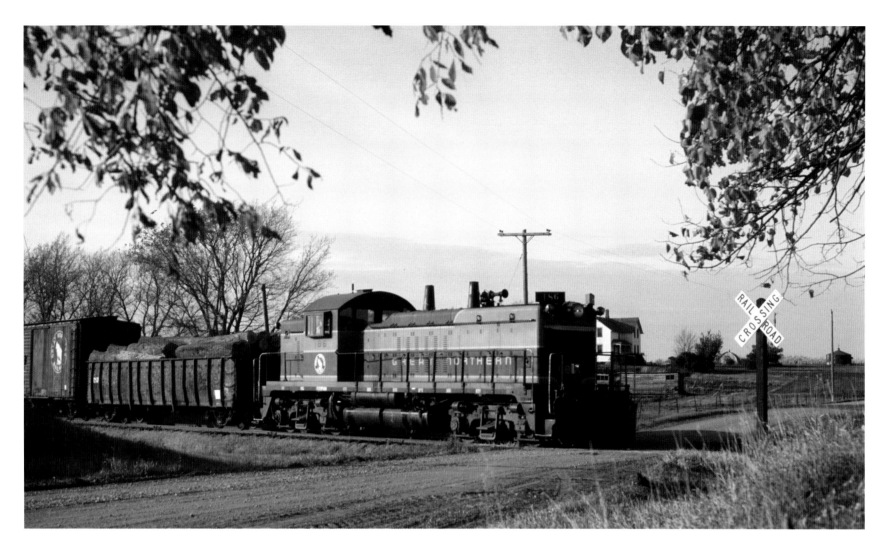

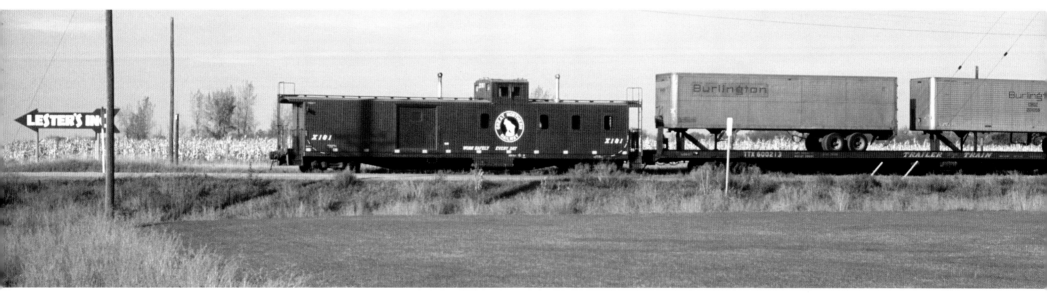

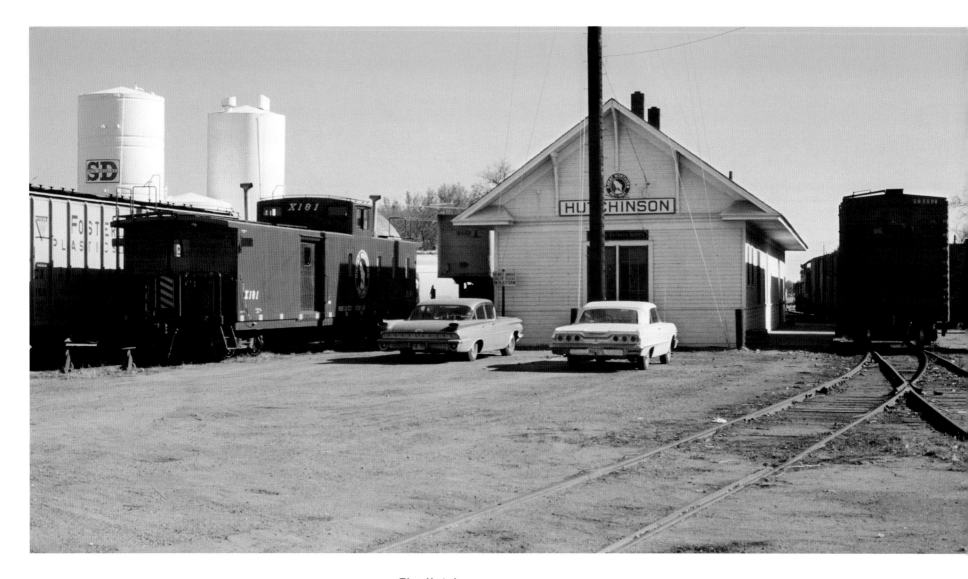

The Hutch

The Great Northern assigned a rare EMD NW5 and an amazing mixed-train caboose to the 44-mile Hutchinson Branch west of Minneapolis.
GN 186–195 were ten of only thirteen NW5s built in 1946–1947. The 50-foot caboose had been built from a boxcar in 1924 and modernized in 1953.
Here in October 1967 it was still used for mail and express. The caboose was awaiting departure from Hutchinson (above) and rolling east
at Lester Prairie (opposite bottom), while NW5 186 (opposite top) was at Quartz Road east of Mayer.

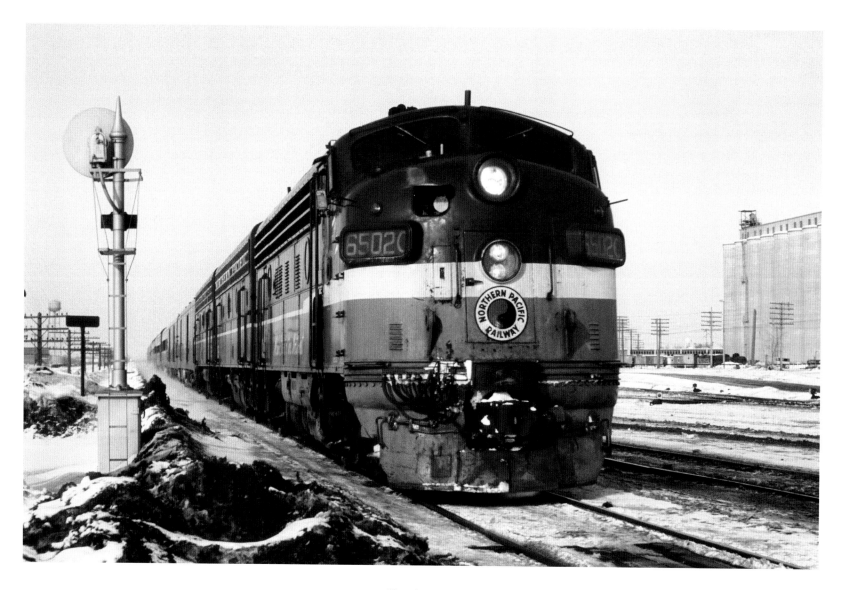

Northtown

The Northern Pacific's home in the Twin Cities was the appropriately named Northtown Yard on the main line above Minneapolis. On a chilly February afternoon in 1969 (above), eastbound No. 2, the *Mainstreeter*, was gliding past Northtown Yard behind an F7 in the Raymond Loewy *North Coast Limited* paint scheme. On a much warmer day in June 1966 (opposite), the engineer of a two-month-old U28C was awaiting an air test at Northtown.

North Country Delights

The Minneapolis, Northfield & Southern was a belt line around the west side of Minneapolis, with its main line reaching 45 miles south to Northfield. In the 1960s it was best known for its six monster double-engined Baldwin centercab transfer units. The 21, a 2000-h.p. DT6-6-2000, was at Glenwood Junction (above) in August 1966. I was a helper on a Boyd Casket Company delivery truck when we laid over for the night of June 29, 1964, at Winona, Minnesota, within walking distance of the Green Bay & Western yard. There I was amazed to find Chicago Great Western 1000 (opposite bottom), a 1910 McKeen gas-mechanical car that had been rebuilt as a gas-electric for the *Blue Bird* in 1928 and cut down to a switcher in 1958, retaining its Winton gas engine. By morning, the 1000 had ventured elsewhere, but the Green Bay & Western (opposite top) was moving Alco DL640 310 and FA1 502 out of the shop.

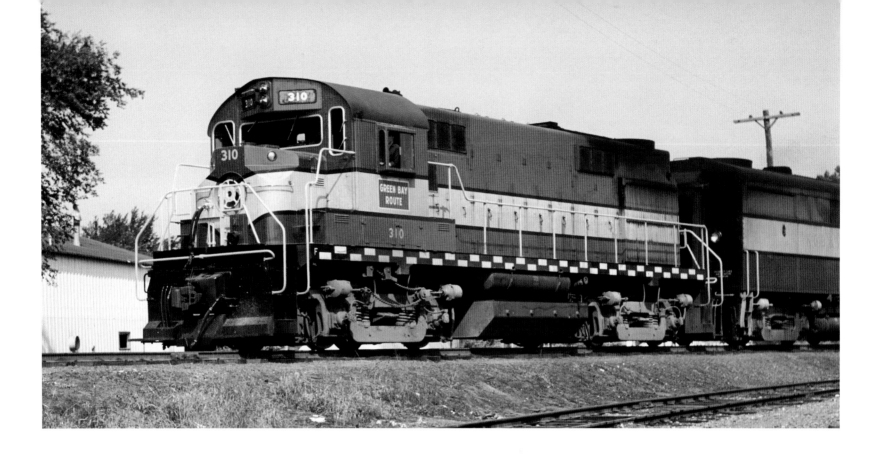

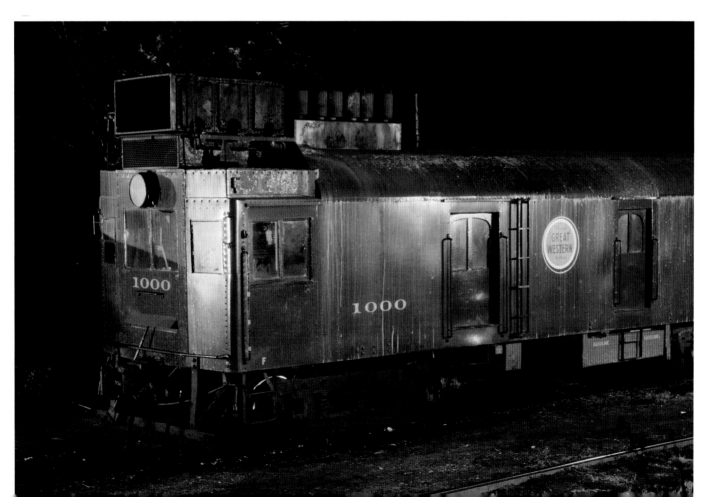

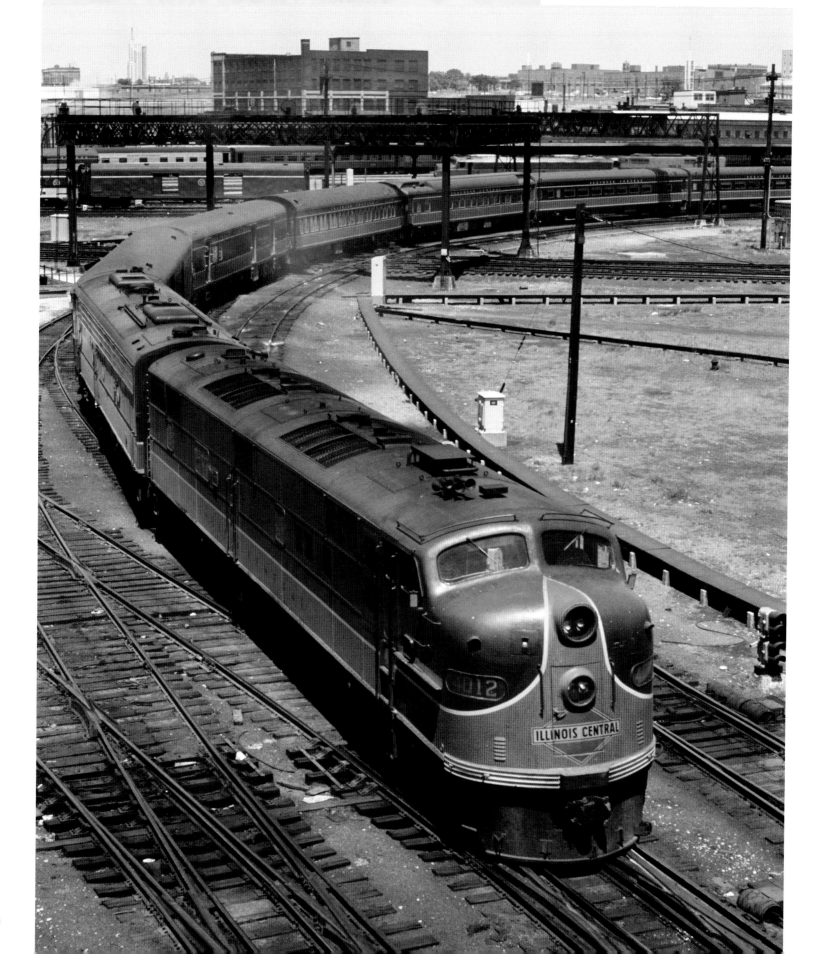

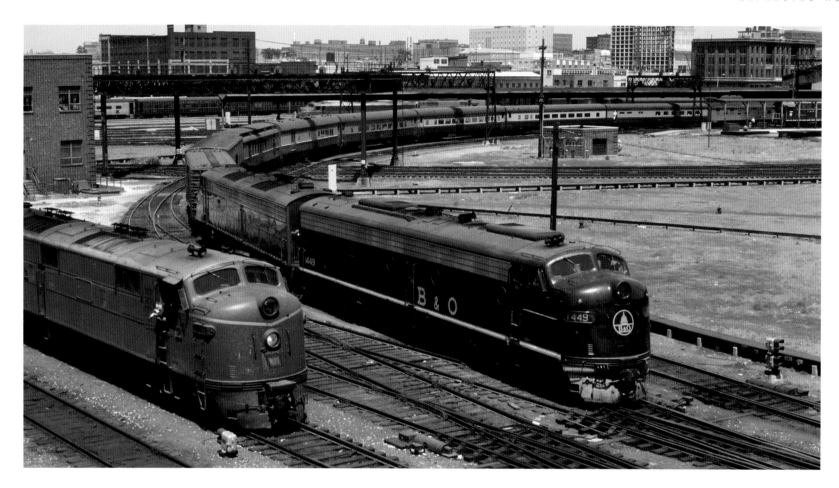

St. Louis Blues and Reds and...

The grandest show in passenger railroading was St. Louis. Chicago surely had more trains, but they were spread out among six stations, while St. Louis concentrated all the action on an incredible maze of wyes and crossings between the 14th and 21st Street bridges at the throat of Union Station. All arriving trains would pass under both bridges and then back around the proper wye to enter the stub-end trainshed. Outbound trains would head directly out either east or west. In June 1965, the overnight *Meteor* from Oklahoma City (right), was arriving at 7:30 a.m. behind Frisco E8s. Illinois Central E7 4012 (opposite) was leading No. 101, the St. Louis to Carbondale connection to the *City of New Orleans* No. 1 and *City of Miami* No. 53, out the east wye and under the South 14th Street bridge at 10:20 a.m. Baltimore & Ohio No. 2, the *National* to Washington and Baltimore, was departing (above) at 11 a.m. as a Wabash E7 was waiting for it to clear on an hour-late No. 214, arriving from Council Bluffs.

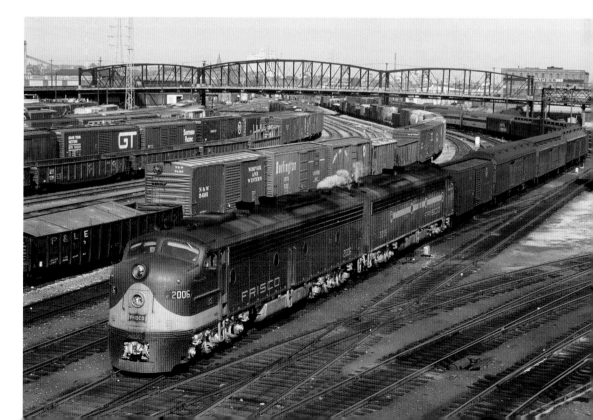

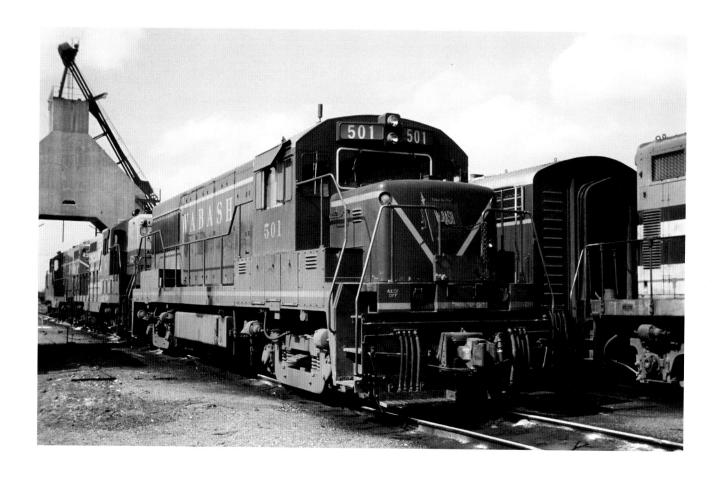

The Wabash Banner

The Styling Section of the Electro-Motive Division of General Motors came up with one of its all-time finest paint schemes when it applied the blue and white streamlined Wabash 4-6-4s to E7 No. 1000 in 1946. The livery fit perfectly on the subsequent F-units, Geeps and Alcos. Passenger GP7 458 (left) was riding the turntable at Landers Yard in Chicago on August 26, 1963. In 1961 the Wabash began painting units in a simplified solid blue, and the first new diesels delivered in that scheme were fifteen General Electric U25Bs in mid-1962. U-boat 501 (above) was in the East St. Louis engine terminal in July 1965. The Wabash was merged into the Norfolk & Western on October 17, 1964, but the classic image remained (opposite) on F7 658 in the Canadian National engine terminal at Windsor, Ontario, in September 1967. Linked to home rails by Detroit River carferries, Wabash operated trains across southern Ontario to Fort Erie and Buffalo using CN trackage and a dedicated fleet of units built by General Motors Diesel in London, Ontario.

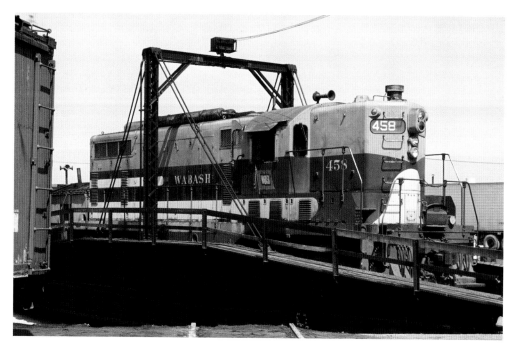

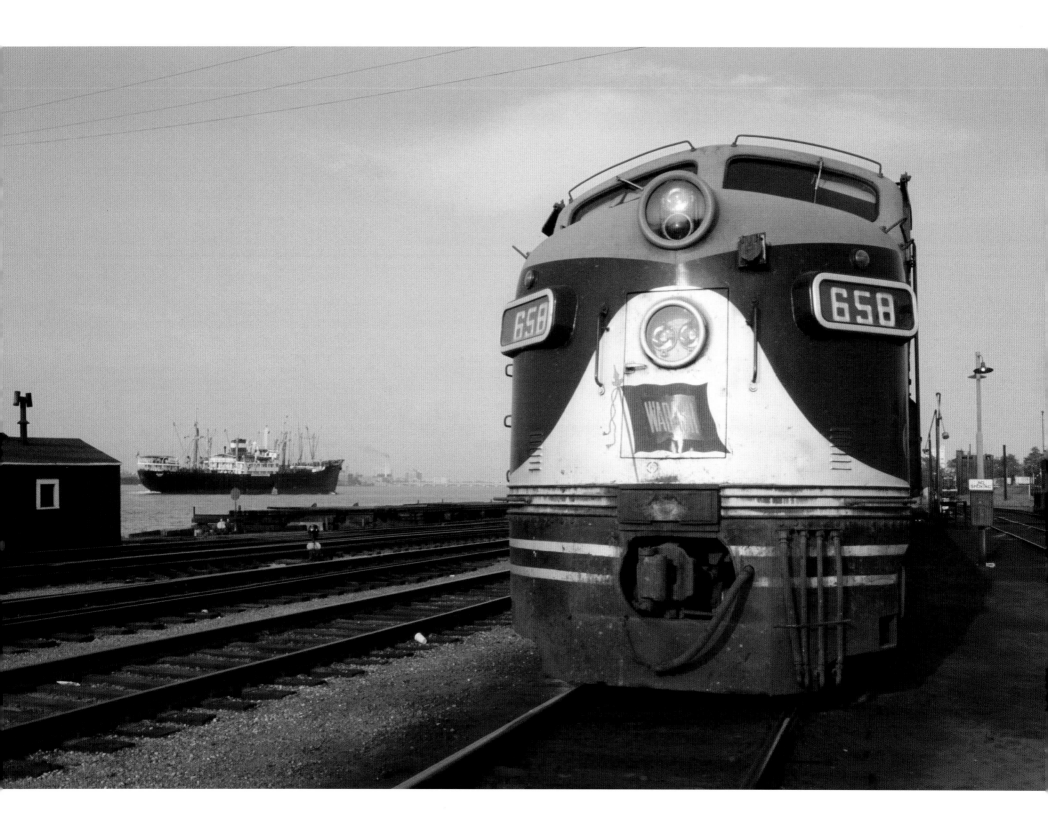

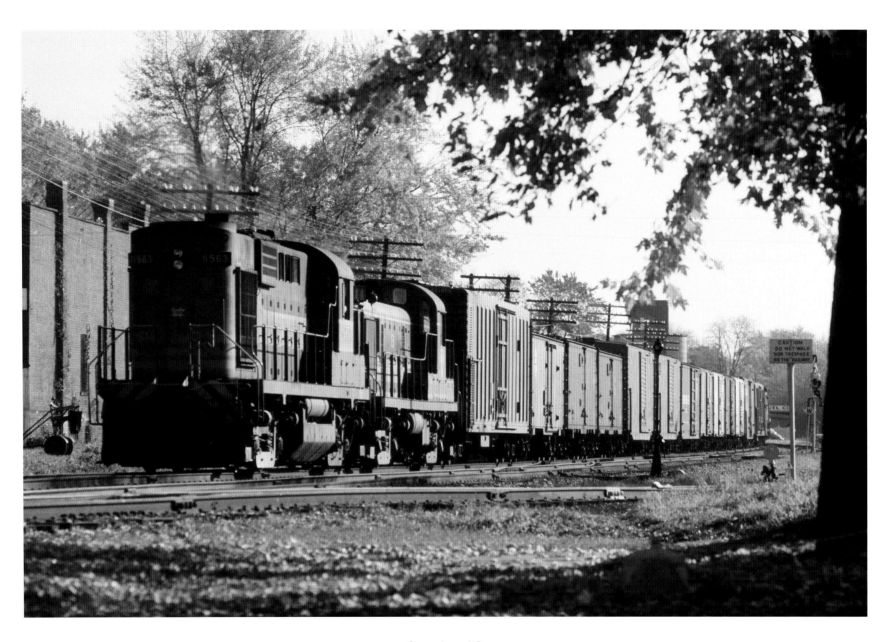

Canada, eh?

In the 1960s, Canada was served by two true transcontinental railways, the privately owned Canadian Pacific and the government-owned Canadian National. The two northern giants had distinctly different personalities in image and operation. In October 1965, Montreal-built CPR RS10 8563 and a Boston & Maine RS3 were westbound through London, Ontario. In spite of appearances, both were powered by the same 1600-h.p. Alco 244 engines.

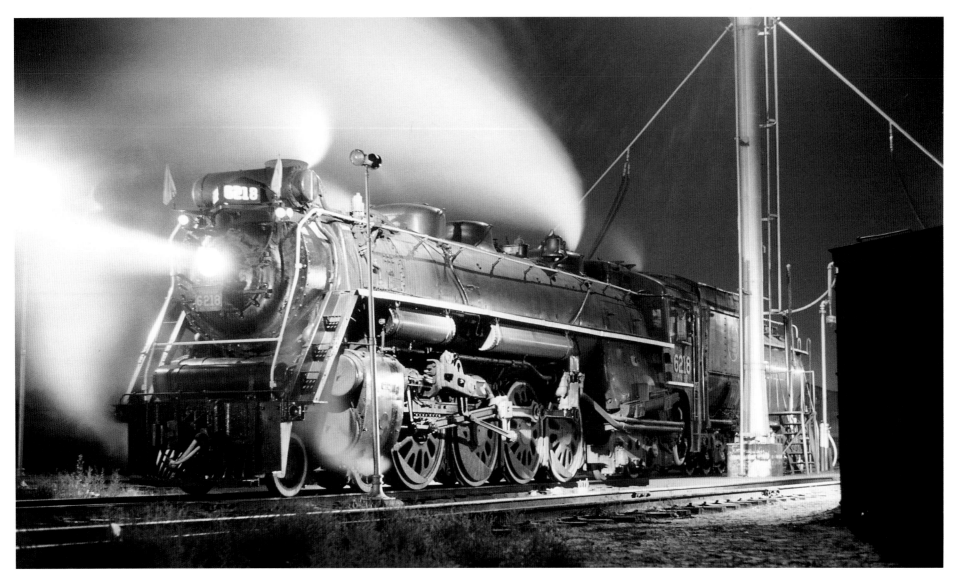

My first trip to Canada was prompted by a fantrip in September 1965 with 4-8-4 6218 from London to Goderich, Ontario. The night before the trip, the 6218 created a timeless image (above) at the London roundhouse. The CNR abandoned its green, black and gold livery in 1961 in favor of President Donald Gordon's new red, white and black. Before 6218's departure the next morning, a Kingston-built Fairbanks-Morse CPA16-5 and Montreal-built FPA4 were rolling into London (right) on No. 106 from Windsor to Toronto.

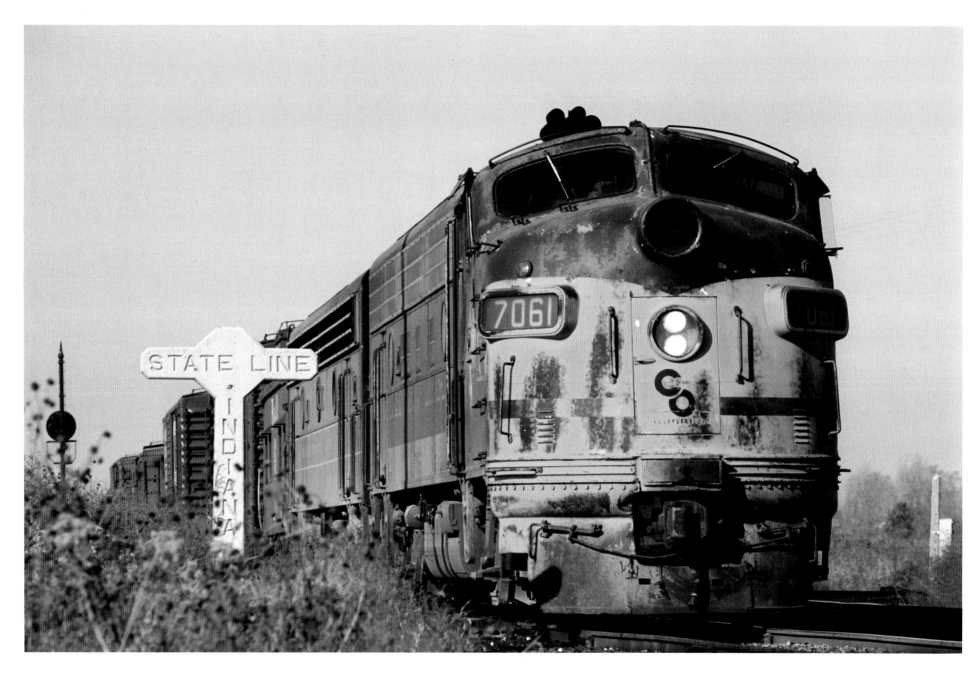

The Big East

I always felt that the "East" began at the Illinois-Indiana state line, where a well-weathered Chesapeake & Ohio F7 was eastbound at the marker at State Line Tower in Hammond, Indiana, in November 1965. The industrial East can't be summed up much better than a Philadelphia-built Bessemer & Lake Erie Baldwin DRS6-6-1500 (right) working beneath the Hulett unloaders on the Lake Erie iron ore docks at Conneaut, Ohio, on October 16, 1968.

THE BIG EAST

Chapter Four

WHERE DOES THE "EAST" BEGIN? I ALWAYS FELT THAT the East began at the Illinois-Indiana state line. Even though half the time Hoosiers didn't know how to set their clocks, Indiana was crisscrossed by all the big names in Eastern railroading— the Pennsy, New York Central, B&O, C&O, Erie and Nickel Plate. And no way could I accept Ohio as a "Midwestern" state. Iowa was Midwestern. Ohio and Indiana were part of the East because of their railroads.

Of course, Chicago gave me a preview of Eastern railroading, but I couldn't really appreciate the majesty of the Pennsy and the Central by standing at Englewood any more than I could comprehend the scope of the Santa Fe from Joliet. When I got my first big vacation, I decided to go east. With all that was out there to explore, the East seemed to offer the most bang for the buck. Any trip west would cost a thousand miles of driving before I even got to the mountains and

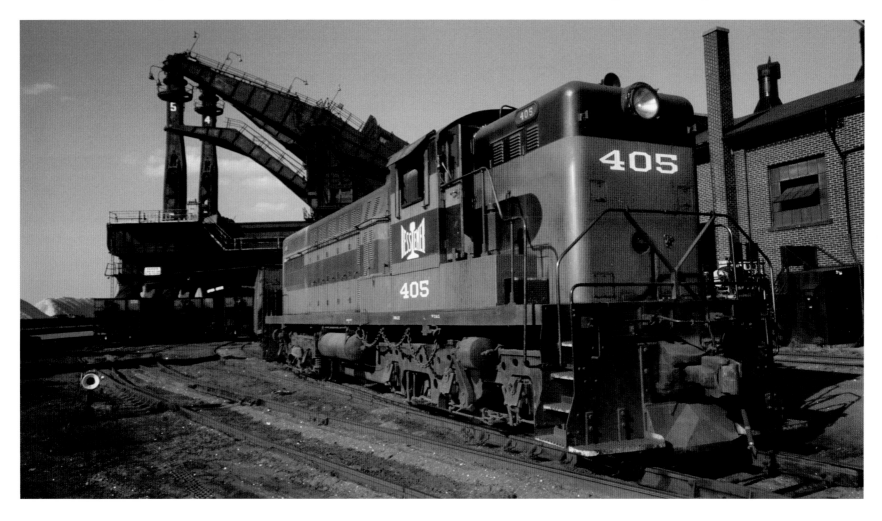

found anything new. Thus, in August 1966, Mike McBride, Dale Jacobson and I set off toward the rising sun in my green Volkswagen Bug. We hit Pittsburgh, Horseshoe Curve and Allentown on the way, and I spent my very first night in New Jersey in the old Wardell Hotel on Union Square in Phillipsburg, where we were rattled out of bed by Pennsy RS11s passing right outside the window. The place burned to the ground six months later.

The next morning we waited on the Jersey Central to catch the High Bridge Job to come east behind Babyface Baldwins (page 102). Then we headed for the Pennsy corridor line at Metuchen for our first look at GG1 electrics. After a few days in the metropolitan area, we headed north and west to catch the New Haven and Lehigh & Hudson River at Maybrook, New York, and the D&H and Lehigh Valley around Wilkes-Barre, Pennsylvania. Two years later, I made a similar trip with Mike Schafer and Bill Wagner, to pick up stuff we'd missed in 1966, including the New Haven Shore Line and the Maine Central and St. Johnsbury & Lamoille County in Vermont and New Hampshire. I was impressed by the hilly and heavily wooded scenery but was a bit disappointed at the "intensity" of the industrial railroads. Turns out it was there, but we just didn't know where to find it, and the weather in Pittsburgh was wall-to-wall miserable.

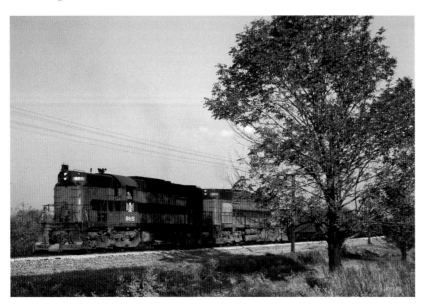

In the late 1960s there was a lot of action and color in the Northeast, and my new job with EMD let me explore considerably more of it. After my first work on the GN in Minneapolis, I was bitterly disappointed to discover that my next assignment would be to escort fifty GP38s for the B&O, a road for which I had little affection. Boy, did that change when I got my first look at Cumberland, Maryland, and took my first ride over the legendary "West End" St. Louis line to Grafton and Sand Patch grade on the Pike to Pittsburgh and Chicago. This was heavy-duty railroading at its best!

Another railroad that was distinctly Northeastern was the Bessemer & Lake Erie, with its Milwaukee Road-style Halloween livery. The Bessemer had Baldwins working Hulett boat unloaders on the Lake Erie ore docks, six-motor Alcos to haul the ore trains uphill to the yard at Albion, and a handsome variety of EMD F-units and SDs for the road jobs down to the North Bessemer yard near Pittsburgh.

Over the next few years I was able to travel extensively in the East and found that the area fit my style of photography. I had developed a preference for wide angle, rather than telephoto, and liked to use details to frame the train. The typical "Jim Boyd shot" had a funky building or two and lots of supporting details. I loved the cluttered urban scenes and the rural vistas of the Northeast, from the four-track, position-light-signaled glory of the Pennsy crossing the Alleghenies to the fine details of a New England short line in the autumn, and even the more mundane surroundings of the Ohio and Indiana farmlands, where the photography was more like back home.

In 1966, when I could have gone in any direction, I had chosen the Northeast for my first venture away from the Midwest. More than the Rockies or Western deserts, I wanted to experience the intensity of Eastern railroading. I never dreamed that I would ultimately live there.

The Bessemer & Lake Erie

Iron ore off the lake boats at Conneaut, Ohio, was crossing the Ohio-Pennsylvania state line while being shoved up the 14-mile hill to the yard at Albion by a pair of 2400-h.p. Alco DL600B helpers on October 16, 1968. The U.S. Steel-owned B&LE terminated 125 miles south at North Bessemer, Pennsylvania, where the Union Railroad took over for the haul into Pittsburgh. F7 722 and SD18 584 (opposite) were at the North Bessemer engine shop in June 1968.

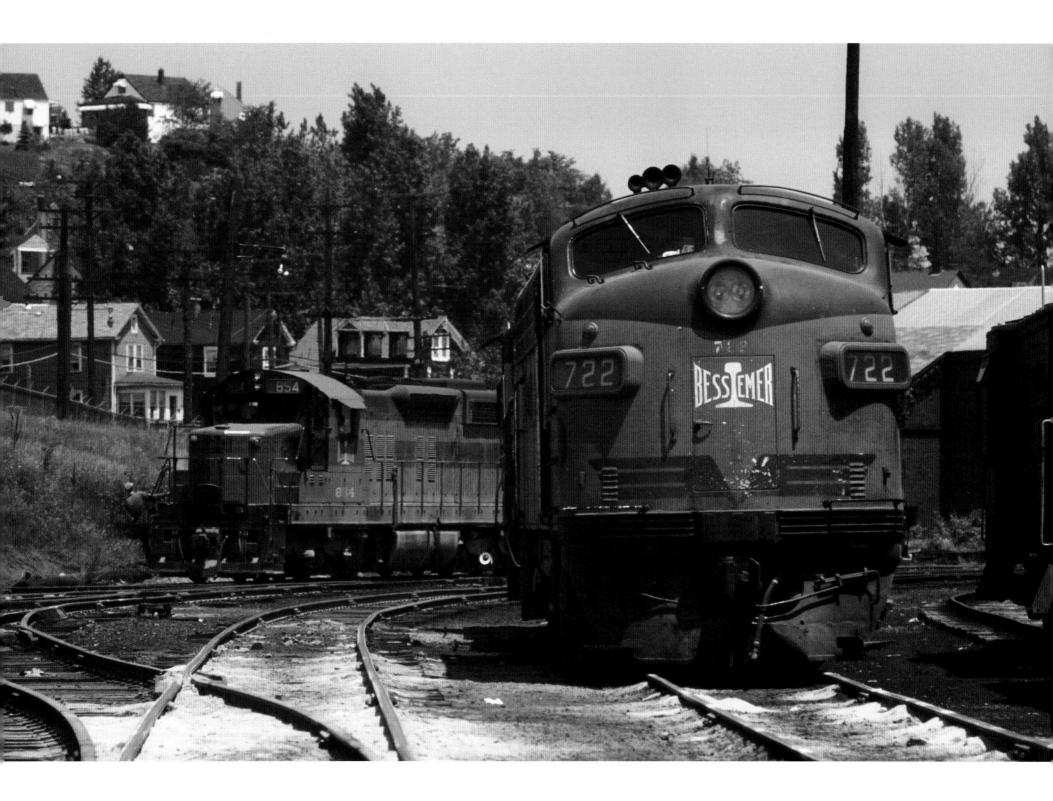

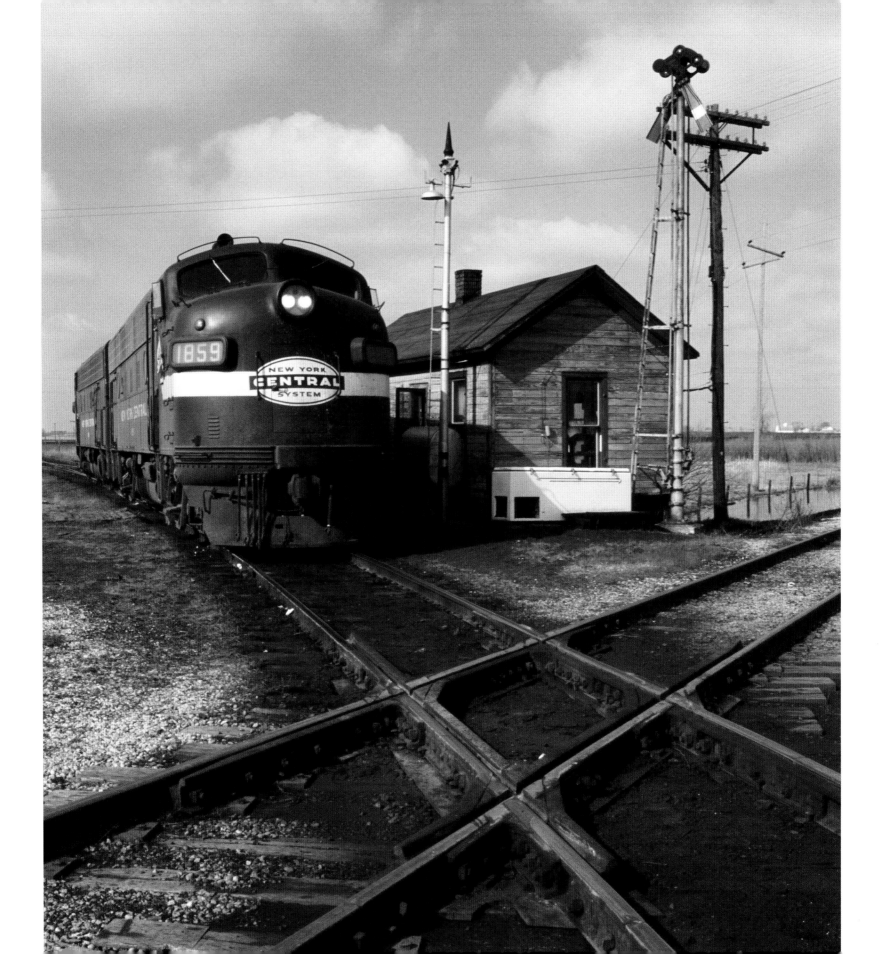

Cigar Bands and Belts

It was a bit of a surprise when I realized that I grew up was less than 30 miles from the northwest end of the New York Central at Zearing, Illinois. The Kankakee Belt Route was a 200-mile line circling Chicago from the CB&Q at Zearing through Kankakee to South Bend, Indiana. In March 1966, a pair of F7s out of Zearing (opposite) was making a pickup off the Milwaukee Road, C&NW and LaSalle & Bureau County at Ladd, Illinois. After taking this photo, I got a cab ride in the 1859, 20 miles south to McNabb. Closer to Chicago, an A-B-B-A set of Alco FA/FB2s (below) was eastbound on the Indiana Harbor Belt approaching the Hohman Avenue crossing in Hammond, Indiana, in 1965. The simple "cigar band" nose stripe showed up well on the pair of Baldwin RF16 Sharks (right) that had just brought a transfer from Riverside into Sharonville yard north of Cincinnati, Ohio, in June 1967. The hump units are Baldwin RS12s.

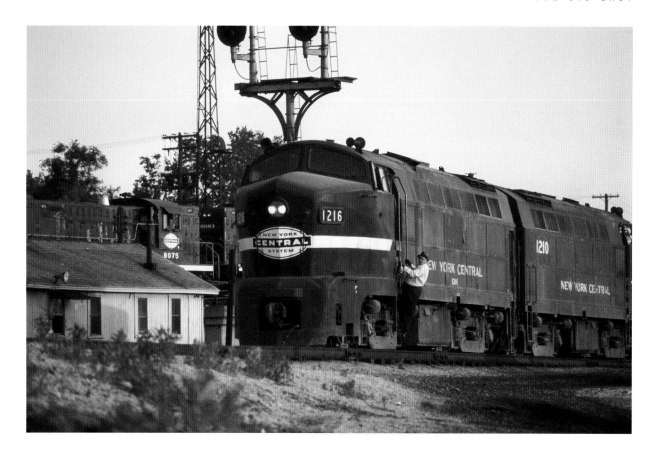

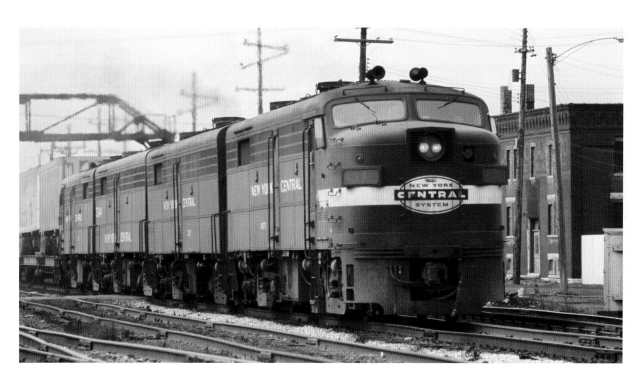

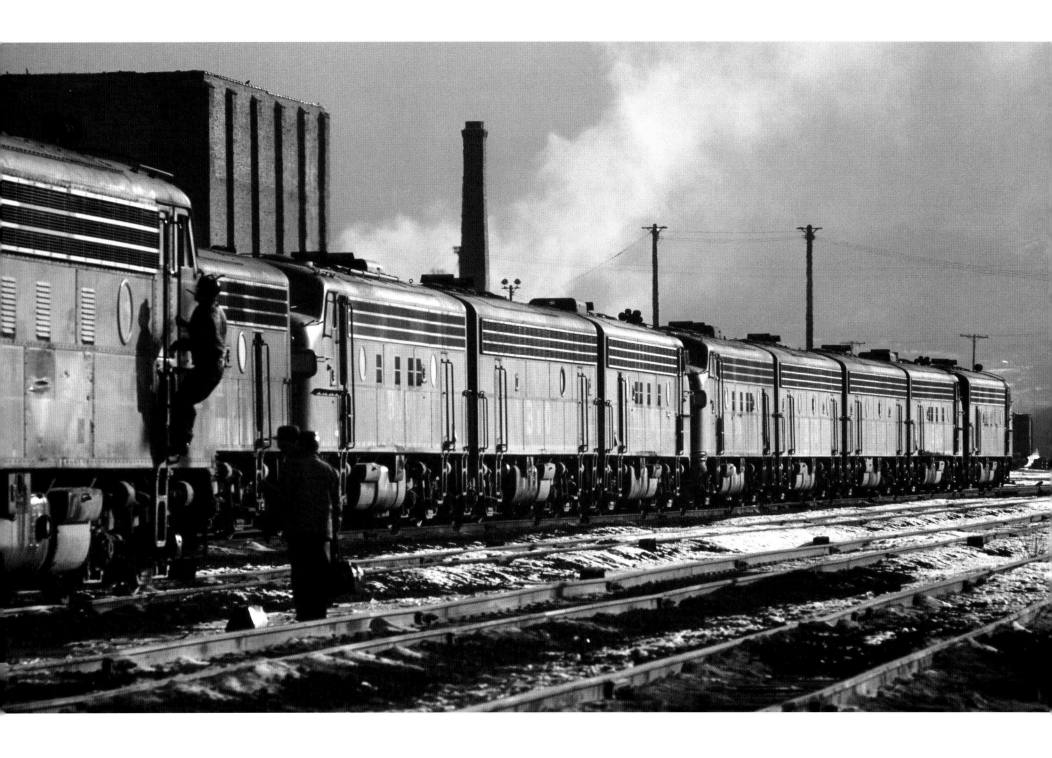

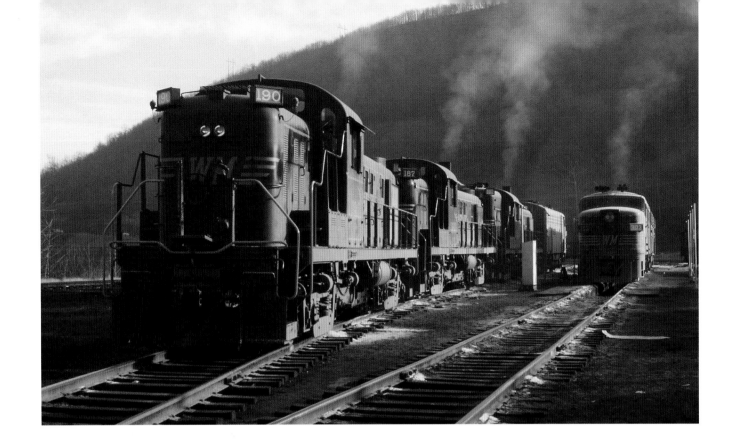

Cumberland in Western Maryland

My second delivery as an EMD Field Instructor was fifty Baltimore & Ohio GP38s (3800–3849). In November 1967, I reported to the big B&O shop at Cumberland, Maryland. On a frosty December morning (opposite), ten F7s, soon to be replaced by my GP38s, were on the ready tracks east of the shop, ready to continue their battles with the Alleghenies. The B&O marked the top of 17-Mile Grade at Altamont, Maryland, on the West End line to St. Louis, with an imposing concrete marker (right). The similar marker on the same ridge on the Chicago line at Sand Patch had "Alleghenies" spelled correctly! Across the Potomac River from Cumberland was the Western Maryland engine terminal at Ridgeley, West Virginia, where Alco RS3s and FA2s (above) were idling in December 1967.

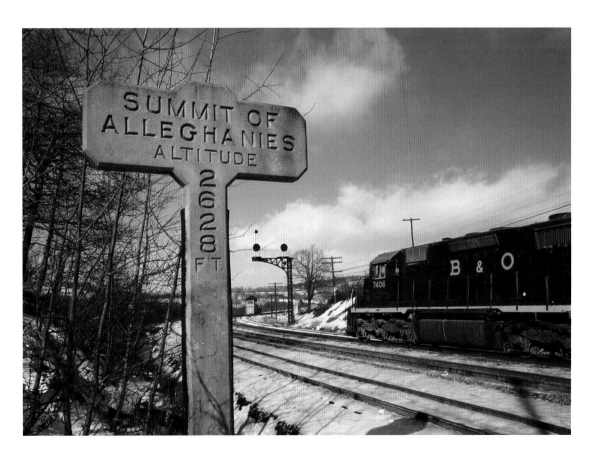

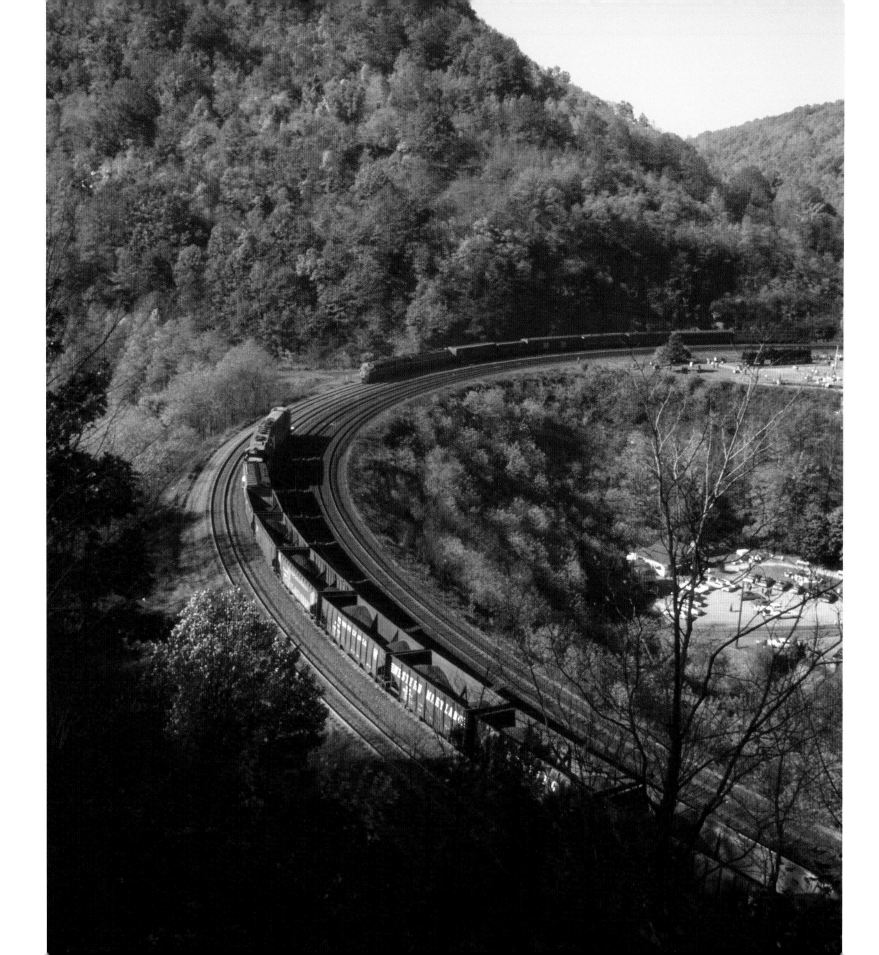

Horseshoe and Gallitzin

Probably the most famous location in American railroading is Horseshoe Curve just west of Altoona, Pennsylvania, where the Pennsylvania Railroad came striding up the Allegheny backbone ridge four tracks wide. Amid the autumn colors of October 1968 (opposite), No. 33, the westbound *Juniata*, was overtaking the pushers of a loaded ore train on the 1.8-percent grade at Kittanning Point. Note the crowd in the trackside park where K4s 1361 is on display. In September 1966 (below) an Alco DL600B was emerging from one of the twin westbound summit tunnels at Gallitzin. That night at AR Tower, where the turn-back wyes at Gallitzin are controlled, the operator (right) got a lineup that included a "ninety-eight-car passenger extra!" A short while later, four E-units rolled east with ninety-seven mail and express cars and a lone rider coach. Who else but the Pennsy?

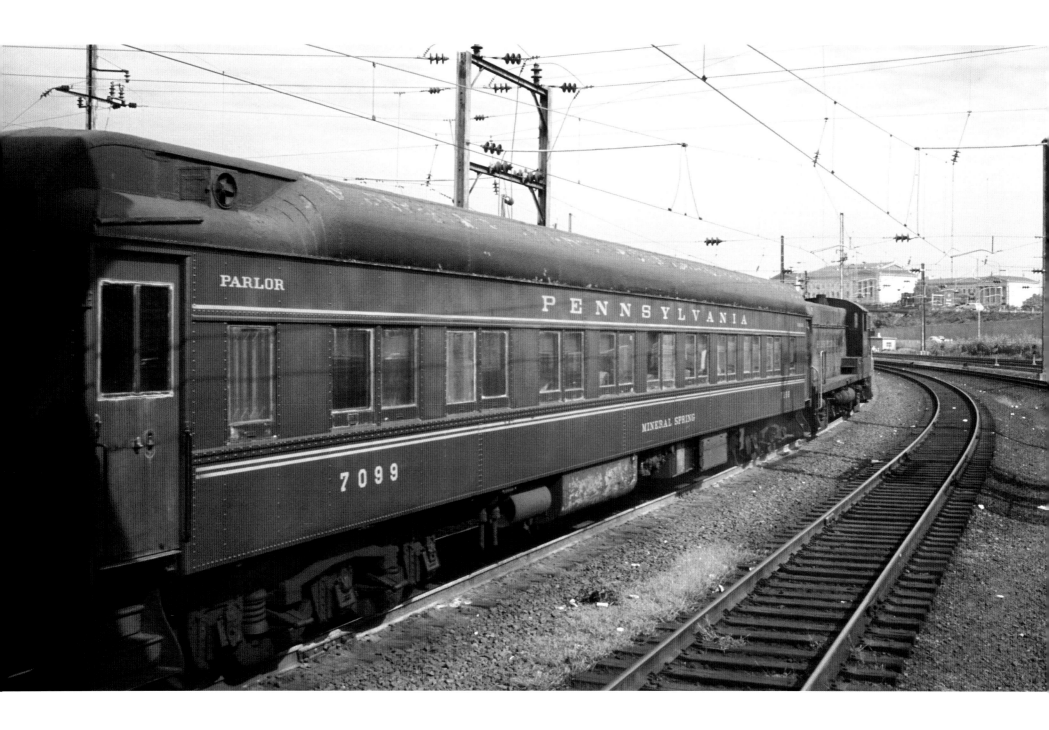

Loewy and Behold

In Philadelphia's 30th Street Station in September 1966, I was watching GG1s parade through when the rare Baldwin DRS4-4-1000 passenger switcher 5593 caught my attention as it pulled out the east end. It was, however, the magnificent Tuscan red-and-gold heavyweight parlor *Mineral Springs* that made the most lasting impression.

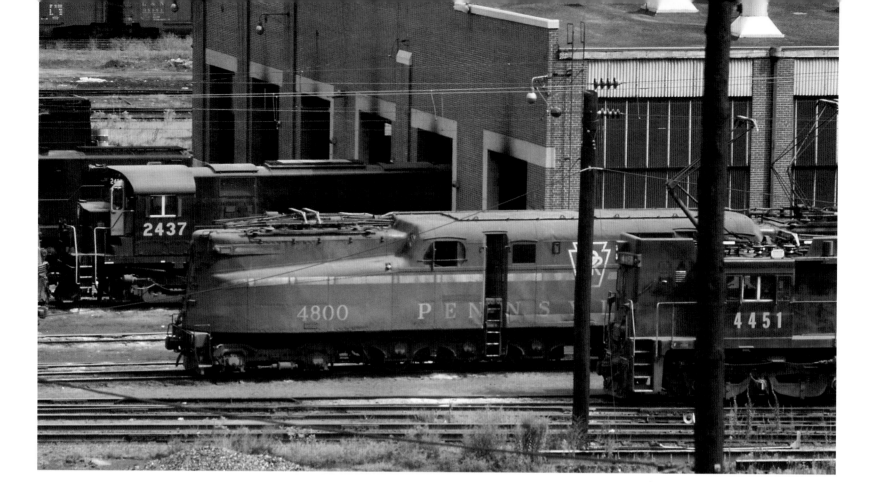

In 1934 the Pennsylvania Railroad developed the 2-C+C-2 GG1 locomotive for the 11,000-volt A.C. heavy electrification from New York to Harrisburg and Washington, D.C. Prototype 4800 (originally numbered 4899), built by Baldwin and General Electric, was a superb performer in both heavy freight and 90-mph passenger service, but it was rather crude in appearance. Stylist Raymond Loewy turned the riveted hulk into a timeless classic by smoothing its rough lines with an all-welded skin for the 138 units that followed from GE and the Altoona Shop. "Old Rivets" 4800 was still in freight service (above) at Enola Yard in Harrisburg in September 1966. The same day, the 4809 and 4872 (right) were pulling into the south end of Enola Yard.

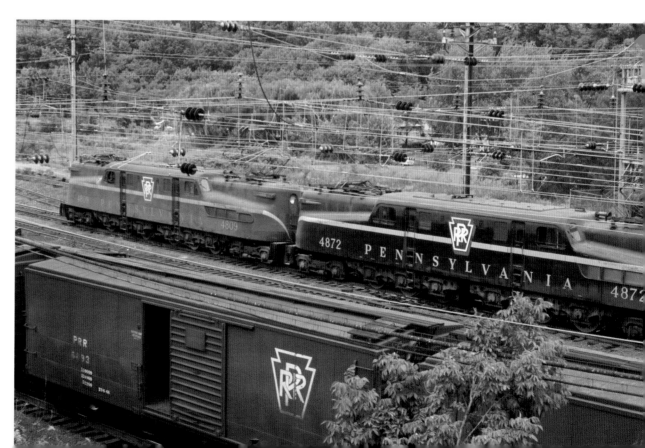

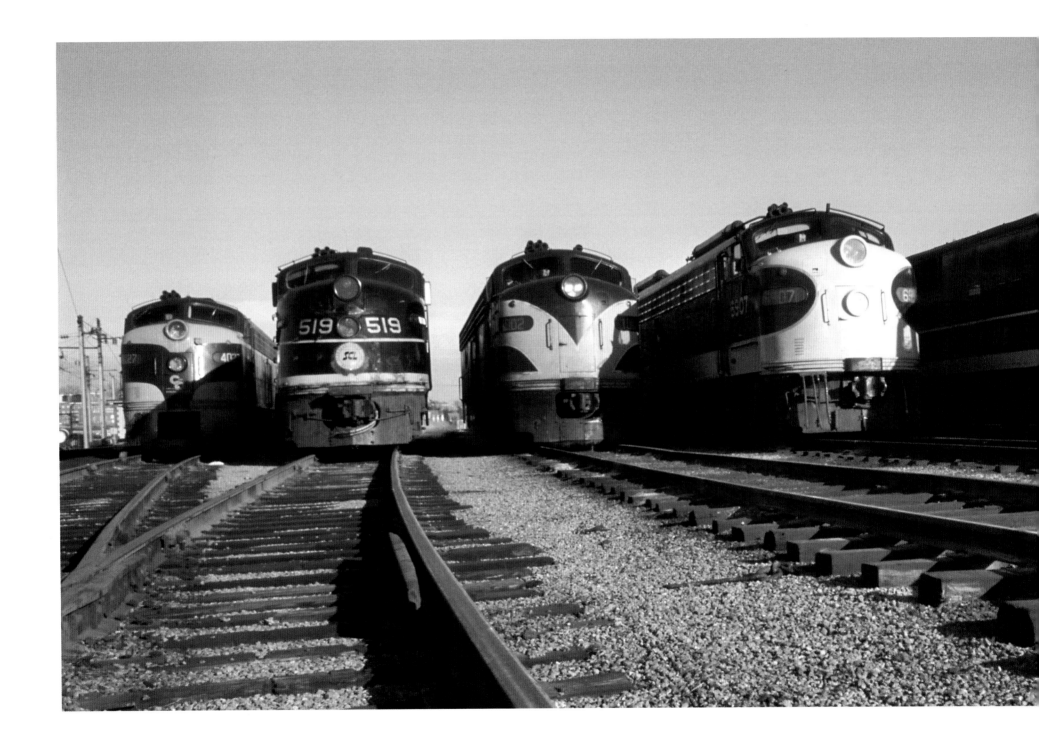

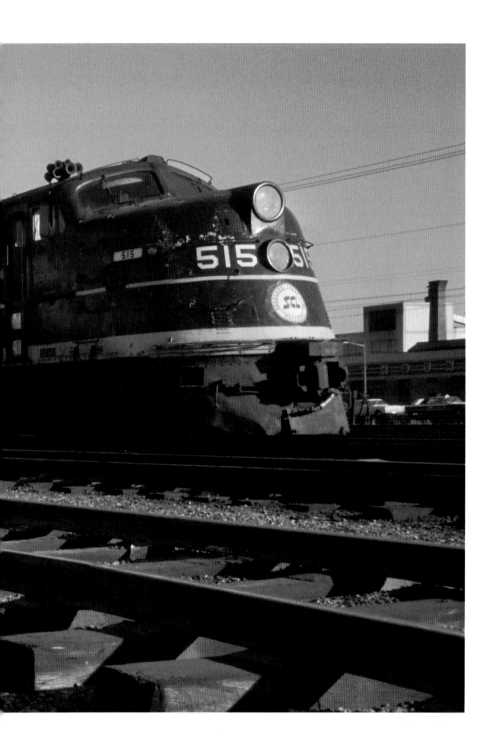

Ivy City, District of Columbia

The passenger engine terminal for Washington Union Station is about a mile north in Ivy City, District of Columbia. In January 1968 (left) I could hardly believe the lineup of E-units at Ivy City, recreating the classic EMD publicity photo featured in color in the *1940 Locomotive Cyclopedia*. One night in November 1967, a Southern E7 and B&O E8 (above) were at the same spot in front of the Frank Lloyd Wright Johnson Wax Building, while Pennsy GG1 4898 and a mate (below) hummed nearby.

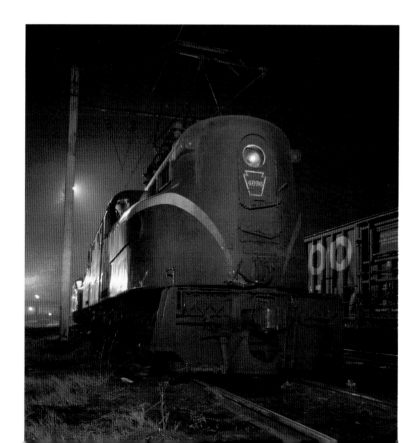

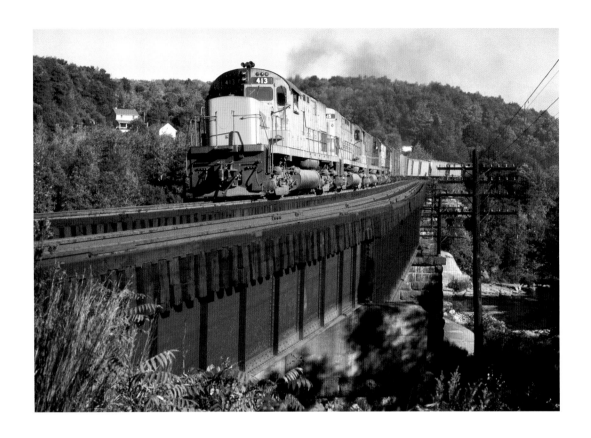

The Colorful Lehigh Valley

The Lehigh Valley was probably the most colorful railroad in the Northeast. In 1964 the Valley abandoned its traditional Cornell red in favor of yellow and gray for twelve new Alco Century 420s (404–415). The 413 (left) was leading a westbound over the Lehigh River at White Haven, Pennsylvania, in July 1972. A year after the C420s arrived, the LV went to the completely different Snowbird livery for seven big Century 628s (625–631). The 636 and 634 (below), in Allentown Yard in July 1974, were former Monon 403 and 401, purchased in December 1967. The LV went back to Cornell red on GP38ACs 310–313 and GP38-2s 314–325 in late 1971 and 1972. The 319 was westbound (opposite) at the huge weather-beaten depot at South Plainfield, New Jersey, on November 7, 1974.

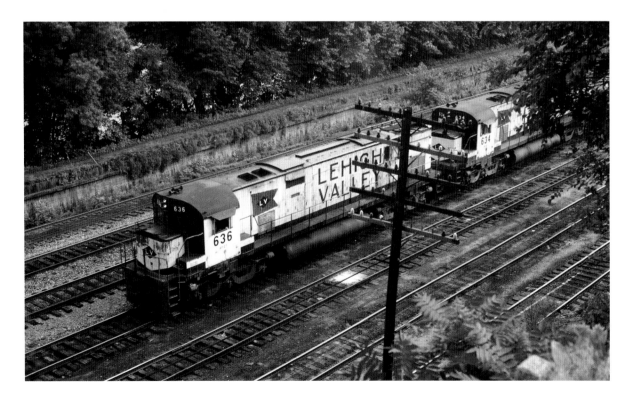

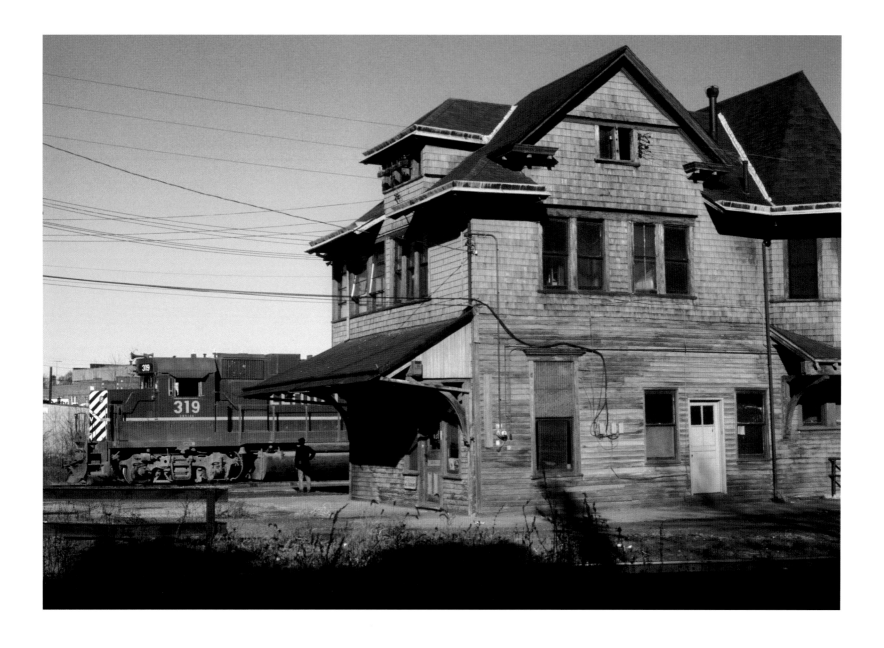

The Lehigh & Hudson River

The 86-mile-long Lehigh & Hudson River killed steam in 1950 with thirteen Alco RS3s and modernized in the mid-1960s by replacing the RS3s with nine Alco Century 420s. When I moved to Andover, New Jersey, in 1973, the L&H became my hometown railroad. By October 1974 the L&H was surviving on carloads of zinc ore out of the deep shaft mine at Ogdensburg, New Jersey, on the former New York, Susquehanna & Western Hanford branch. Westbound NE-3 out of Warwick, New York, was picking up loads there (opposite) for the New Jersey Zinc mill at Palmerton, Pennsylvania. NE-3 would then deliver its cars to the Lehigh Valley (right) at Hudson Yard in Phillipsburg, New Jersey. In October 1977, the L&HR's first C420 (above) was crossing Baird's Lane, where the railroad had installed a dispatcher's phone so Mr. Baird could get clearance to herd his cows across the track.

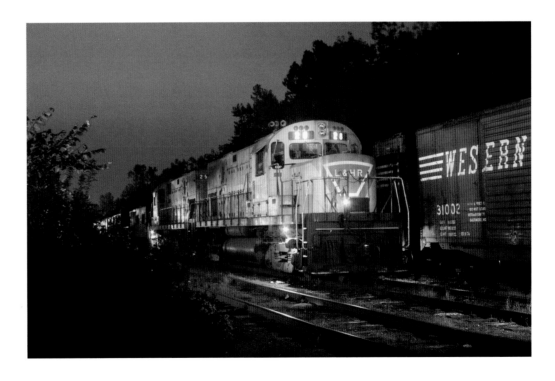

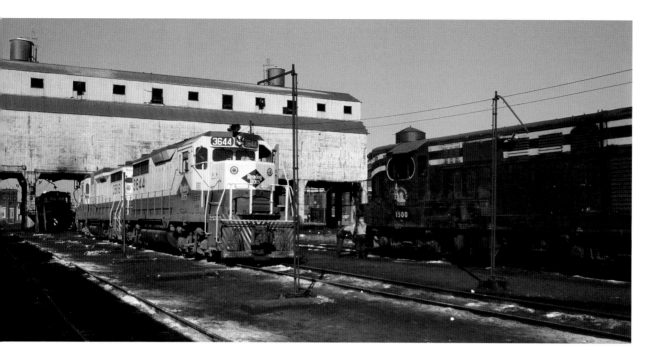

Jersey Central: The Big Little Railroad

For a relatively short railroad, the Central Railroad of New Jersey did things in a big way. Its main line was only 192 miles from Jersey City to Scranton, but it ran an extensive commuter service. An impressive array of semaphores (right) guarded the throat of Jersey City Terminal, where an evening commuter to Raritan or Bay Head was outbound behind a GP7. The adjacent Communipaw engine terminal (above) also served the B&O and Reading. The CNJ 1500 was the Fairbanks-Morse prototype H15-44. These photos were all made on my first visit to New Jersey in August 1966. My first day there began with Babyface Baldwins (below) heading up the branch out of High Bridge.

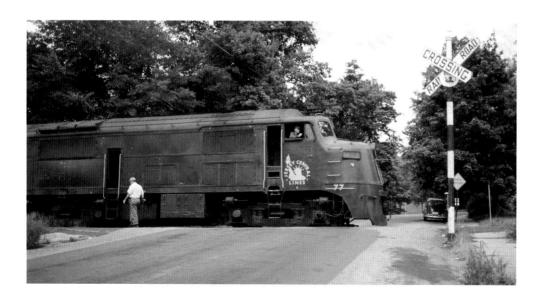

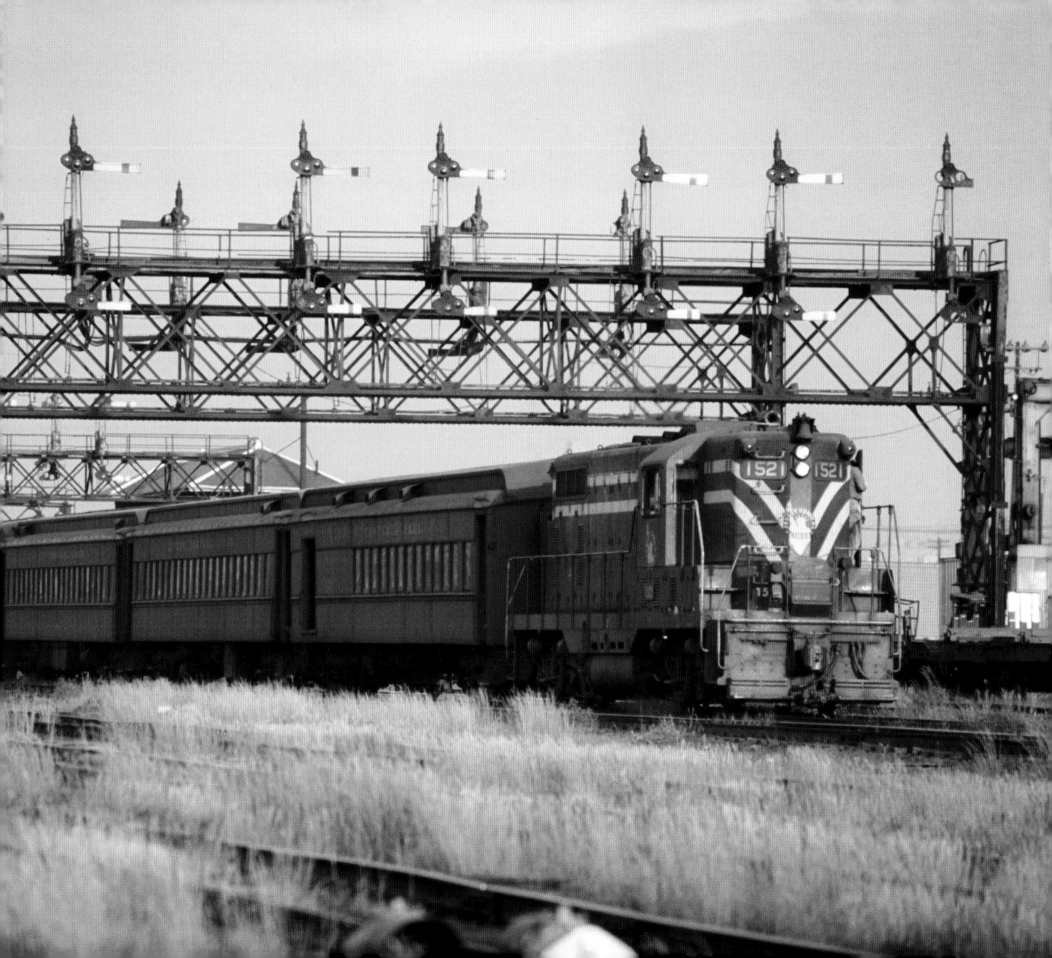

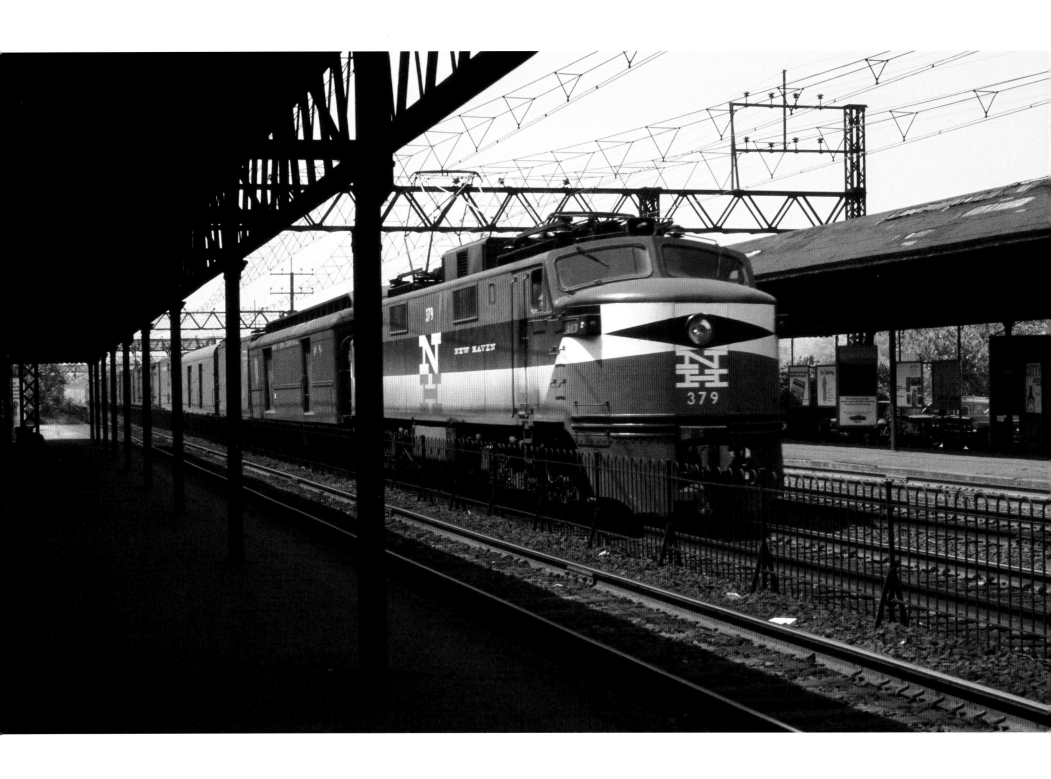

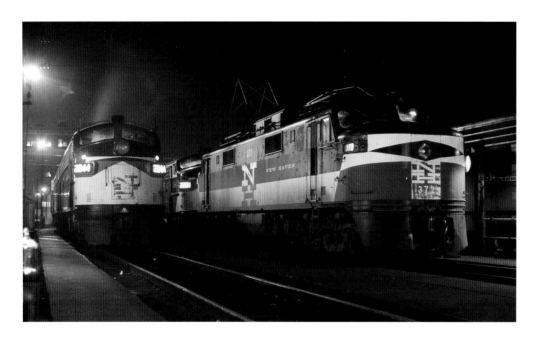

The McGinnis New Haven

If Jay Leno was doing monologues in 1968, he'd probably have picked on the New Haven Railroad, which provided commuter service from southwestern Connecticut to New York City and through service to Boston. In 1953 Patrick B. McGinnis won a nasty proxy battle for control of the conservative New Haven. Though McGinnis lasted there only two years, his enduring legacy was his brilliant vermillion, white and black paint scheme. In 1955 the New Haven bought ten EP-5 double-ended 4000-h.p. passenger motors from GE that contained vacuum-tube ignatron rectifiers to convert the 11,000-volt A.C. power to D.C. for diesel-style traction motors. Because of their noisy cooling blowers, the units were nicknamed Jets. Between 1956 and 1960 the New Haven got sixty unique FL9s from EMD that could operate as either 1750-h.p. diesels or off the New York Central's 660-volt D.C. third rail into Grand Central Terminal. In June 1968, Jet 379 (opposite) was blowing through on the eastbound express track at the Mamaroneck, New York, station. A short while later, a pair of FL9s (right) was approaching the same location. The FL9s could not utilize the 11,000-volt A.C. power from the distinctive triangular catenary. FL9s and EP5s shared the New Haven passenger motor pit (above) that evening. The A.C. electrification ended at New Haven, and everything east of there got diesel power. Of course, the FL9s could run right through from New York to Boston.

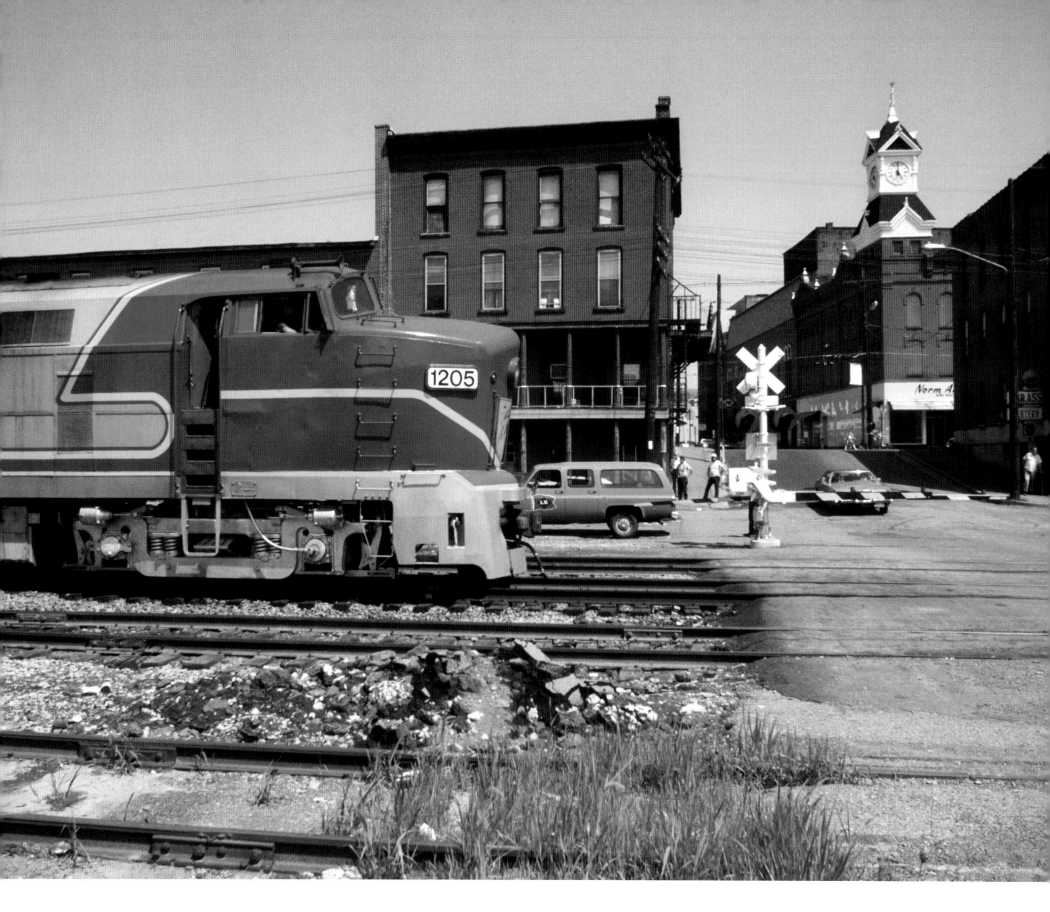

Centuries, PAs and Sharks

In the mid-1960s the Delaware & Hudson got eighteen massive 2750-h.p. Alco Century 628s, including the 613 (below) kicking up the snow in February 1972 at Harriman, New York, on an Erie Lackawanna run-through. In 1967 the D&H bought four Alco PA1s from the Santa Fe for its Albany–Montreal passenger trains. Bumped from service by Amtrak Turboliners, the fabulous four (right) were poking their noses into the Colonie Shop in September 1977, before being leased to Boston's MBTA for commuter service. In 1974, D&H acquired two ex-NYC Baldwin RF16 Sharks for freight and excursion service. On June 23, 1975, they were on the EL at Waverly, New York, (opposite) on their first day on the Binghamton–Sayre "Owego Connection" freight job.

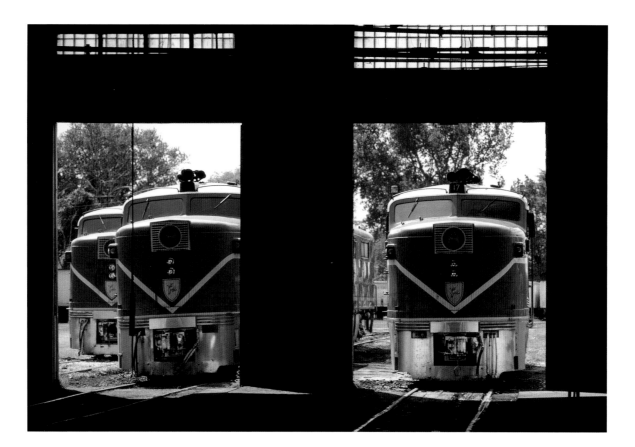

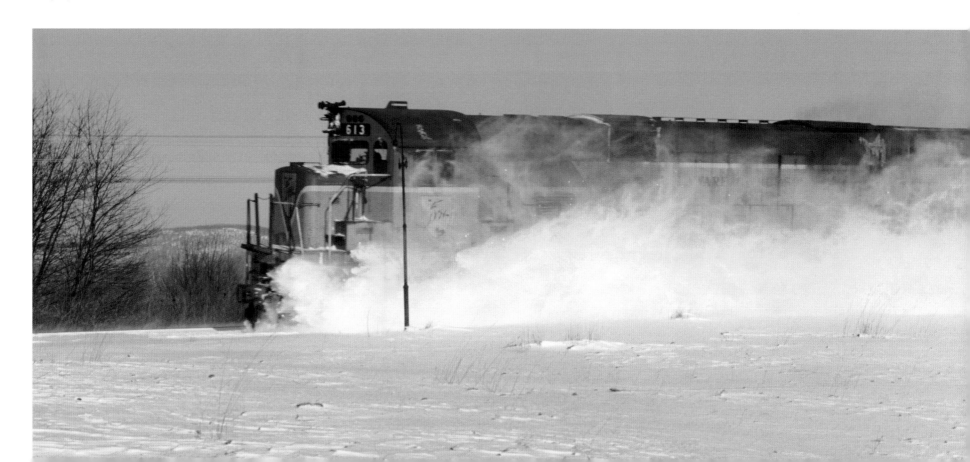

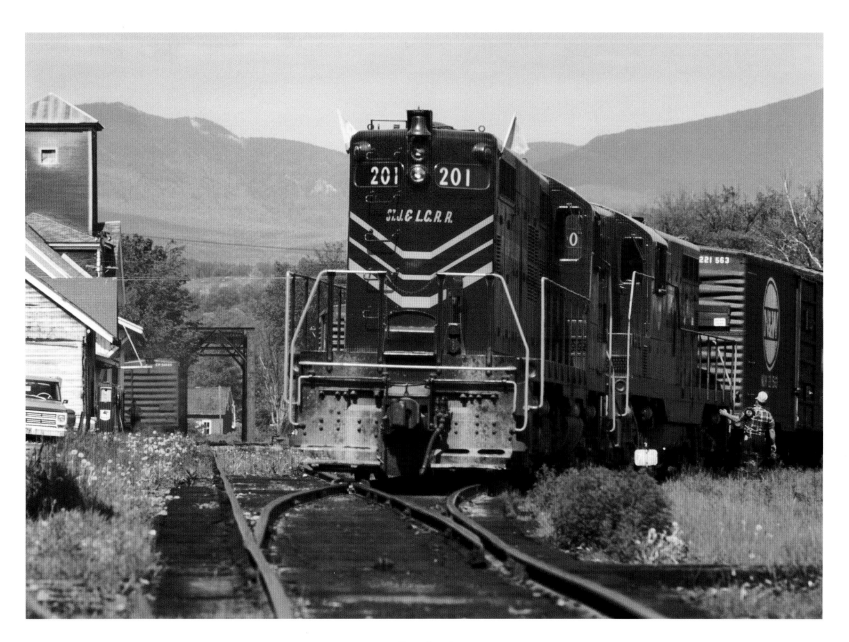

The St. J

Vermont's historic St. Johnsbury & Lamoille County Railroad, owned by Murray M. Salzberg, was taken over in 1967 by Samuel M. Pinsley, his brother-in law.
Pinsley replaced Salzberg's long-lived GE 70-tonners with five used RS3s and two ex-NYC GP7s. Pinsley painted his units a colorful red and yellow,
shown on the Geeps (above) at Morrisville, Vermont, in May 1968. When Pinsley and a handful of other operators bailed out in the following decade,
the railroad emerged in January 1978 with a state subsidy as the Lamoille Valley Railroad Company.
One of the LVRCs four ex-D&H RS3s (opposite) was westbound near Danville, Vermont, on September 26, 1978.

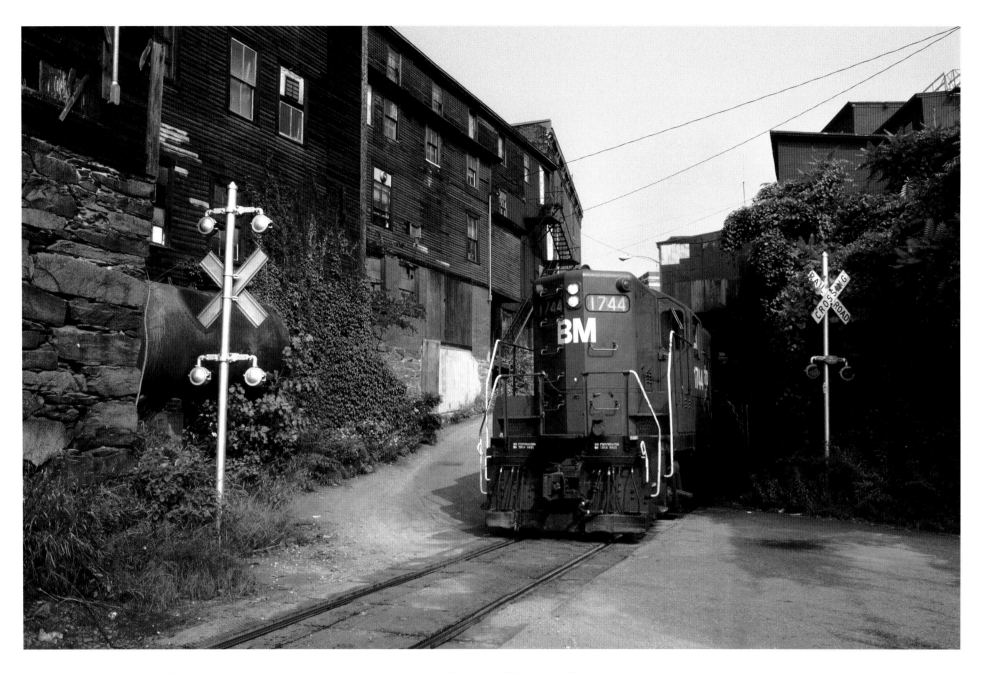

Believe it or not—although it looks like an industrial spur, this is one of New England's more important main lines! In September 1983 a Boston & Maine GP9 was rolling southward through the compact tunnel beneath downtown Bellows Falls, Vermont. The railroad here is shared by the B&M and Central Vermont from the Massachusetts state line at East Northfield 73.5 miles north to White River Junction, Vermont.

The Last Highball

The last functioning ball signal in North America guarded the crossing of the Maine Central and B&M at Whitefield, New Hampshire. In October 1978, a GE U18B (right) was leading MEC's St. Johnsbury to Rigby Yard (Portland, Maine) YR-1 as the conductor set the "two balls up" indication to claim the junction for the Maine Central. A short while later, the Boston & Maine's Wells River to Berlin local showed up (below) with a pair of Geeps and hauled one down to give the B&M's "one ball up" indication. While ball signals could be read from any direction, everyone had to know the meaning of each ball combination.

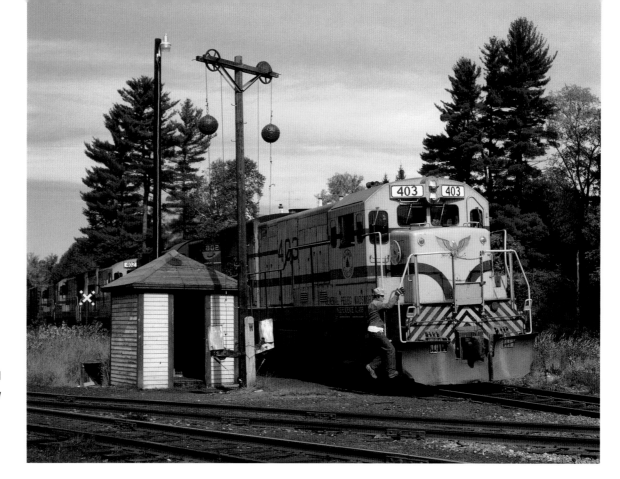

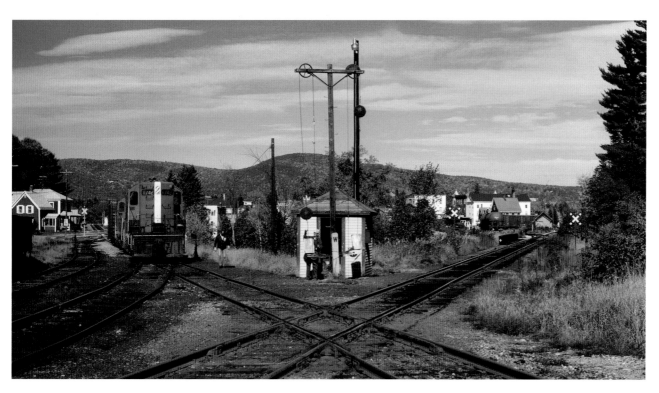

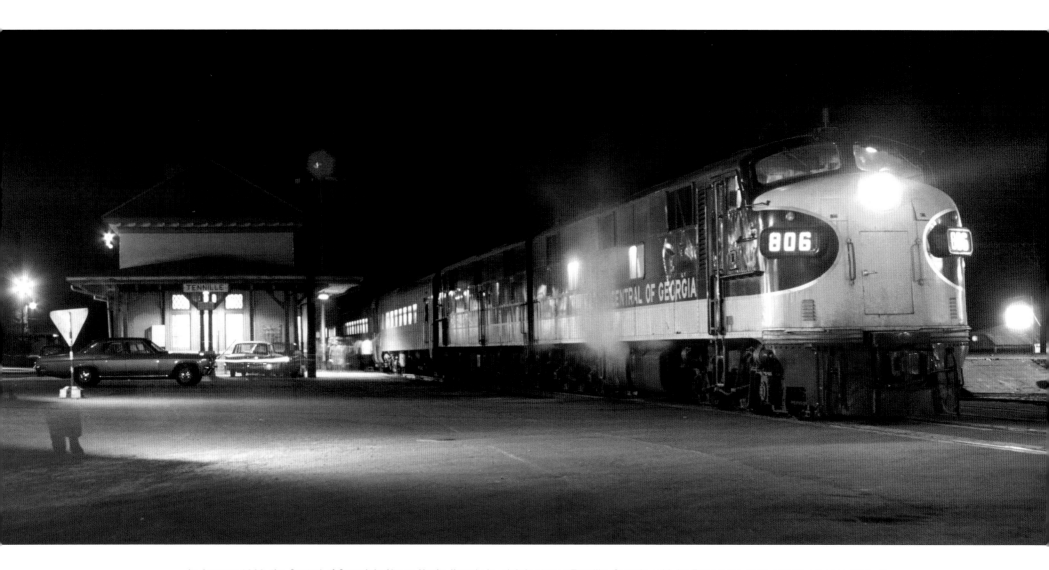

In January 1968, the Central of Georgia's *Nancy Hanks II* made its nightly stop at Tennille, Georgia, with its E7s on the town square crossing (above). My flashbulbs attracted the attention of the local cop, who showed up to make sure I wasn't a Nazi spy. Only my EMD identification and my dropping the name of the Sandersville Railroad's president, Ben Tarbutton, got me off the hook. In November 1969, Montpelier & Barre and Frankfort & Cincinnati GE 70-tonners in Pinsley livery (opposite) approached the distillery at Stamping Ground, Kentucky, on the F&C.

DEEP IN DIXIE

Chapter Five

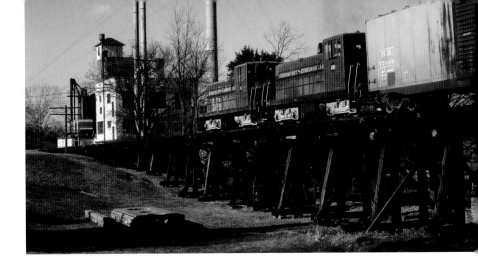

THE CLOSEST I'D COME TO THE DEEP SOUTH BEFORE I went to work for EMD in the fall of 1967 had been a wonderful trip in August 1965 that wound up in Louisville, Kentucky, where the Louisville & Nashville sent its spiffy blue streamliners to Atlanta and New Orleans behind Confederate-colored slant-nosed E6s. It was like going to a swimming pool and only being allowed to stick your toe in the water.

In January 1968, I was thrown into the deep end when I was assigned to the Sandersville Railroad in the heart of Georgia. The town of Sandersville was still segregated at the time and was about as traditional Deep South as you could get without a time machine. The lone SW1500 behaved well and required only a couple of hours of my time each day, so I had plenty of opportunity to explore the nearby short lines of the Lucius Beebe *Mixed Train Daily* era. Alco hood units and EMD switchers had replaced the elegant Ten-Wheelers found in Beebe's book, but the rural charm of the Old South was still very much there. I even learned to eat grits, though I did pass on hog jowls.

When I traveled, I carried a small research library with me in the rear boot of my Volkswagen Bug. Knowing where I was likely headed, I'd pull out the *Railroad* magazines with the appropriate regional rosters and include any books that might be helpful. Going into Dixie, of course I took along Beebe's *Mixed Train Daily*. In his fairly detailed coverage of the Sandersville, Beebe commented about the Tarbutton family, who owned the railroad, and also told how he was fascinated by a big square mirror in the baggage compartment of the mixed-train combine.

I showed the book to the two Tarbutton sons, who still owned the railroad, and they were fascinated and delighted to see their father described in the book. Ben Tarbutton saw the photo of the combine and told me, "We've still got that car, y'know. We use it for a fishing camp out by the pond."

The next day one of 'em gave me a ride out to the pond, and, sure enough, there was the weatherbeaten wooden combine (page 127), off its trucks but still with Beebe's square mirror still in the baggage compartment. Talk about a link with the past!

They weren't accustomed to railfans in the middle of Georgia. The Central of Georgia had a picturesque passenger station in nearby Tennille (pronounced Ten-ul), and the Savannah-bound *Nancy Hanks II* made a nice image as it paused for passengers on the crossing at the edge of the town square. One night I decided to photograph it (opposite), lighting the E7 with flashbulbs. The flash caught the immediate interest of the town cop on the other side of the square. I saw him start to move his car and hoped that he wouldn't screw up the shot with his headlights as he came my way. I closed the shutter, and the *Nancy* resumed its eastbound trek, running interference between me and the cop. I decided to just wait for him, and he gave me a very suspicious interrogation before he was satisfied that I wasn't a Nazi or Yankee spy. As I say, this was still the Old South.

I was fortunate to get a number of assignments in the Deep South, from the Illinois Central in Birmingham and New Orleans (where I rode out Hurricane Camille in Rozal's Motel near Mays Yard in Metairie, Louisiana) to the Georgia Railroad and Atlanta & West Point in Atlanta. I also had switcher assignments in Mobile, Alabama, and Cartersville, Georgia. When I wasn't working, I was exploring, and I got to know the region's red clay, piney woods and kudzu pretty well. I can "y'all" with the best of 'em, and to this day I refer to "DeCAB" County, Georgia, and DeKALB, Illinois, though they're both spelled DeKalb.

I was a bit disappointed to find the colorful Central of Georgia reduced to just a name on the side of the Southern's black and gold "tuxedo" livery, but Atlanta in the late 1960s was a wondrous place with two downtown passenger stations hosting everything from big

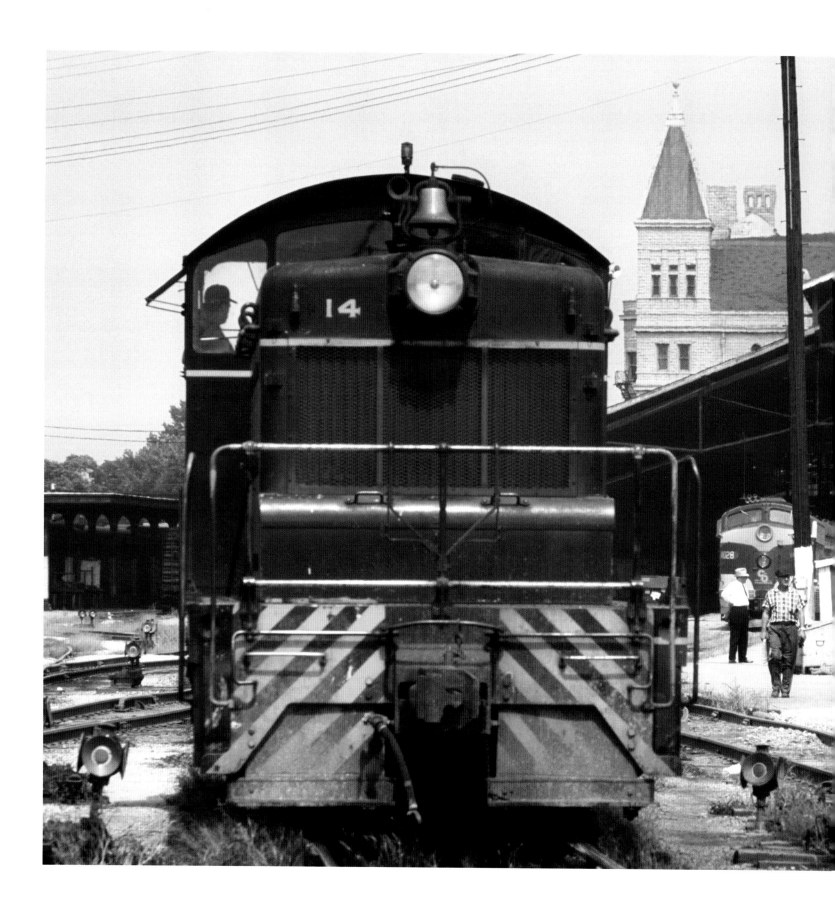

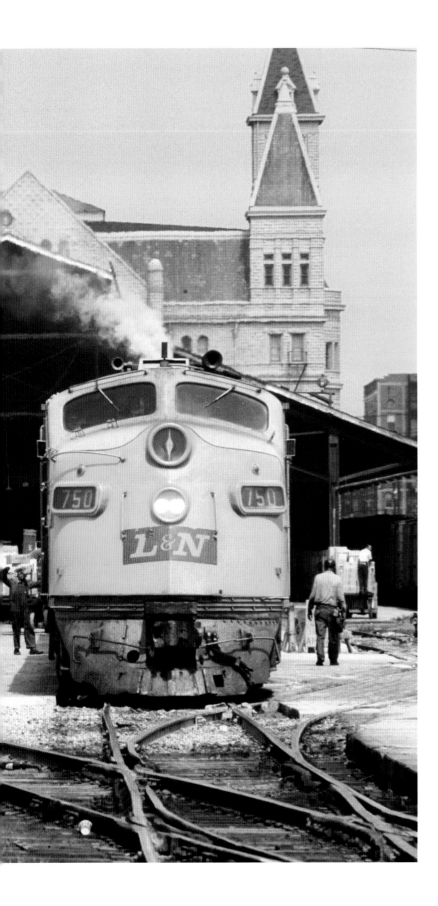

streamliners on the Atlanta & West Point, Southern and L&N to mixed trains on the Georgia Road. The mergers that would blur the future with sameness hadn't quite yet ruined the Seaboard Coast Line, which still fielded both ACL and Seaboard colors.

There were two unifying elements in the Deep South of the 1960s, the Southern Railway and the Louisville & Nashville. Within the triangle formed by Cincinnati, New Orleans and Atlanta, those two roads were just about everywhere, and confirmed the Southern's slogan, "Covers Dixie Like the Dew." The recently merged Atlantic Coast Line and Seaboard Air Line carried New Yorkers to Florida every winter and schlepped them back to Long Island in the spring. In between were dozens of shortlines, each with its own personality.

I was photographing the Louisville & Wadley's ex-Southern SW1 departing the CofG interchange at Wadley, when the train came to a halt at a crossing, and the owner of the railroad came down from the cab and asked if I'd like to ride over their recently refurbished trestle. His conductor was following the train in his pickup truck, and the boss said that he could give me a lift back to my car when we got to the other side. I climbed aboard the "back porch" of the SW1, and as we eased out onto the mile-long timber trestle, I was surprised when the owner/engineer joined me at the end railing (page 128). He'd left the throttle in Run 2, and our five-car train just continued over the bridge at about five miles per hour. It was a bit unnerving to have the switcher on autopilot as the weight of the unit slapped the rails crisply down onto the creaking wooden bridge over an endless swamp that likely was home to every reptilian nasty in the state of Georgia. You just don't get hospitality like that in New York.

At the other end of the spectrum was the Appalachian coal region of Kentucky and Virginia, where the Norfolk & Western, Chesapeake & Ohio and Clinchfield reached into the "hollers" to serve the grimy coal mines. Though Appalachia was different from Alabama and Georgia, the local folks spoke pretty much the same language and had the same Rebel flags on their pickup trucks.

An SW1 was working head-end cars as the *Pan-Am* and C&Os "Little George" connection to the main-line *George Washington* at Ashland, Kentucky, awaited departure at Louisville Union Station in August 1965.

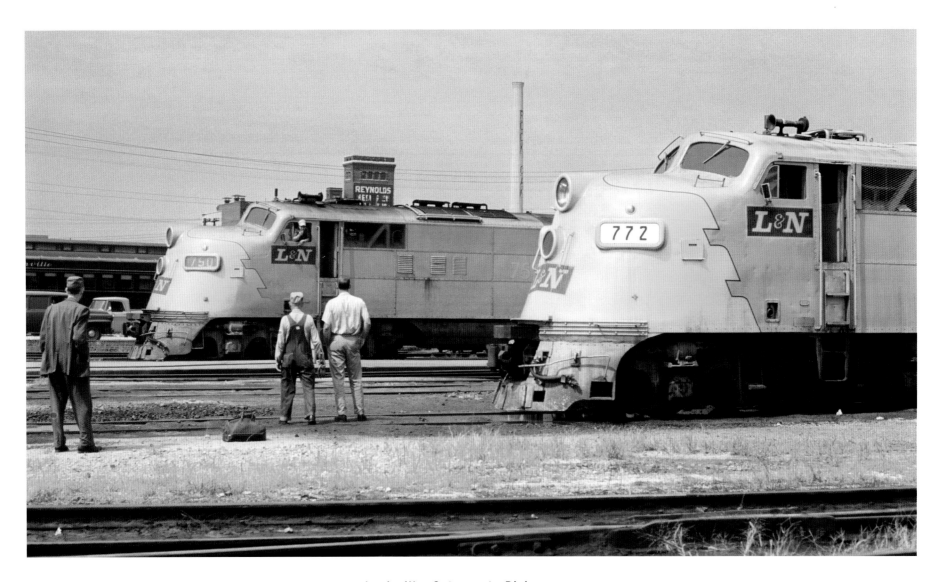

Louisville: Gateway to Dixie

Louisville Union Station was a classic stub-ended terminal with a six-track trainshed and a handsome Romanesque headhouse.
It was dominated by the Louisville & Nashville but also served the Pennsy, Monon and C&O. In August 1965 the lead E6 on the *Pan-American*
from Cincinnati to New Orleans (above) was backing past sister E6 772 on the 10th Street Roundhouse service track.
Under the trainshed, with its stained-glass north end (opposite), were three heavyweight sleepers.

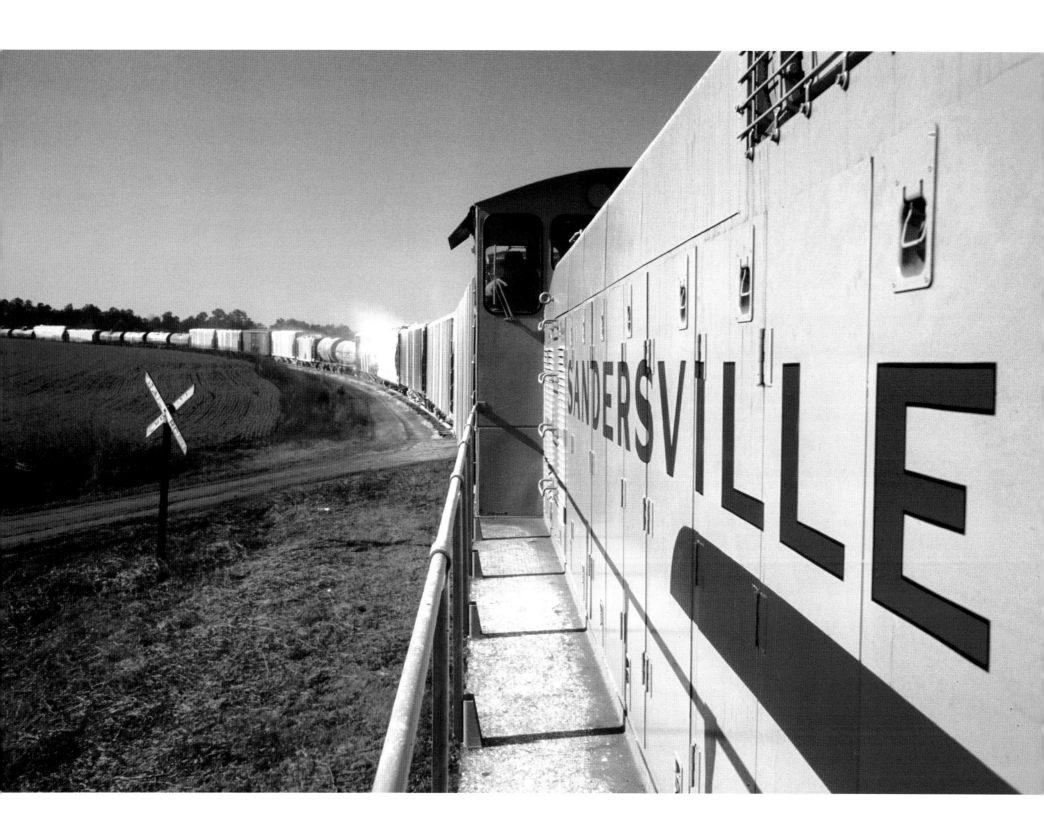

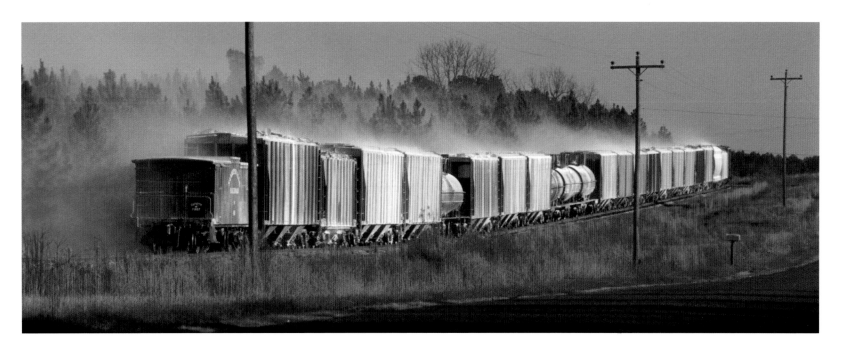

Three 100s on the Sandersville Railroad

Kaolin is a chalk-like clay that is used to coat raw paper to make it white. Kaolin is found in only a few places, and some of the largest suppliers are located on the 9-mile Sandersville Railroad in the center of Georgia. In January 1968, I was assigned by EMD to the Sandersville to cover the delivery of an SW1500. At that time the railroad had Fairbanks-Morse H12-44 No. 100, which had replaced steam in 1953, and EMD SW1200 No. 200, which had come along in 1964. With such a crowded roster, the SW1500 was given the number 100 of the FM it was to replace. When it arrived, the Sandersville roster hit its all-time peak of three units, including two 100s (below right). The FM was renumbered 10 by painting out the last zero. The new 100 was making good time (opposite) the run from Kaolin to the CofG at Tennille. Just out of the loaders, the cars (above) shed their coating of clay dust.

In his book *Mixed Train Daily*, Lucious Beebe described a combine with a 6-foot-square mirror in its baggage section. In 1968 that car was used as a fishing camp, complete with the mirror. Its number? Why, 100, of course.

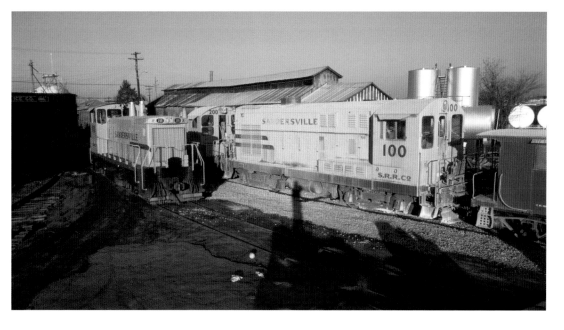

Rural Georgia

One of the last two operating FTs in the South was Georgia, Ashburn, Sylvester & Camilla 16, originally Southern Railway 4100, seen flaunting its steam engine bell (opposite) near Sigsbee, Georgia, in January 1968. It was making a brisk and risky 35-mph northward on the rollercoaster Georgia Northern main line. Its mate, Georgia Northern 14, was derailed a few miles north at Bridgeboro, where the east-west GAS&C crossed the north-south GN.

Since its charter in 1833, the Georgia Railroad was exempt from state and local taxes as long as it ran passenger service. In August 1968 (left), that obligation was being fulfilled by the Washington Branch mixed, scampering toward Augusta on the main line just east of Barnett.

The CofG was operating the 36-mile Wrightsville & Tennille in January 1968. The CofG RS3 153 (below left) was burbling out of Donovan, Georgia, 13 miles south of the CofG connection at Tennille with a train of pulpwood.

President and engineer B.D. Gibson of the 10-mile Louisville & Wadley invited me aboard to see his recently refurbished trestle (left) from the deck of CofG SW1 No. 2. They returned me to my car (above) in their pickup truck.

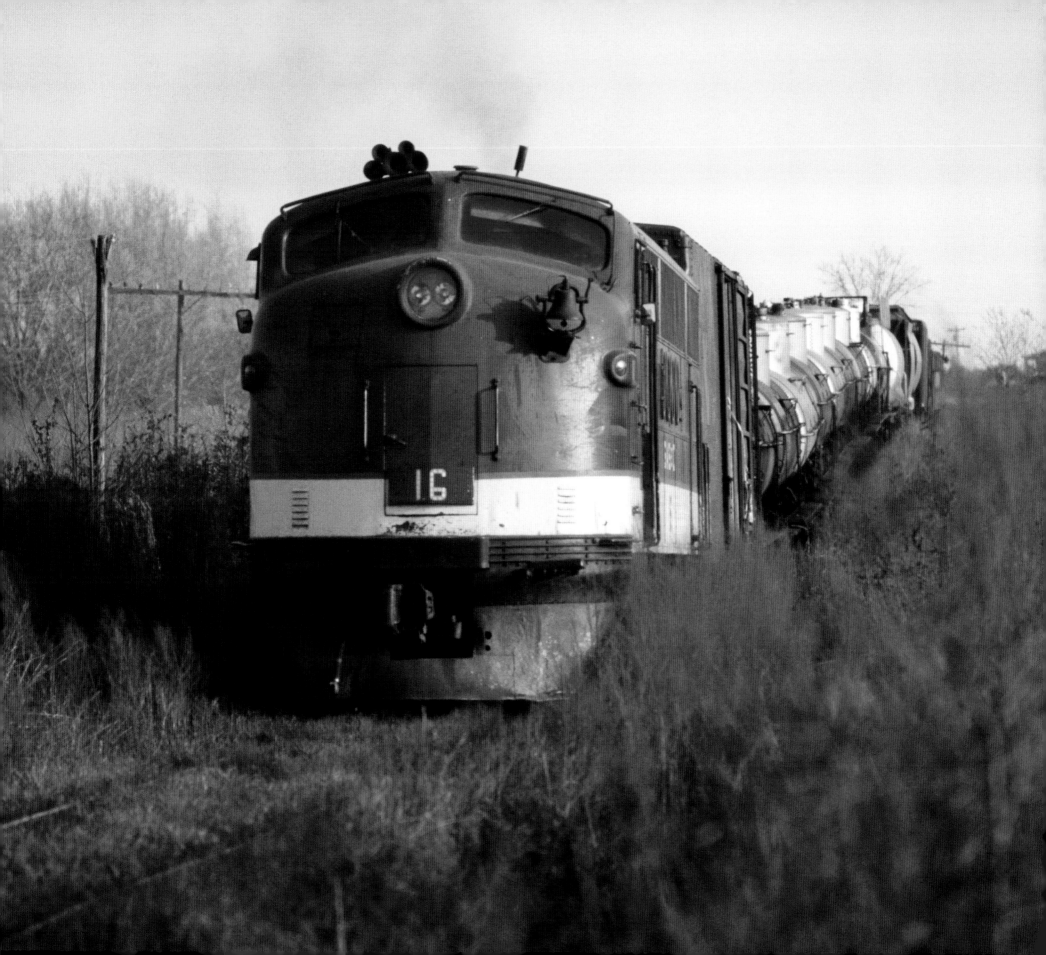

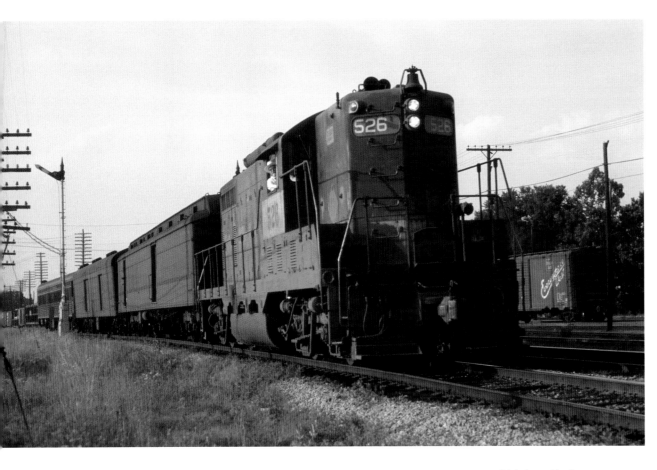

Chicken Train

I was at East Point, Georgia, on the Atlanta & West Point just west of Atlanta in June 1969, awaiting the late-morning approach of No. 38, the humbled remnant of the once glamorous *Crescent Limited*. As Western Railway of Alabama GP7 526 rolled past, I couldn't believe what I saw in the cab. The chickenmeister himself, Colonel Harlan Sanders, was at the throttle! I hopped into my car and chased the train into Terminal Station, where I found A&WP engineer J.W. McNair from Montgomery, who had grown the beard for a centennial celebration. Realizing his resemblance to the chicken man, he bought the full white outfit to wear whenever he caught the passenger job. When the kids would ask him for free samples, he'd reply, "I got no chicken, but you can lick my fingers!" The WofA and A&WP were partners of the tax-favored Georgia Railroad. While the West Point trains used the the Southern's big Terminal Station, the Georgia Road used the smaller Union Station. Georgia Road FP7 1003 (opposite) was in Union Station on a rainy night in January 1968, awaiting the 8:45 p.m. departure of No. 4 to Augusta, where it would connect at 2 a.m. with SCLs *Everglades* on the old ACL via Florence to New York.

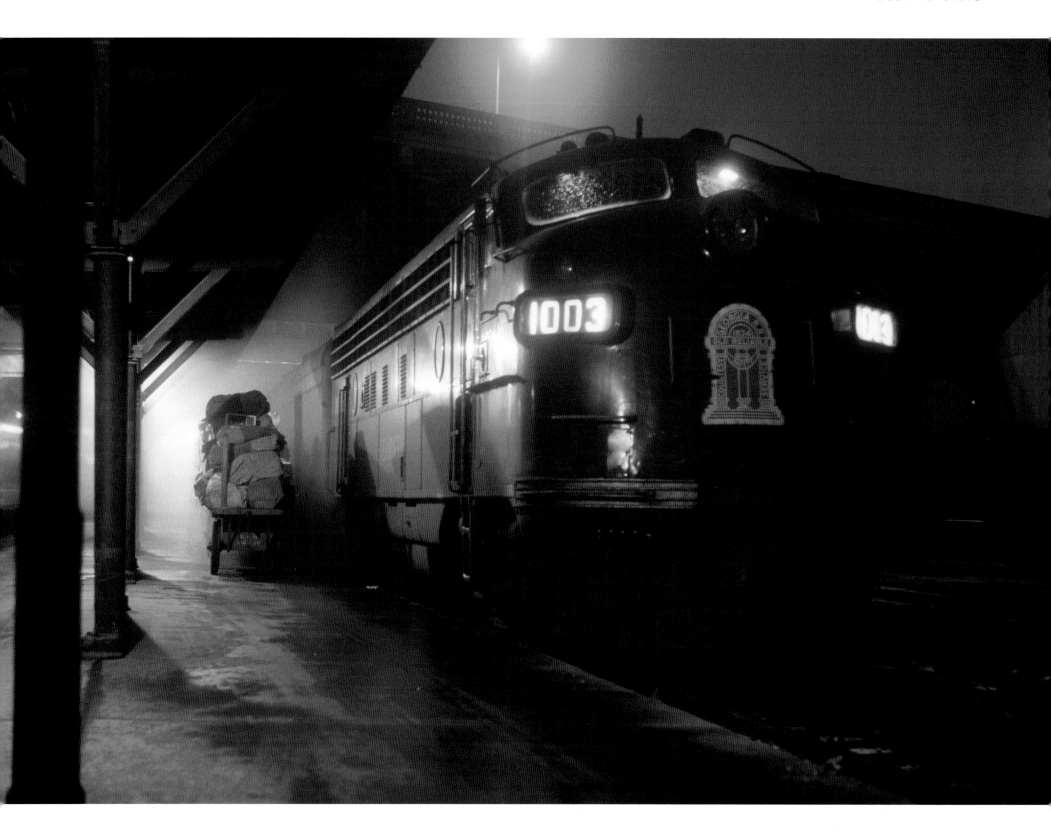

Favorite Images of Dixie

It was a dark and stormy night (with apologies to Snoopy) as my VW slid down the snowy mountain into Nashville in January 1968. I was about to get my first and only look at the Tennessee Central before it was abandoned four months later. Idling at the ancient roundhouse was RS3 249 in the new blue and gray livery (below). The lights of Nashville against the snow and low clouds produced the interesting colored sky.

In August 1968, I delivered a pair of SW1500s to the Terminal Railway of the Alabama State Docks. I encountered one of my units crossing the working swing bridge (opposite) over an inlet off the Mobile River as it departed North Docks Yard with the Country Job to an inland paper mill and Alabama Power steam plant.

In March 1971, I took a vacation trip through the South with Bob Walker, who had just returned from Vietnam. We stopped at Greenville, Mississippi, where Bob posed (right) with Columbus & Greenville Baldwin AS416 606.

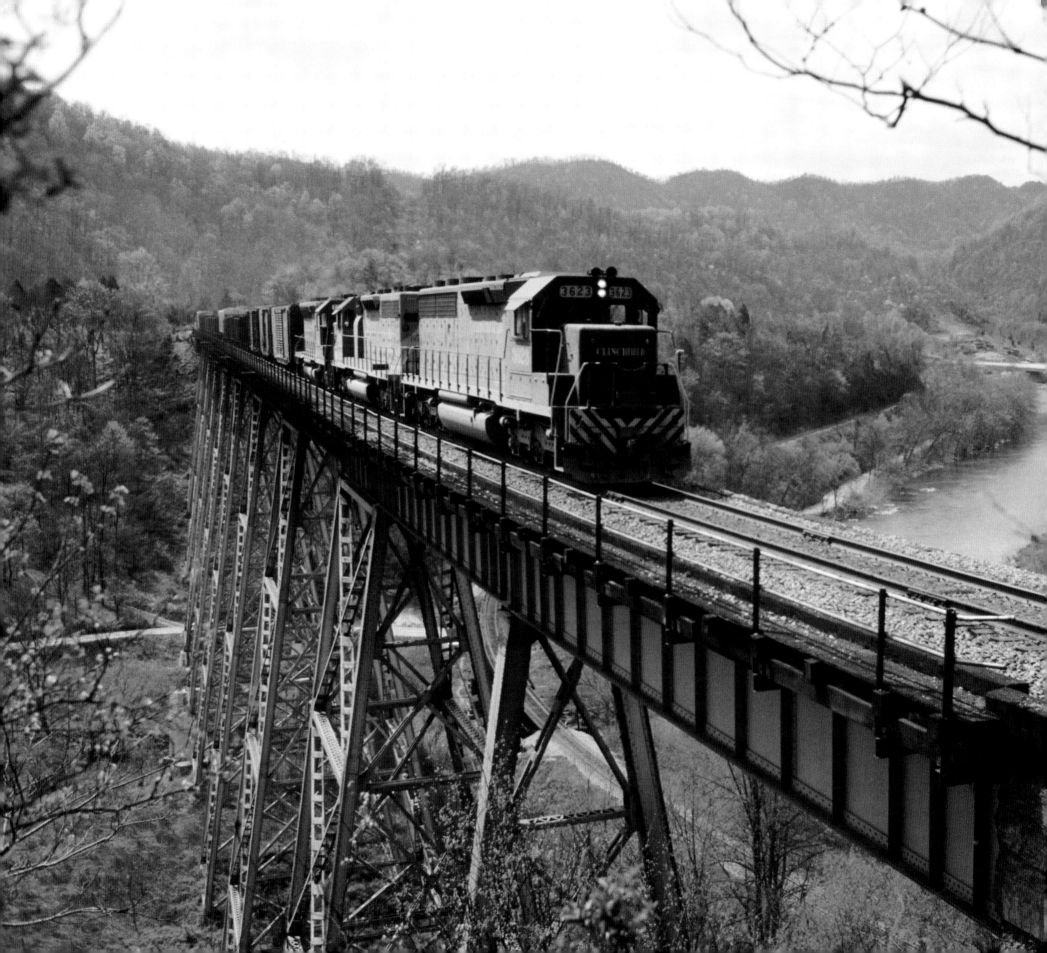

Fire on the Mountain

The Clinchfield Railroad provided a 277-mile link between the C&O at Elkhorn City, Kentucky, and connections to the south at Spartanburg, South Carolina. Three SD45-2s were northbound (left) on the huge Copper Creek Viaduct at Speers Ferry, Virginia, in May 1978, with the Southern Railway beside the Clinch River below. Later that day, a southbound coal train was winding its way up toward Altapass with a helper set. GP7 904 was working wide open, snorting out a spectacular stack fire. Cutting off at Altapass, the Geep died, with a wisp of blue smoke drifting from its hood.

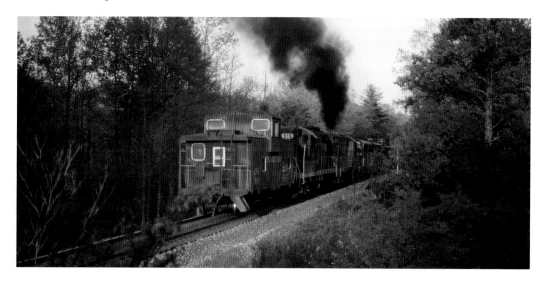

West Virginia Shifters and Splashers

They say that if you flattened out West Virginia it would be bigger than Texas. And all them hills and hollers seemed to have a Chesapeake & Ohio coal branch in them. The town of Thurmond, deep in the New River Gorge, had an enginehouse designed for 2-6-6-2s and a block of downtown buildings that had the C&O main line for its main street. Two sets of Geeps were on the main line (above) in October 1970. Kids in Van were splashing in the Pond Fork of the Little Coal River (opposite) while the Barrett Shifter, returning to Danville, paused across the river. A pair of Alco RSD12s on the Rum Creek Shifter (below) had just run around their empties at Yolyn before shoving them the next two miles to the mine at Slagle, where the valley was too narrow for a yard.

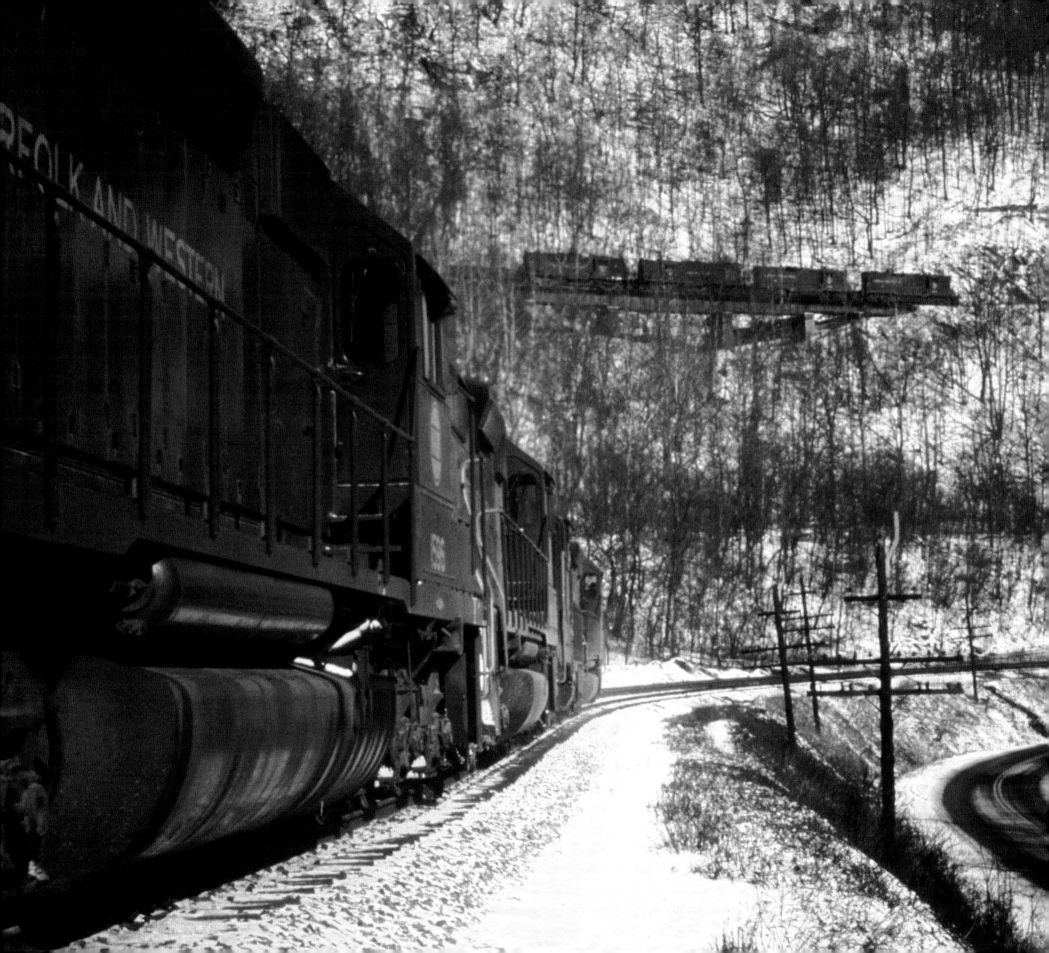

Bluefield's Geeps

The Norfolk & Western didn't get its first freight diesels until 1955, when it began buying EMD GP9s and Alco RS11s to replace its 2-8-8-2s and 2-6-6-4s. The Geeps that were gathered (below) at Bluefield, West Virginia, in February 1970 were the same units that killed steam. A set of Geeps, RS11s and a lone Century 425 was leading a merchandiser (right) in July 1971 as it met an eastbound coal train beneath the new Interstate 77 bridge at Mills Valley, south of Ingleside, West Virginia, where the old Virginian Railway from Princeton swung around the mountain high above the N&W main along the East River. In February 1970, a set of Geeps and an RS11 was dropping down the Virginian (opposite) above eastbound six-motors on the N&W main alongside Route 112 between Hoot Owl Hollow and Oakvale.

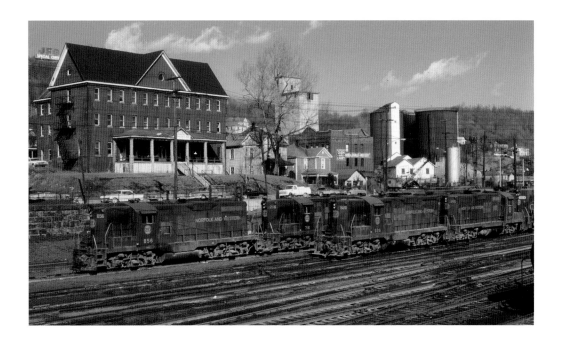

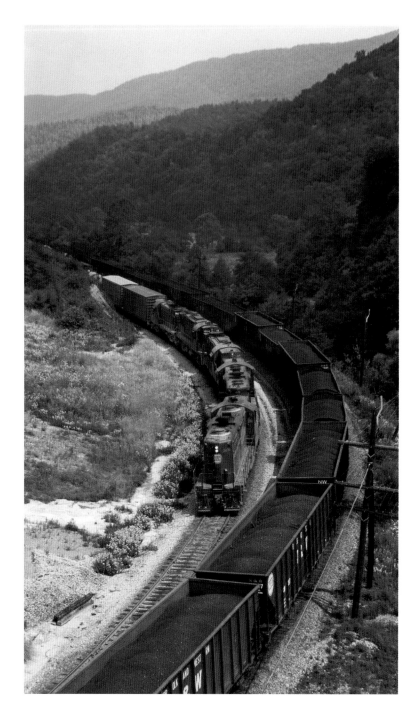

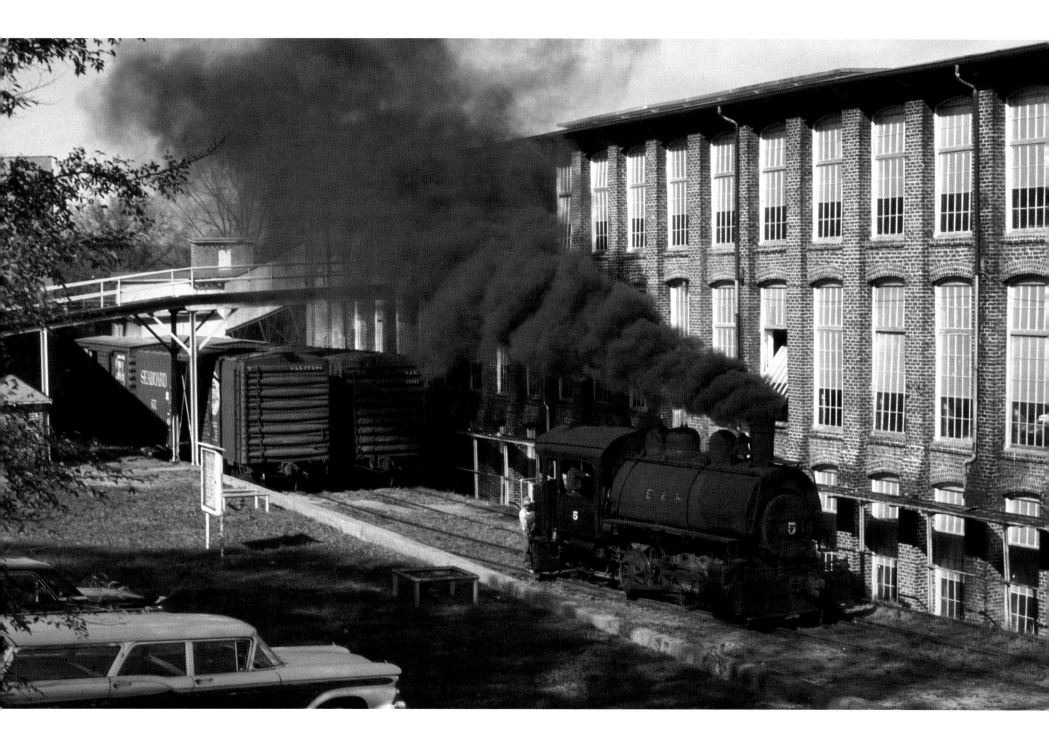

The Last Steam Shortline

Throughout the 1960s, the few surviving steam shortlines killed their fires or turned into tourist roads. By October 1971, only one remained, the 3-mile Edgmoor & Manetta in South Carolina, whose only purpose was to link the Marietta Mills textile plant at Lando with the SCL (ex-SAL) Hamlet-Birmingham line at Edgmoor. Its sole motive power was 1917 Porter saddletank 0-4-0T No. 5. After spotting two boxcars for loading with Canon blankets, the engine moved (opposite) to the service pit at the end of the tail track to take on coal from a truck and water from a hose. The mill complex had only one run-around track and two spurs. Number 5 then shoved the two loads up to Edgmoor and swapped them for two empties at the SCL interchange (right). As the saddletanker waddled past the Edgmoor depot (below), a set of SCL GP35s roared past, their whistle and air horn salutes spanning the generations and decades.

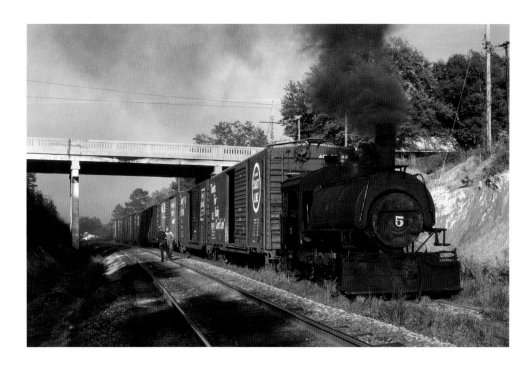

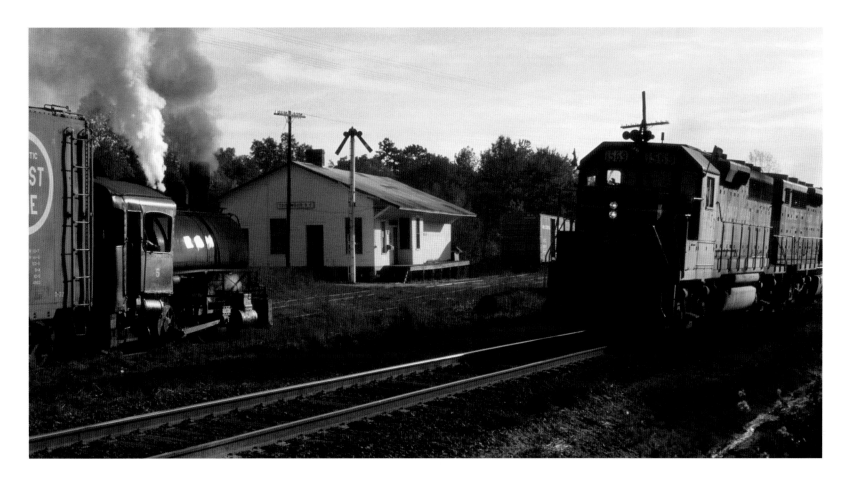

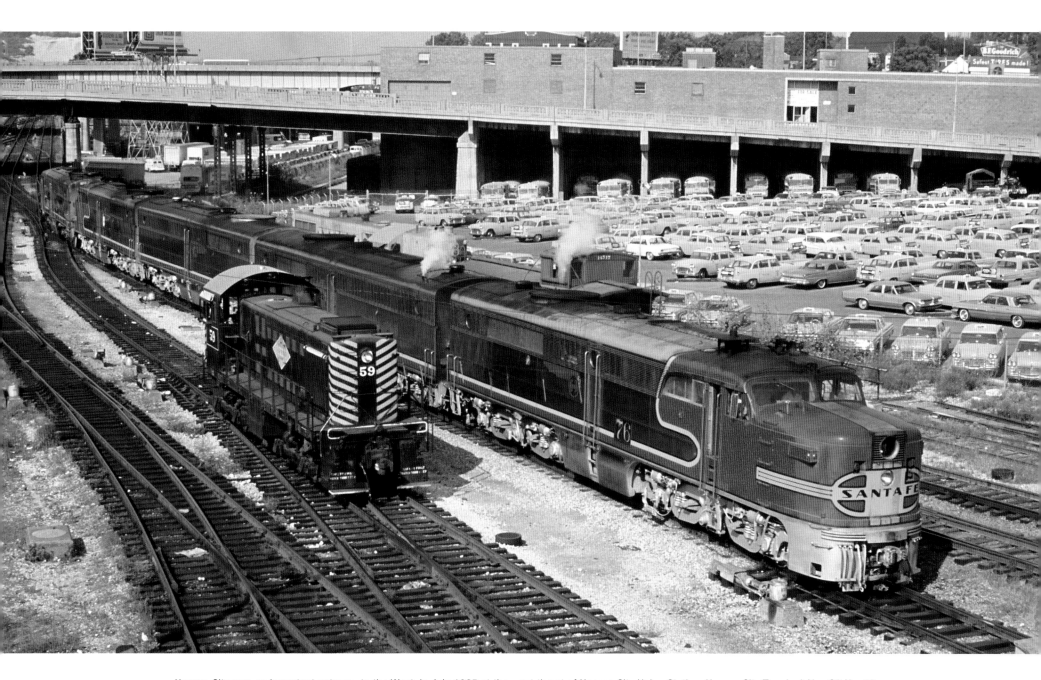

Kansas City was an important gateway to the West. In July 1965 at the west throat of Kansas City Union Station, Kansas City Terminal Alco S2 No. 59 was idling next to two kinds of "cabs," Santa Fe PA1 76L on an A-B-B-A-A set about to take No. 12 into Chicago, and an entire parking lot full of yellow taxis. A westbound Western Pacific freight (opposite) was on the bridge between Tunnels 31 and 32 just west of Keddie, California, in July 1969.

BEST OF THE WEST

Chapter Six

OUTBOUND TRAINS FROM DIXON WERE HEADED WEST. "Inbound" were the C&NW trains into Chicago, and the north-south IC trains seemed to just pass through to destinations that were irrelevant to a teenager. But "the West" was a place worthy of the term "outbound." It conjured up images of the Rockies and Cascades and Milwaukee Road electrics and all those Pacifics—Union, Western, Southern, Northern and Missouri.

The western distances were a bit intimidating, so I didn't get much beyond St. Louis, Omaha or Minneapolis until 1969, when I had a reliable VW Squareback and some money in the bank, thanks to EMD. In July 1969, I completed my assignment on the Georgia Road in Atlanta and headed off for a two-week trip west with Mike Schafer and Richard Dean. It was one of those fabulous trips where the weather was generally perfect and the action superb. We started out with turbines on the UP, the real *California Zephyr* on both the Rio Grande and Western Pacific and, of course, the Milwaukee Road electrics.

We were running about a day behind our planned itinerary after hitting Harlowton, Butte and Deer Lodge without seeing any electric road jobs. As we departed Missoula, Montana, where we got the westbound Northern Pacific *North Coast Limited* at dusk, we were following the Milwaukee Road electric line in the dark, en route to Avery, Idaho. After 30 miles of seeing the spectacular railroad in the dark, I declared, "We gotta stop here and do this in daylight. This is the railroad we came here to see, and we're following it at night!"

Mike and Richard disagreed, insisting that we press on the next 100 miles to Avery. The nice thing about owning and driving the car is that you have veto power, and I pulled off at a mom-and-pop hotel in the next little town we got to. We got a room with three beds, and Mike and Richard were grumbling as we settled in for the night. I was getting hungry and went out in search of a restaurant while Mike and

Richard, still grumping, went to bed. There was nothing open except a gas station with choke-'em-down Stewart's microwave sandwiches. On the way back to the hotel, I noticed a light on in the Milwaukee Road depot. Not only was a light on, there was an operator on duty!

It turns out that this "next little town" was Alberton, Montana, a division point on the Milwaukee. The operator was also the crew caller.

In July 1969 there was usually only one train a day in each direction under the wires, so I asked the op if he had anything on the lineup. "Yep," he replied, "Westbound XL-263 should be here about dawn."

I couldn't believe it. Not only would we see the railroad in daylight, we'd have a train to follow! The op confirmed that the lead unit was a Little Joe electric.

I told the op I was staying at the hotel.

"That's where my crew is," he said. "They don't have phones in the rooms, so I have to go over there to wake 'em up. Want me to give you the call when I get them?"

Mike and Richard were already asleep when I got back to the room.

At 6:15 in the morning, the sudden pounding on our door damn near scared my roomates out of their skins. When the voice on the other side announced "Mr. Boyd, 263's called for 6:45," they looked at me, accusing and incredulous.

"We've got Joes headed west that will be here in a half hour," I explained. "I'd suggest you get dressed!"

Their "attitude" immediately vanished as the sun popped over the mountain on a misty but crystal-clear morning and Joe E78 and four GP40s eased into Alberton for the crew change. What followed was one of the best days of photography I've ever had, as we easily paced the train all the way over St. Paul Pass to Avery, in the St. Joe River valley, the west end of the Rocky Mountain Electrification.

After Avery, we hit most of the classic spots in the Pacific Northwest and West Coast as far south as Los Angeles. We hit the Feather River Canyon both coming and going, and that piece of railroad is not over-rated! We even were incredibly lucky to catch the westbound *California Zephyr* running eight hours late in perfect light at the Pulga overlook. That train usually goes through there when the canyon is in morning shadow. A few days later we just missed the detouring westbound *CZ* in Royal Gorge but did catch it exiting Tennessee Pass Tunnel and negotiating Eagle River Canyon on the Rio Grande.

Also on our return trip, we were listening to the radio news and paused in the middle of Nebraska to watch the quarter moon in the afternoon sky as Neil Armstrong announced "The Eagle has landed."

When I went to work for Carstens Publications in October 1971, I drove from Illinois to New Jersey by way of Seattle, Los Angeles, El Paso and Memphis. It was a two-month photo gathering trip that included visits to numerous Carstens advertisers and contributors. The Bitterroot Mountains were in spectacular fall colors, and the Burlington Northern merger had more than doubled traffic on the Milwaukee Road, which brought out the boxcab "Pelicans" that had been absent from the 1969 trip.

One of the things that surprised me about Western railfan photography was how many of the classic shots were easily accessible and in some cases were from the only possible vantage points. The famous overlooks at Pulga and Keddie Wye are right off the shoulder of the highway! The spectacular Donner Lake overlook on the Southern Pacific 1867 main line between Tunnels 6 and 7 could be reached in a wheelchair. After learning photography in the flatlands, the mountains and expanses of the West were an embarrassment of riches.

I made numerous trips back to the West after 1971 and never came away disappointed, but those two trips in 1969 and 1971 still define the best of the West for me.

Turbine 5 at Council Bluffs, Iowa, in June 1962.

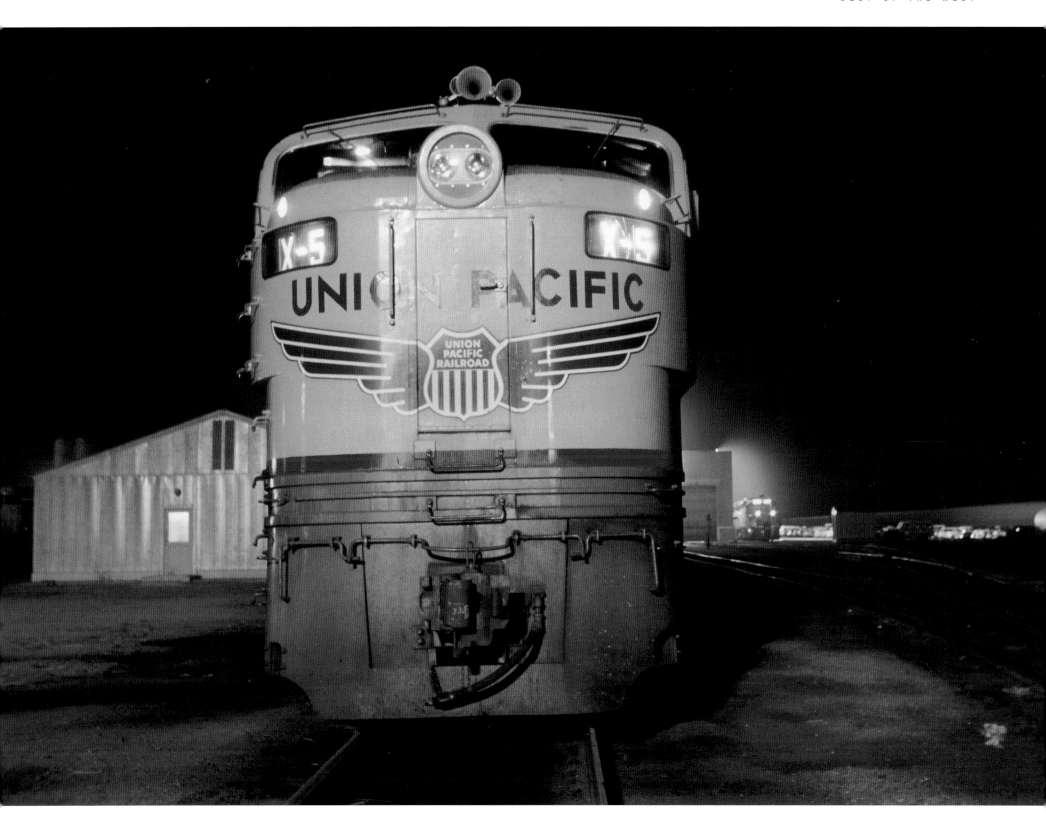

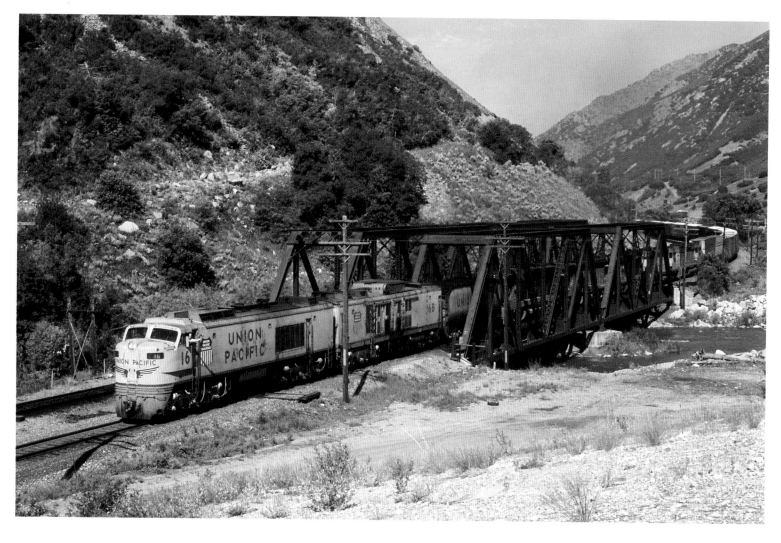

Big Blows!

The most impressive locomotives this side of steam had to be the Union Pacific's 10,000-h.p. gas turbines, numbers 1 to 30. The first eight were delivered by General Electric between August 1958 and March 1959 as 8500-h.p. units, and the remaining twenty-two were delivered as 10,000-h.p. units between November 1959 and June 1961. Not only were they the most powerful things on rails, in my opinion they were the best-looking cab units ever built. The 16 (above) was howling up Weber Canyon east of Ogden, Utah, in July 1969 with 15,000 h.p. worth of SD40s m.u.'d behind it. Driving alongside, a turbine sounded like a Boeing 727. I let curiosity get the better of good judgment at Omaha in July 1965 when I stood directly overhead on a bridge as a turbine roared underneath and took a photo (right) into the exhaust port. The exhaust was warm and turbulent but well diffused and lacking velocity. The problem with the turbines was that they used almost as much fuel idling as they did wide open, drastically reducing their overall efficiency. They were all retired by 1970.

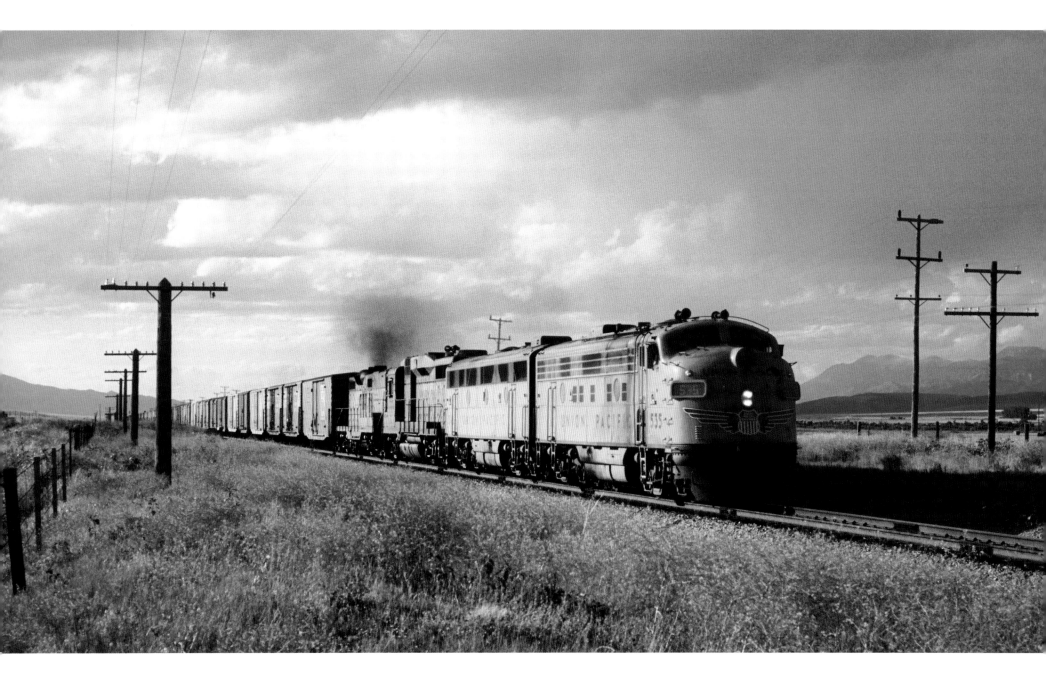

First Generation Union Pacific

Not every train on the Union Pacific got "Unlimited Power." The first-generation 1500-h.p. units that killed steam, from Consolidations to Big Boys,
were still working well into the 1960s. In July 1969 a veteran F7A and F3B from 1951 and 1948 were teamed up with a GP30 and
cabless GP9 on an eastbound freight near Pocatello, Idaho.

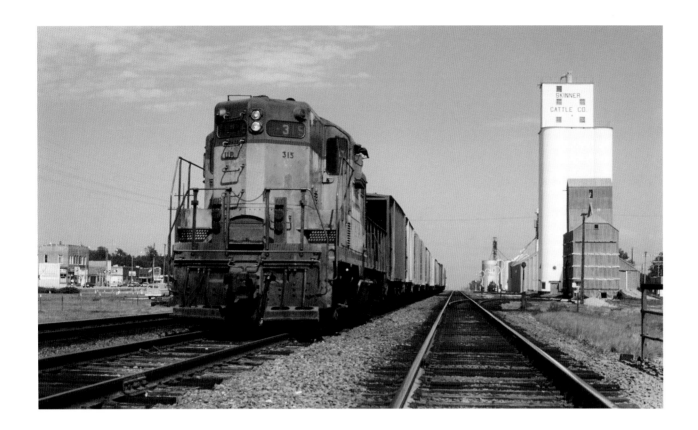

Dodging 70-mph manifests on the double-track main line, GP9 315 (above) was at Overton, Nebraska, working a westbound local between Kearney and North Platte in July 1969. A few days later, lightweight GP9 134 (right), with a small fuel tank, came growling up the steep grade into Wallace, Idaho, the end of a 130-mile branch out of Spokane. The weatherbeaten 1954 Geep still carried the Route of the Streamliners slogan on the side of its cab.

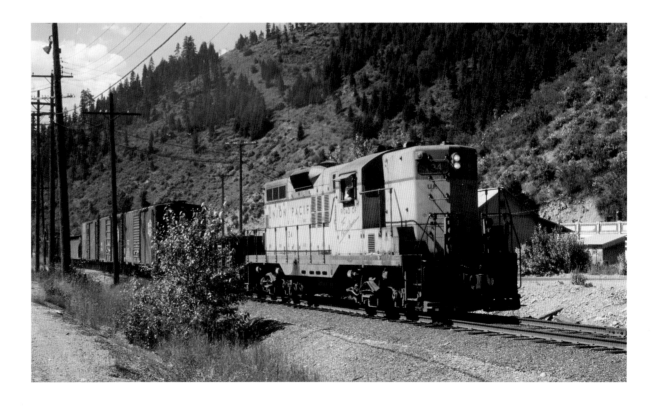

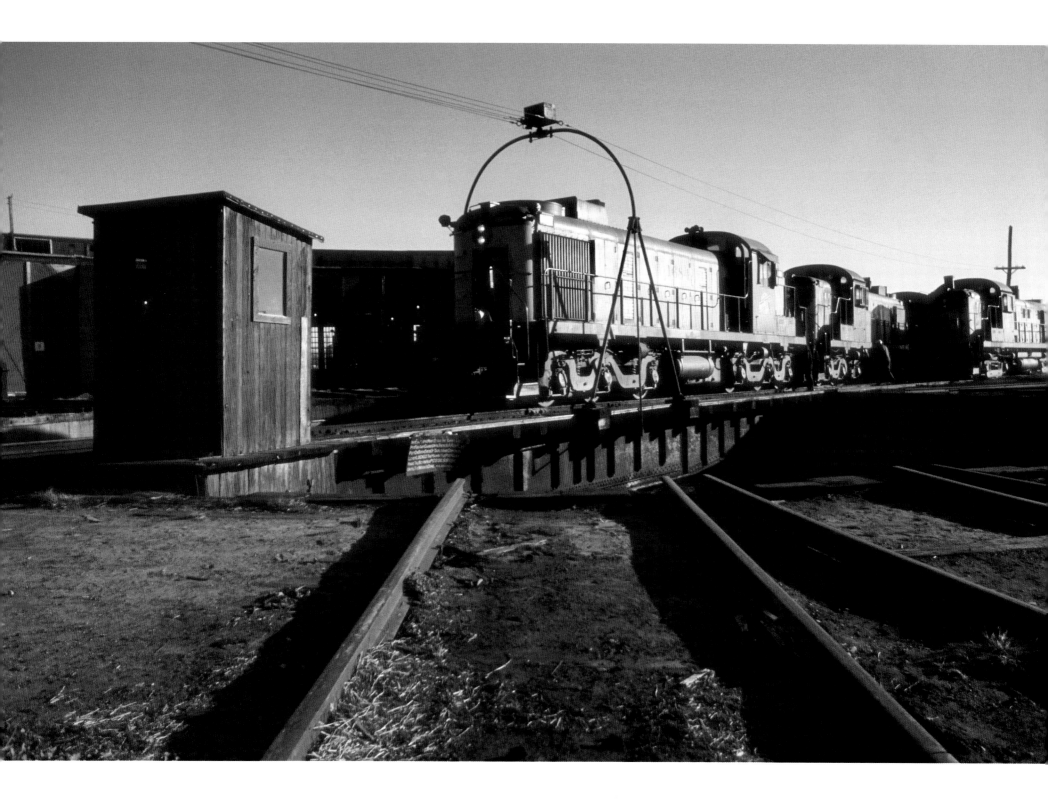

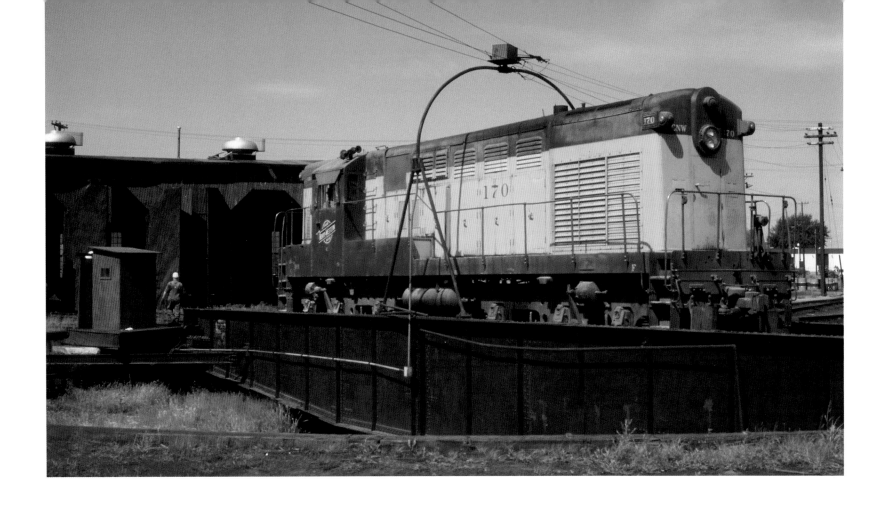

Banished to Huron

In the 1950s, when it would buy anything that made noise and pulled cars, the Chicago & North Western acquired quite a fleet of minority units. By the 1970s, the oddballs were clustered at remote locations. The Alco road switcher fleet was banished to Huron, South Dakota, where RSD5s 1865 and 1864 (opposite) were on the turntable in October 1971. Omaha Road Fairbanks-Morse Loewy H16-66 170 (above) was at home with the rest of the F-M fleet at Escanaba, Michigan, in July 1966. The rare unit at Altoona, Wisconsin, (right) was not RS3 1622 but Geep 1518, EMD's very first GP7.

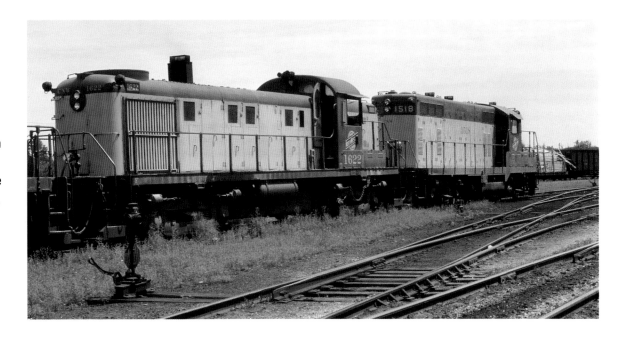

Little Joes and Pelicans

In July 1969 the Milwaukee Road Rocky Mountain electrification was running only one train a day in each direction. Little Joe E78, rebuilt after a wreck with EMD cabs and grilles, was leading XL-263 (left) west of Alberton, Montana, in the morning mists. The Joe motors had been modified to multiple with diesels. The main electric shop at Deer Lodge the previous day (below) presented a lineup of just about every type of locomotive used on the line: an Alco-GE steeple-cab, a GP9, a Little Joe and a set of the 1916 boxcab Pelicans. In January 1970 the Burlington Northern opened up new interchange gateways on the west end, and Milwaukee traffic more than doubled, putting the boxcabs back to work. In September 1971, the first boxcab, E50A, was eastbound as a mid-train helper at Saltese, Montana.

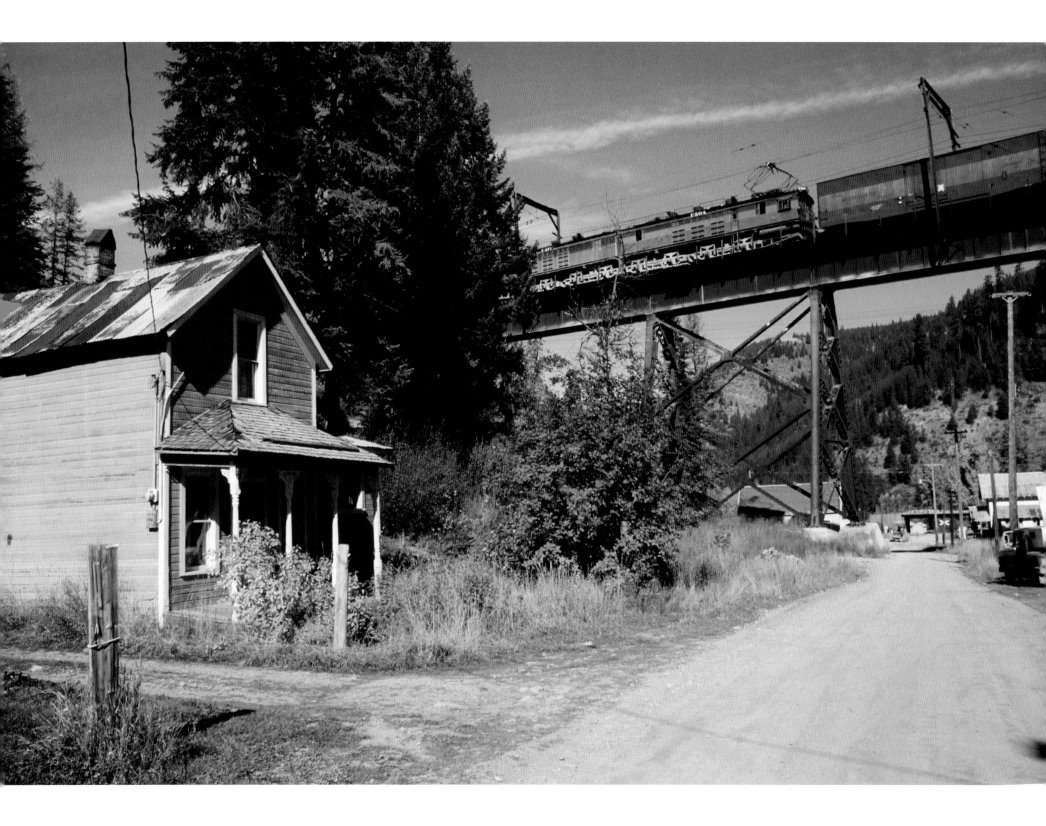

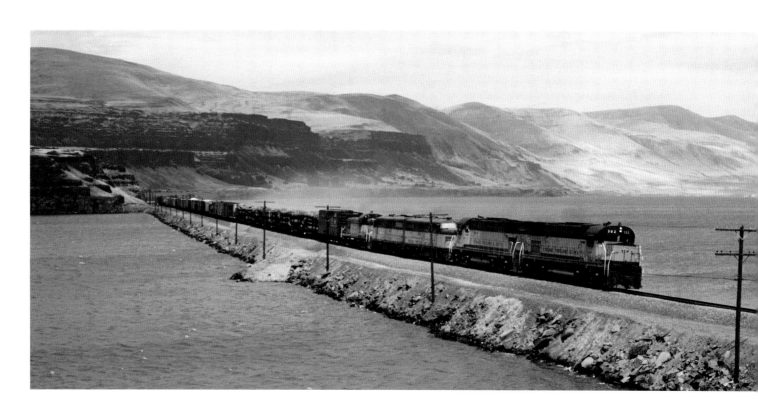

Alco's Own Northwest Railway

The Spokane, Portland & Seattle provided a link from Spokane to Portland for the Great Northern and Northern Pacific transcontinentals. Its main line followed the north bank of the Columbia River for most of its 380-mile route. In July 1969, two Alco Century 425s (opposite) had just departed the GN's Hillyard terminal as they passed the GN-SP&S Spokane depot. The next day, two RS3s (left) were working the yard at Wishram, where the Oregon Trunk crossed the river and headed for Bend and the Inside Gateway to the Western Pacific. That same day, a pair of Century 424s, FAs and an RS3 (above) were westbound near North Bonneville, Washington.

Classic Scarlet

The Southern Pacific gave up its complex Black Widow paint scheme in 1958 in favor of a simplified *Lark* grey and scarlet. Although it was admittedly an economy livery, it fit modern diesels well and became a classic in its own right. In July 1969 the H24-66 Train Masters (opposite) lined up for the evening rush hour at the Mission-style terminal at Third and Townsend in San Francisco. The 2400-h.p. F-M units handled the peninsula commutes to San Jose. On the Coast Route between San Francisco and Los Angeles, three GP9s (right) were southbound on the Point Honda trestle a few days later. General Electric U25B 6747 (above) was making 60 miles per hour near Gila Bend, Arizona, in October 1971.

Cajon and Tehachapi

Mention California railroading, and two landmarks will come to mind, Cajon Pass and Tehachapi Loop. Both are famous for scenery and traffic density. Above San Bernardino, the Santa Fe shared the Cajon Pass main line with the Union Pacific and partnered with the Southern Pacific over Tehachapi from Bakersfield to Mojave. In July 1969 (opposite) an Alco DL600B Alligator was leading a set of EMDs around the S-curves at Cajon Summit that would soon be bulldozed straight. A GP35 (left) was leading a southbound up through the Tehachapi Loop tunnel and soon crosses over itself (below left). An F45 was approaching Mojave (below) after dropping down from Tehachapi.

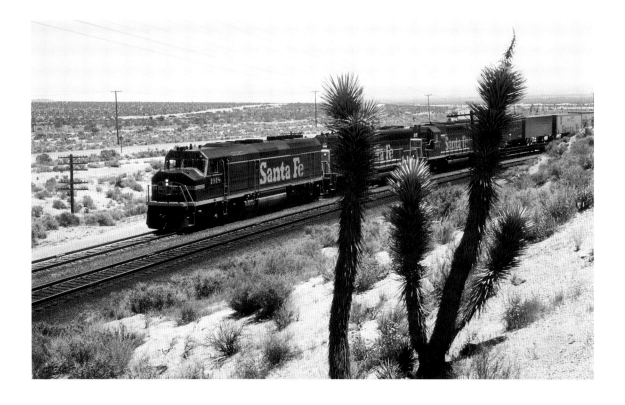

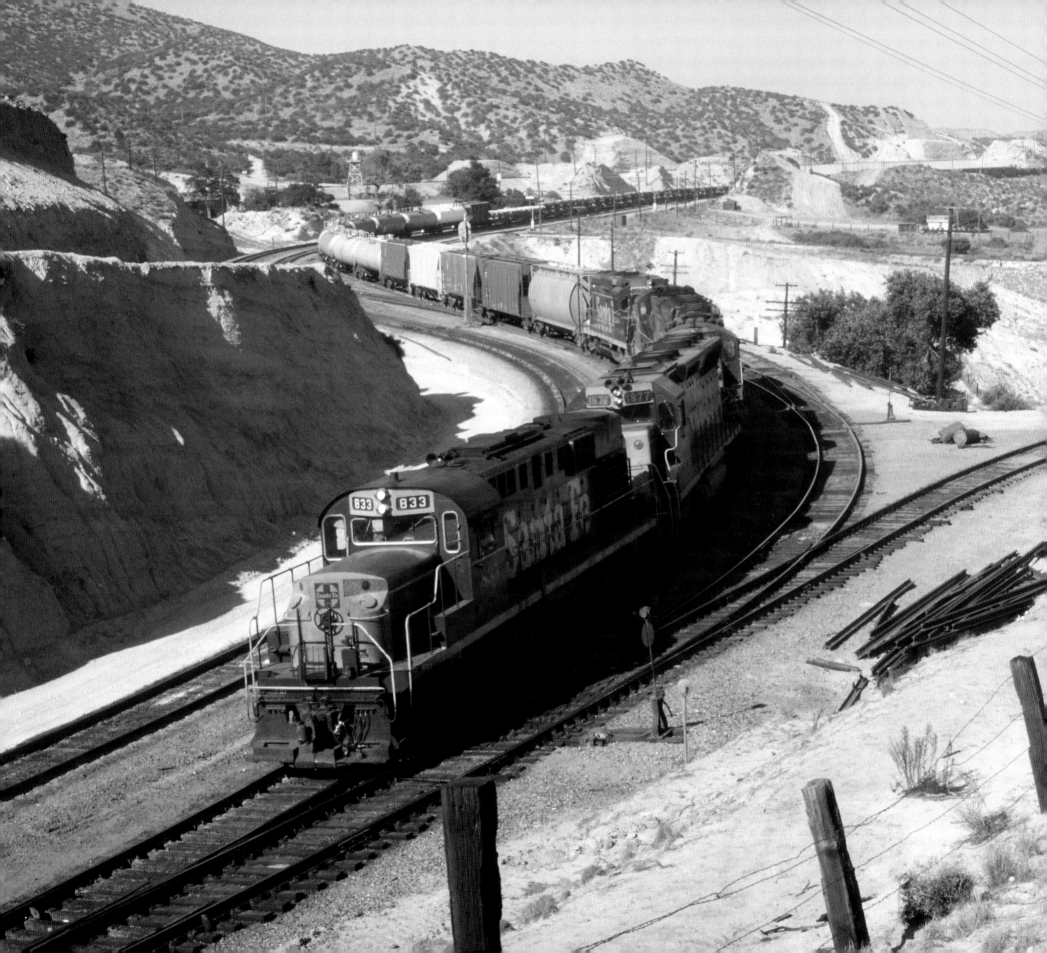

Pretending to Be Ted Benson

When you go train chasing with a master like Ted Benson, you somehow get "Ted Benson shots" unlike anything you'd typically do. In April 1993, John Sistrunk and I accompanied Ted for a day on the Sierra Railroad. At dawn (above) we got the Baldwins departing Oakdale. After picking up loads at Standard and Chinese, the S12s snorted almost to a stall (below) on the 3-percent grade of Quinn Hill. Two teenagers were fishing (opposite) as the train crossed the Rock River bridge. "Where's the train?" seemed to be the question (right) as Ted stood by his tripod and John gazed in the opposite direction.

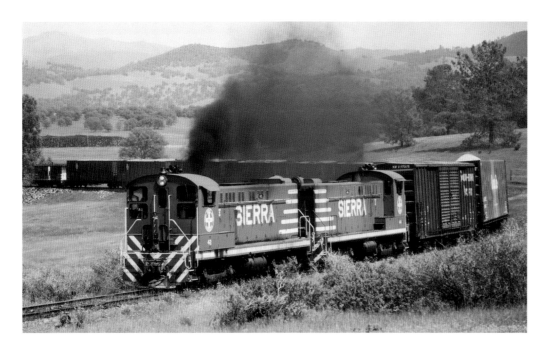

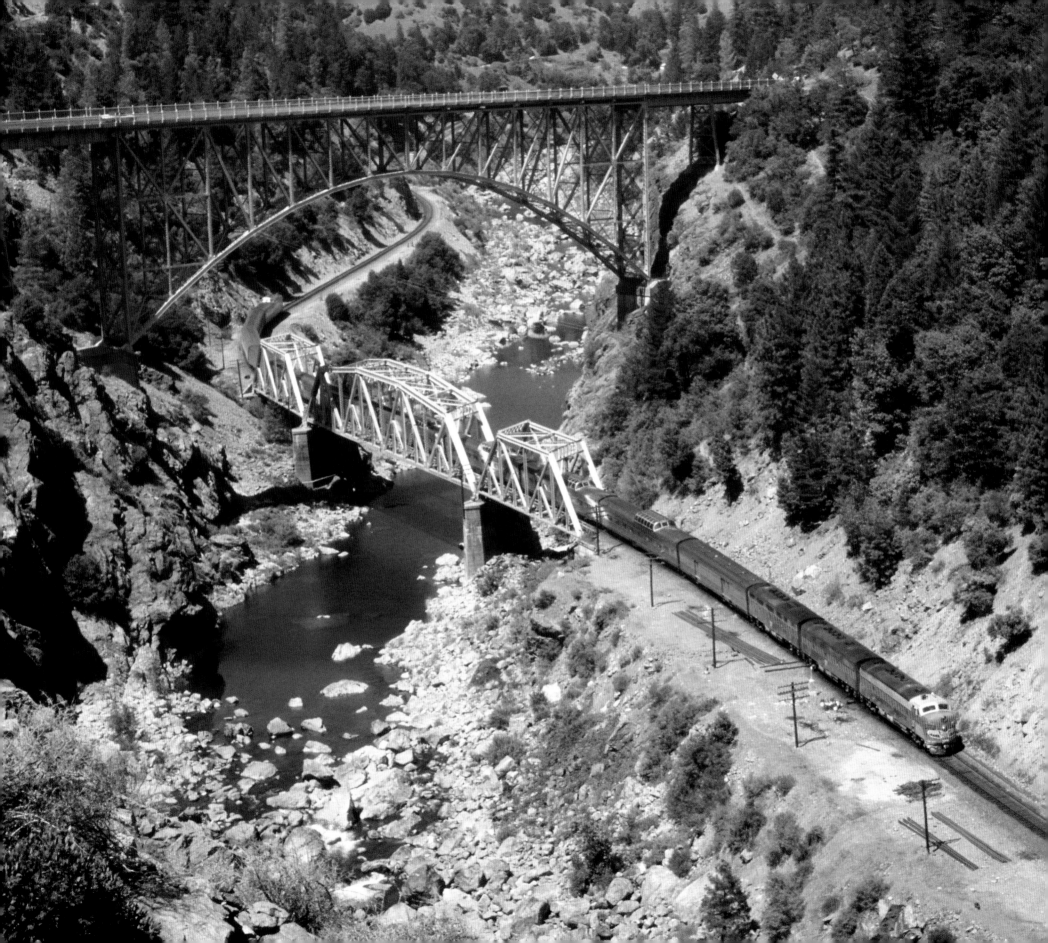

The Late, Great California Zephyr

We were running about four hours late trying to get to Keddie by 8 a.m. to catch the westbound *California Zephyr* in Feather River Canyon in July 1969. We gave up on the *CZ* and got to Keddie about noon and learned that No. 17 was running six hours late! When it's on time, the light in the canyon is rather spotty, but when 17 finally showed up, the light at Pulga (opposite) was absolutely perfect. And just to top it off, 17 met 18 at the next siding, and we got the same shot of the eastbound obs car a few minutes later and followed it back up the canyon. The next day an Inside Gateway freight was making a pickup at Keddie (below) while its GP9 helpers were waiting to cut into the consist. Note the steam-locomotive-style headlight that WP had specified as factory equipment. At the WP's Sacramento Shop (right) were two former New York, Ontario & Western F3s that had been sold to the Sacramento Northern in 1957.

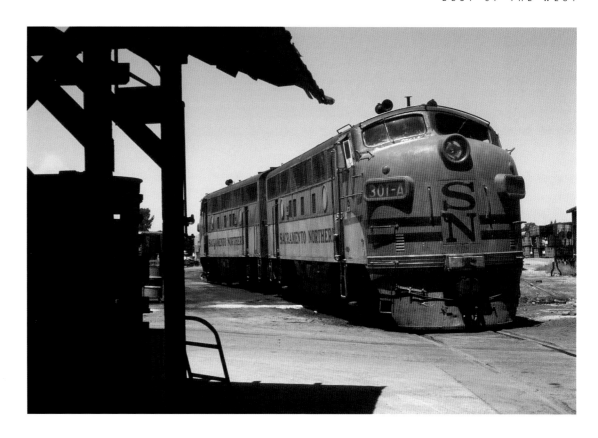

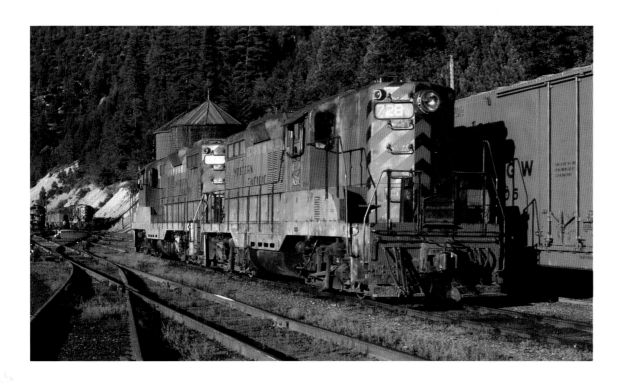

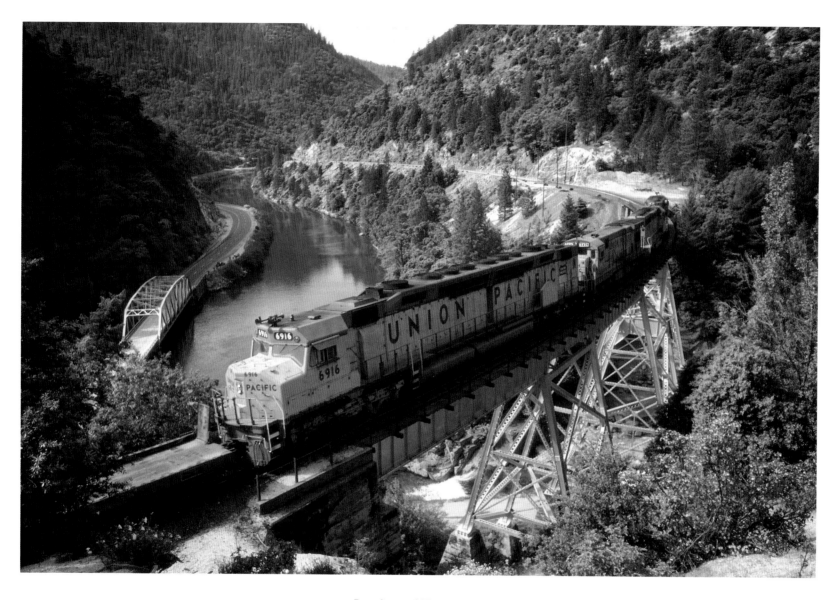

Preview of Tomorrow

In a fate that would befall almost every railroad featured in this book, the Western Pacific died on December 22, 1982, when it was absorbed by merger. In the WP's case it was the Union Pacific, the only mega-system of the 21st century to retain its historic name and image. In 1982, a downturn in traffic had sidelined the UP's fleet of the World's Largest Diesel Locomotives, the EMD twin-engined 6600-h.p. DDA40X Centennials. When traffic began to boom in January 1984, the UP pulled out the 6900s, blew out the cobwebs and put them into service between North Platte, Nebraska, and Oakland, California, via the Feather River Canyon. Seldom was the scenery so perfectly matched with the motive power. The giant Centennials were even more impressive in the confines of the Feather River Canyon. In May 1984, the 6923 (opposite) and an SD40-2 led the OMW, Overland Mail West, along the cliff in Cold Spring Ravine, and 6916 (above) trailed a mixed-power set over the Rock Creek trestle on another OMW. As new power began to arrive, the 6900s were retired again in December 1984. While the geography would remain, the railroads and locomotives would continue to change. The motto for railfans was "Get 'em while you can!"

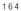

I knew that its days were numbered as I studied CB&Q O5b 5632 in Clyde Roundhouse in 1965 (above). At that time I was twenty-four years old and could not imagine the steam adventures that awaited me. In October 2003, I spent two full days photographing "Western Maryland 734" (a modified LS&I 2-8-0) on a Carl Franz photo freight (opposite) on the WM Scenic Railroad. I gave them the CB&Q 4-6-4 3010 headlight that completed the makeover.

DREAMS IN STEAM

Chapter Seven

AFTER MY RUDE AWAKENING WITH THE DEATH OF steam around home in the mid-1950s, I spent most of my time and energies seeking out the steam that remained. I was eternally frustrated, however, because my age, finances and transportation caused my travel range to expand less rapidly than steam was retreating. By the time I could get to Chicago, steam had withdrawn to Canada, and by the time I could get to Canada it had retreated to Mexico, and by the time I could get to Mexico it was South Africa and China. At that point I pretty much gave up. Chinese QJ's were no match for IC 2800s.

The bright spot in all of this was the development of steam fantrips. Maury Klebolt's Illini Railroad Club scheduled some excellent excursions out of Chicago in the late 1950s that gave me a look at CB&Q 4-8-4s, 4-6-4s, 2-8-2s and a 2-10-4 on main and branch lines and gave me access to sights ranging from the Rio Grande narrow gauge to DM&IR 2-8-8-4s.

As time rolled on, well beyond the pre-merger diesel years depicted in this book, the steam experience got richer and more varied. The creation of *Railfan* magazine in 1974 gave me the legitimacy to approach the numerous steam operators as a reporter, and suddenly I was living the dream from which I had been awakened in 1955.

I teamed up with Marc Balkin of Mark 1 Video to produce programs of numerous main-line steam locomotives with lineside and onboard cameras that gave me even greater exposure and access to the engines. I think that the magazine publicity and video work helped to promote the steam operations and keep them economically viable.

Steam program boss Jim Bistline gave me access to the Southern Railway locomotives, and friends old and new were achieving important positions in other operations. I developed a good working relationship with Ross Rowland on Nickel Plate 2-8-4 759, Reading 4-8-4 2102 and C&O 4-8-4 614, as well as Doyle McCormack and Jack

Wheelihan with SP *Daylight* 4449; Rich Melvin with Nickel Plate Berk 765 and Steve Sandberg with Milwaukee Road 4-8-4 261. They gave me access to their locomotive cabs, and I returned the favor with cover photos and feature articles in the magazine.

An e-mail exchange of good-natured insults got me acquainted with the Union Pacific's new steam boss Steve Lee (who had grown up on the Illinois Central in Kentucky). Steve welcomed me aboard the world's largest operating steam locomotive, 4-6-6-4 3985, and one of the highlights of my steam life was a 120-mile cab ride in the Challenger at track speed with a seventy-eight-car freight east out of Cheyenne.

By this time Jim Bistline had retired from what had turned into the Norfolk Southern steam program. His successor definitely lacked Jim's sense of gracious Southern hospitality and abruptly severely

limited my access to "his" N&W Class J 4-8-4 and Class A 2-6-6-4. You really don't want to treat a magazine editor that way. While he was boasting that the 1218 was "The World's Largest Operating Steam Locomotive," I ran a cover feature comparing the N&W 2-6-6-4 to the UP 4-6-6-4 and included a diagram that showed how the N&W boiler would fit completely *inside* the UP's boiler! From that day on, the N&W engine never got shown or mentioned in *Railfan & Railroad* without a bigger and better photo of UP 3985 in the same issue. I can definitely hold a grudge.

One of the great moments in the "Battle of the Giants" occurred at the 1990 NRHS convention in St. Louis when the UP arrived with their 4-8-4 844 and the N&W showed up with the 2-6-6-4. The first time the two engines encountered each other in a yard west of Union Station, the UP rolled up in their 80-inch-drivered 4-8-4 and looked down into the cab of the more compact 2-6-6-4. "I thought you were gonna bring your big engine!" Steve Lee shouted to the N&W crew. We cannot print the reply here.

On the other hand, the SP *Daylight* crew was rather suspicious of Steve Lee when he took over the UP steam program from the retiring Frank Acord, who had been rather aloof to other operators. I had gotten to know Steve and sensed his distrust of the *Daylight* group. I put in a good word for my longtime friends McCormack and Wheelihan, and similarly gave them a good word about Steve. They were all battling to keep steam alive in a hostile diesel world and would make better allies than rivals. At the time, Jack Wheelihan was a District Engineer with EMD and got an assignment to deliver a batch of big new diesels to the UP, and Steve Lee was his counterpart in Omaha. Apparently Steve had taken my advice to heart and told Jack to "bring his work clothes" when he came to the UP. Before Jack left the diesel delivery, he was firing the 844 and has since become the UP's "Extra Board" fireman. The two crews have worked closely since then to benefit everyone trying to run steam in the post-merger environment.

I had gotten to know Rich Melvin when he advertised his Hopewell Productions videos in the magazine. He later become the road engineer for Ft. Wayne's Nickel Plate 2-8-4 765, and I was able to get a lot of cab time with him on the C&O in the New River Gorge. As he was

fighting to keep the 765 under control on the wet and slippery rail on Cotton Hill in October 1988, he described to me what he was watching and feeling to keep the engine from wheel-slipping out of control on the heavy thirty-car passenger train. He knew that he needed to maintain 150 p.s.i. of cylinder pressure to hold his speed on the hill, but she was slipping at 140, and he was losing momentum to the hill. He succeeded, though, and crested the grade at 19 miles per hour with a thunderous exhaust.

When CSX approved the use of Milwaukee Road 4-8-4 261 between Charleston and Hinton in 1994, they wanted "qualified engineer" Melvin to run it. I was in the cab when Rich pulled the 261's throttle wide open on Scary Hill westward out of St. Albans, West Virginia. He crested the hill at about 35 miles per hour and closed the throttle, but the locomotive kept right on accelerating. Rick yanked the throttle open and slammed it shut again. The stack kept roaring, and with the train now on the downgrade, the speed was up past 50. Rich set the air and tried the throttle a couple more times before the exhaust suddenly went silent. He had the engine and train back under control. It turned out that the 261 has a throttle similar to the one on Nickel Plate 765, but it had no stop pin on the throttle quadrant like the 765's. Rich had pulled the throttle out beyond its usual wide-open position, causing the pilot valve in the front-end throttle to jam itself in crooked. Banging it with the throttle rod finally jarred it loose and closed. The 261 now has a nice, new throttle stop pin on it.

How many railfans in the 1950s could have had a first-hand adventure like that? Or be able to describe from personal experience how a Challenger rides at track speed on a mile-long freight?

The position of magazine editor got me involved with steam ranging from the original 1831 John Bull to Edaville two-footers and main-line Berkshires, Mountains and 4-8-4s, as well as nearly any museum or tourist operation that captured my curiosity. While I made my living from the "real world" of diesels, it was the fantasy world of restored steam that fulfilled the dreams of my youth. As a senior citizen, I'm satisfied that the steam experience didn't get away from me after all.

And it was my photography that had made everything possible.

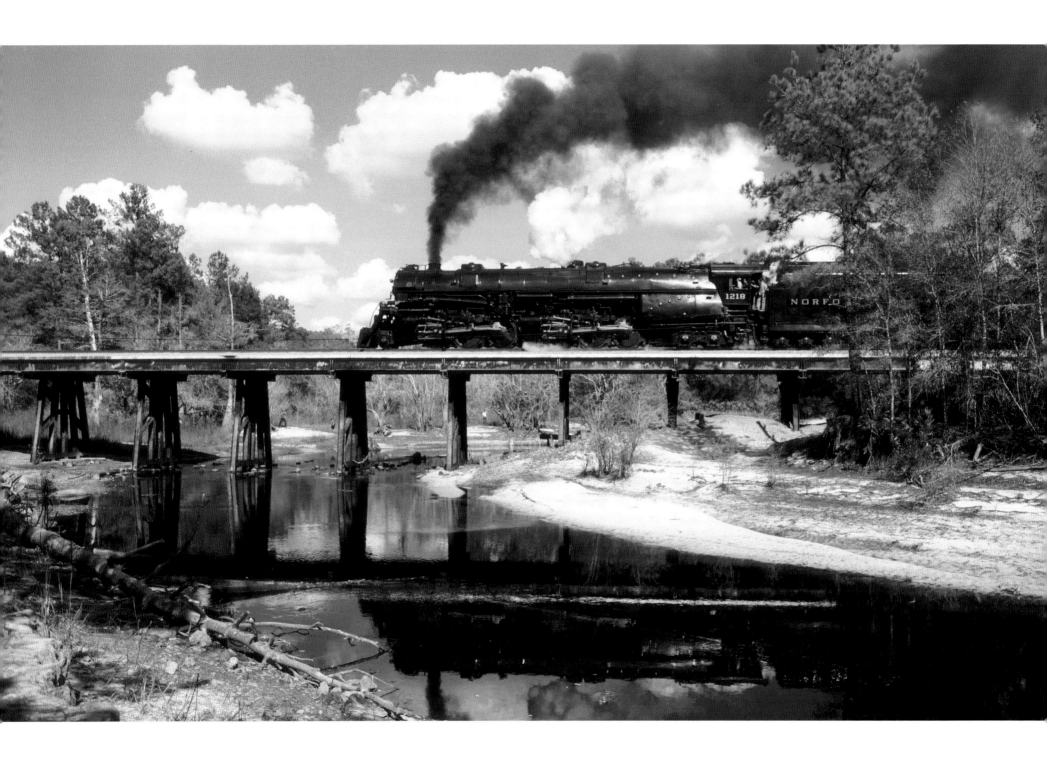

The Brothers Claytor

The first major railway to bring back steam was the Southern, when future President W. Graham Claytor Jr. gave the okay to operate Mikado 4501 that had been purchased by DuPont engineer Paul Merriman. The 4501 was the Southern's first 2-8-2 and had been working on the Kentucky & Tennessee coal shortline. In green and gold, it became the genesis of the long-lived Southern steam program. The 4501 (previous page) was northbound at Vesuvius, Virginia, in September 1977, passing the old gas pump featured in a famous O. Winston Link night photo. When the N&W and Southern merged in 1982, Graham's brother Bob became president of the new Norfolk Southern and put both N&W Class J 4-8-4 611 and Class A 2-6-6-4 1218 through the company's Birmingham steam shop. The 611 (above) was crossing the Roanoke River west of Salem, Virginia, in November 1982, while the 1218 was a long way from Roanoke (left) as it crossed the Suwaunee River at Fargo, Georgia, on November 7, 1987.

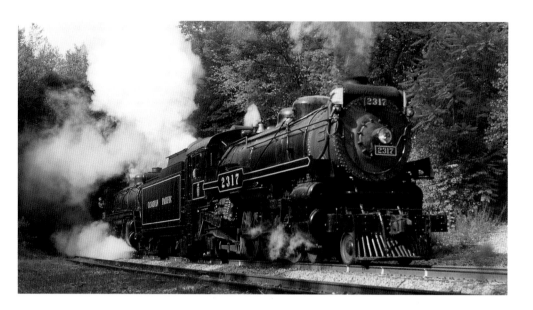

Authentic Canadian Pacific

In the early 1970s the Ontario Rail Association restored CPR 4-4-0 136 and 4-6-0 1057, and in 1973 the 4-4-0 was used for the filming of a CBC documentary of Pierre Berton's book *The National Dream*. In October 1973 it was used on an excursion (left) from Toronto to Owen Sound. At the Steamtown National Historic Site grand opening in July 1995, the beautifully restored G3 4-6-2 2317 blasted out of Nay Aug Tunnel (above) while doubleheading with CNR 2-8-2 3254. Royal Hudson 2839 (below) was owned and restored by railfans at Northampton, Pennsylvania, and on February 4, 1979, it was ready to depart for Birmingham to join the Southern Railway steam program.

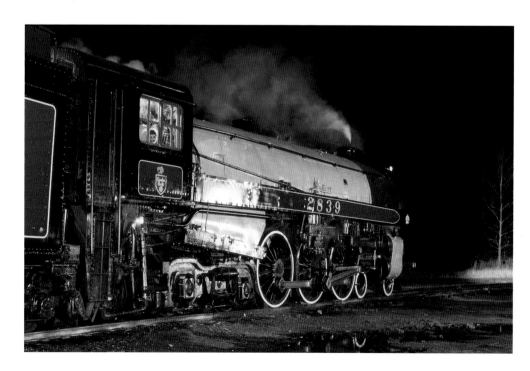

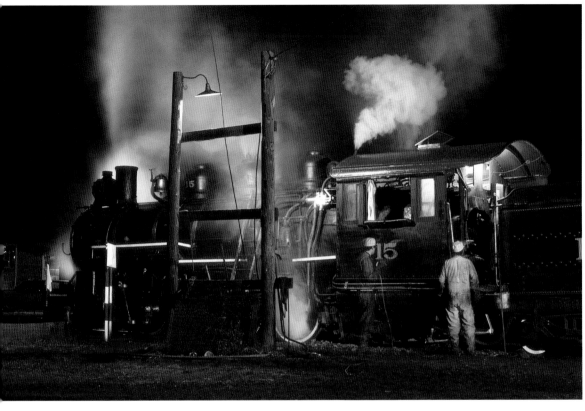

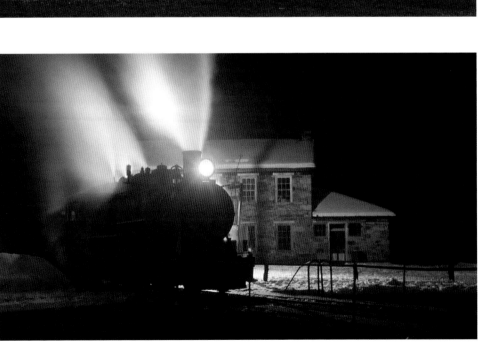

Pretending to Be Phil Hastings

The most memorable images I remember of the East Broad Top were night shots by Phil Hastings published in *Trains* magazine in the 1950s. The EBT survived as a tourist railroad, focused around the shop and roundhouse at Orbisonia, essentially unchanged from the Hastings era. In February 1975 (left), one of the Mikes was being serviced at a winter Railfan Weekend. In October 1988 the roundhouse was an incredible experience, with four of the seven Mikados under steam! The spirit of Hastings was there.

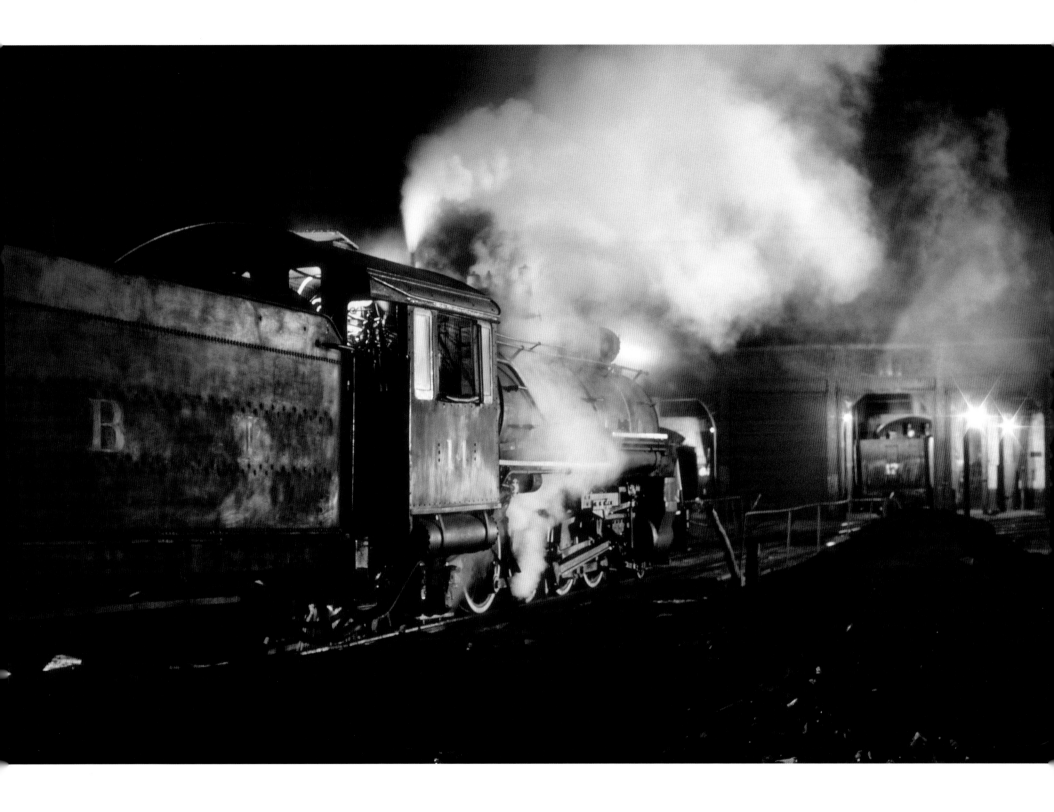

Narrow Gauge Photo Freights

When the first tourist railroads emerged in the 1960s, most were convinced that they had to look like the Wild West, with garish paint jobs, phony cowcatchers and diamond stacks. It wasn't until the 1990s that it began to dawn on them that authenticity could sell. When Carl Franz chartered a freight train on the East Broad Top in October 2002, he got the railroad to get rid of the white tires and trim and restore the authentic lettering. When the 14 was coupled to their restored coal train, with the typical single boxcar at the head end, the effect was stunning. Finally, a locomotive matched the authenticity of the preserved Orbisonia shop complex.

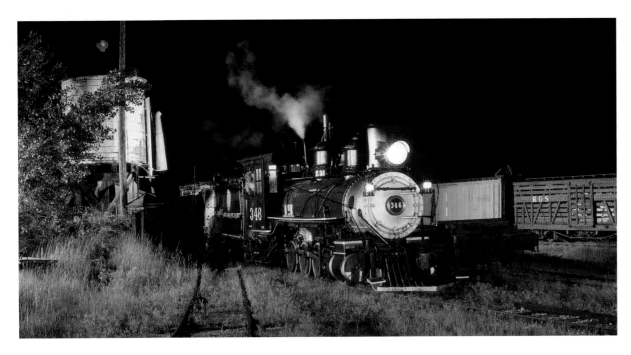

Ever since it was created by Ellis D. Atwood in a Massachusetts cranberry bog in 1945, the two-foot-gauge Edaville Railroad never operated an authentically lettered locomotive. In October 1991, however, I convinced management to reletter No. 7 B&HR and let us cover up the brass boiler bands with black gaffer's tape. They would not let us repaint the garish silver cowcatcher, but just before we left the night before the run, two cans of black spray paint somehow managed to get rid of the silver. 'Twas easier to gain forgiveness than secure permission. But it sure looked great (above) on the weekend's photo runbys. There was never any question of authenticity at the Colorado Railroad Museum (left), which created diorama scenes on their very compact site at Golden. Rio Grande C-19 2-8-0 346 posed for a night session in May 1985.

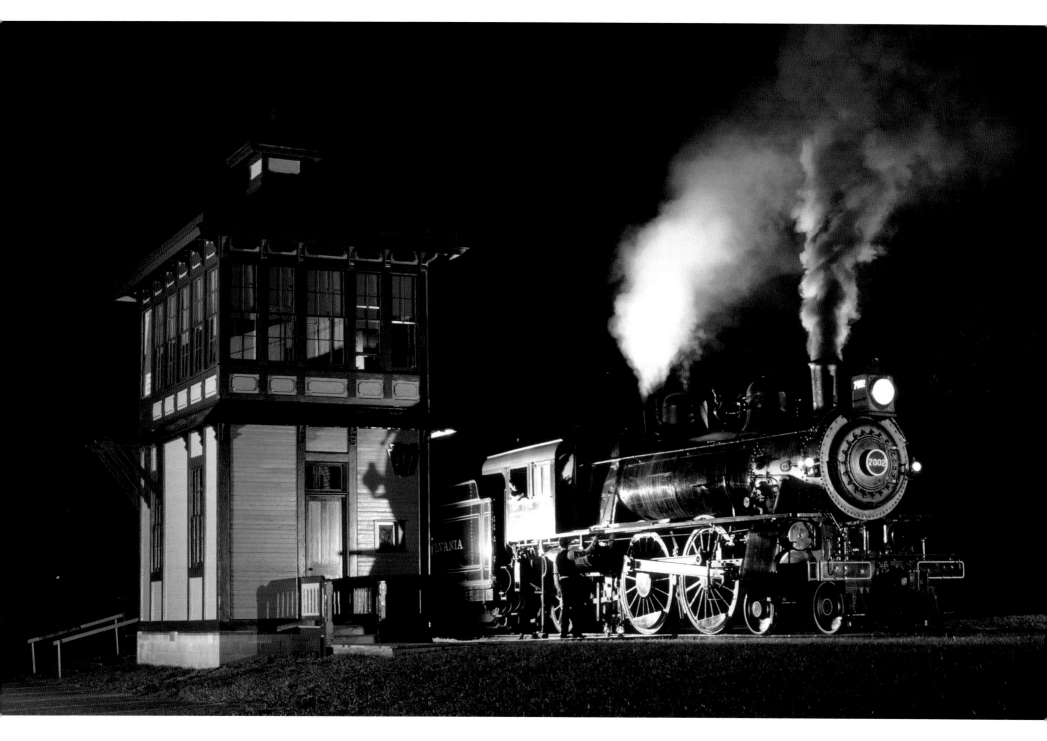

Images of the Pennsy

Of all the locomotives that have returned to steam, one of the most amazing to me was Pennsylvania Railroad E2 Atlantic "7002." On July 12, 1905, PRR 7002 set an unofficial world speed record of 127.1 mph, but it was scrapped unceremoniously in 1934. In the 1940s, Pennsy, realizing its mistake, selected nearly identical sister 8063, christened her 7002, and placed her in the company historical collection, most of which resides today at the Railroad Museum of Pennsylvania at Strasburg. The adjacent Strasburg shop restored the 80-inch-drivered 4-4-2 in 1983.

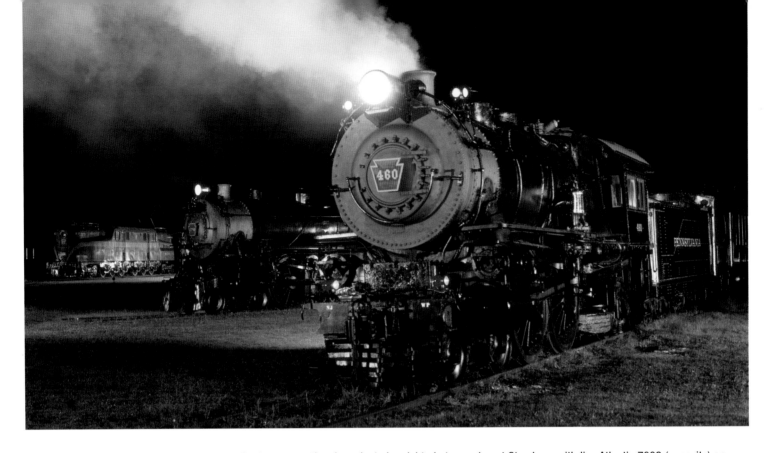

For the 1983 National Railway Historical Society convention, I conducted a night photo session at Strasburg with live Atlantic 7002 (opposite) on the Strasburg Rail Road and GG1 electric 4800, E6s Atlantic 460 and K4s 4-6-2 3750 (above) lit up and producing fake smoke at the Railroad Museum of Pennsylvania. Only two K4s remain, and the other one, 1361, was pulled off display on Horseshoe Curve, restored at Altoona and test-run (below) on the Nittany & Bald Eagle in April 1987. It was remarkable to be able to see both the 1905 Atlantic and modern K4.

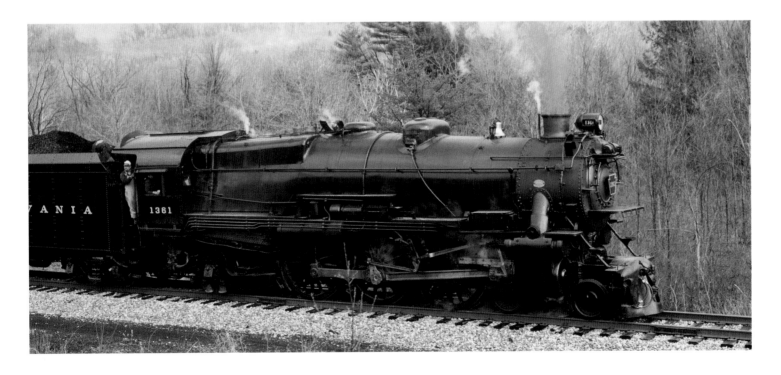

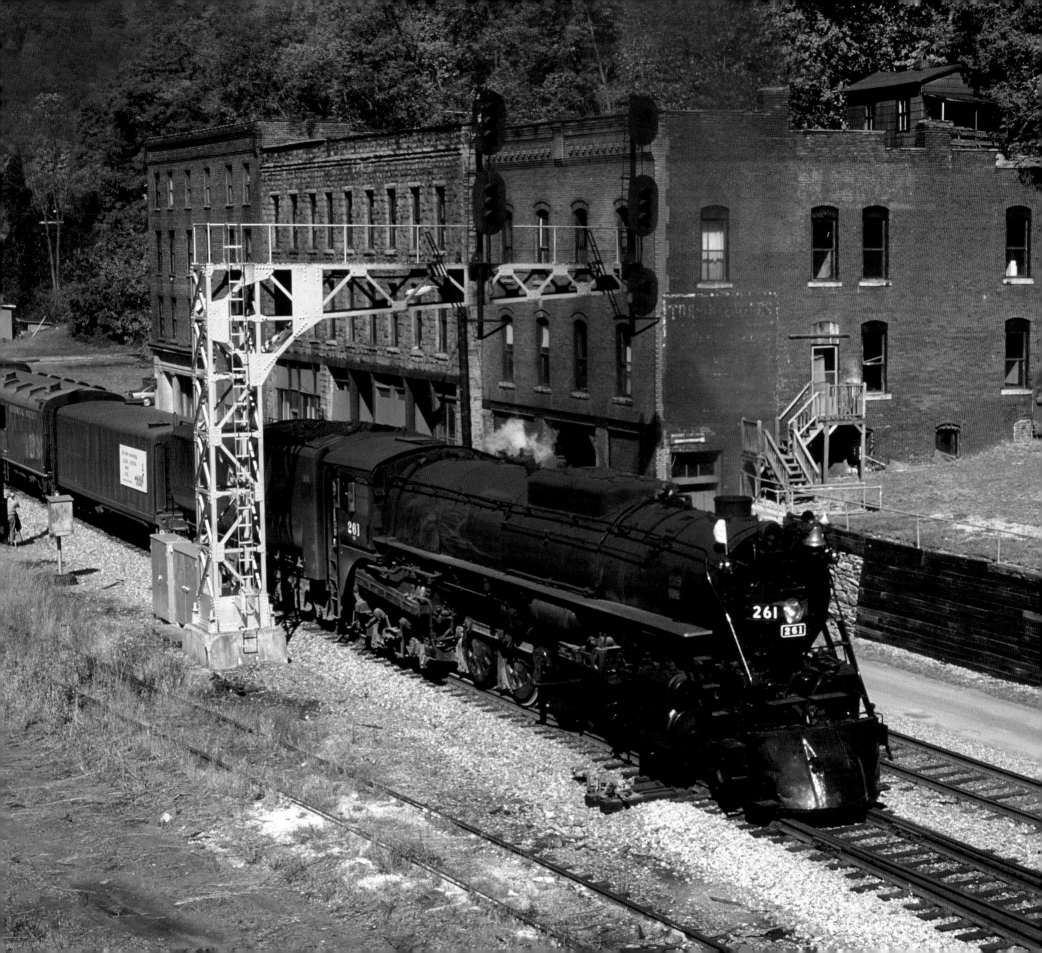

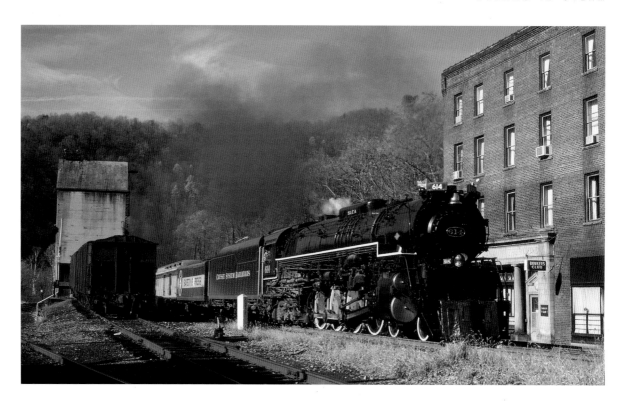

Thurmond, U.S.A.

It's doubtful that there's a more All American community than Thurmond, West Virginia, when it comes to railroading. Its main street is the C&O main line, and the variety of steam engines that has been run through there is pretty amazing, thanks to the annual C.P. Huntington Chapter NRHS New River Train excursions. In October 1981 (right) the engine was home road veteran C&O Greenbrier 4-8-4 614. In 1988 the power (below) was Nickel Plate Berkshire Berkshire 765, and in 1994 it was Milwaukee Road S3 4-8-4 261 (opposite).

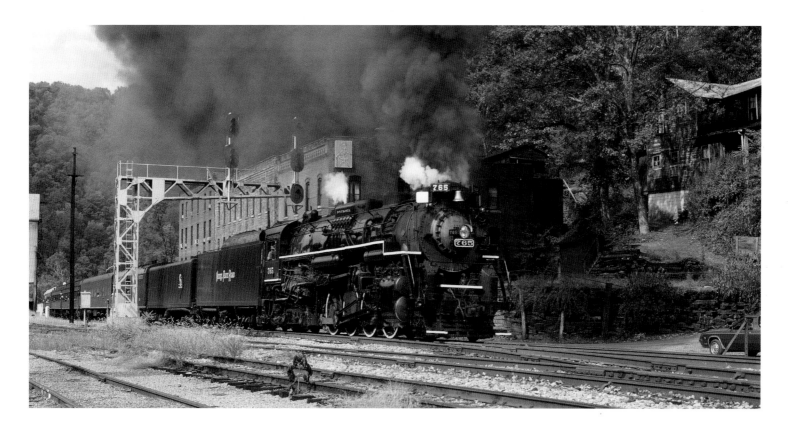

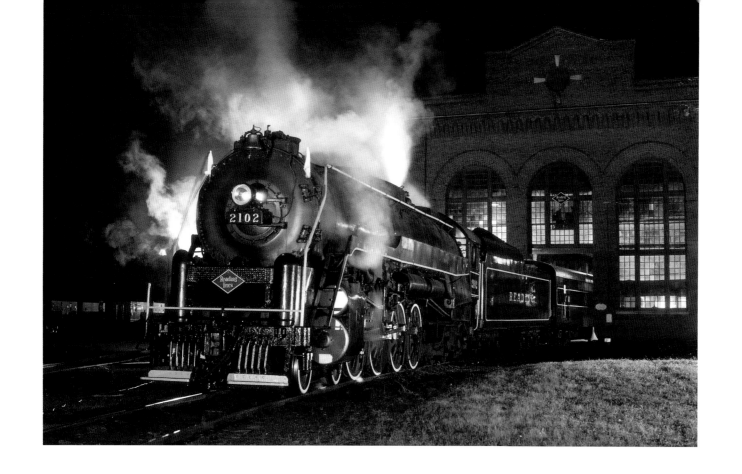

Big Noisy Engines and the Light at the End of the Tunnel

On my first trip to St. Louis in May 1965, I found a half dozen big steam engines in and around the Frisco roundhouse, including handsome 4-8-2 1522 (right). Never in my wildest dreams would I have imagined I'd see her blasting holes in the sky uphill on home rails (above) out of Sullivan, Missouri, on June 16, 1990. One of my favorite images of the Reading Rambles 4-8-4s was a Don Wood night shot of 2124 at the Reading Shop in 1959. On September 21, 1985, I was able to duplicate that shot (opposite top) when 2102 returned home to the Blue Mountain & Reading. On October 20, 2003, Western Maryland Scenic 2-8-0 736 (opposite bottom) was working a Carl Franz photo freight uphill into Brush Tunnel. In this case, the light at the end of the tunnel was mine! As a teenager, I had "salvaged" the headlight from CB&Q 4-6-4 3010, with an unbroken "Golden Glow" reflector. When the WM Scenic was doing a cosmetic makeover to convert a Lake Superior & Ishpeming 2-8-0 into a WM 700, they had the incorrect Pyle National headlight, so I donated my correct WM-style headlight to the project.

Northerns in Context

Reading 4-8-4 2102 shed its Rambles image (page 182) for workaday black on the Blue Mountain & Reading, and in 1991, it was put to work on a two-day assignment gathering coal. On April 6, 1991, it handled thirty 100-ton loads of anthracite from Tamaqua through Port Clinton (above) to Belt Junction in Reading. On that day, I made my peace with the Reading T1s. Spokane, Portland & Seattle 4-8-4 700 (opposite top) was running on the Washington Central's former NP main line out of Yakima, Washington, on October 18, 1990. SP&S had three Northerns patterned after NP's A-3 class 4-8-4s.

The Cotton Belt's last 4-8-4 was pulled out of a park and overhauled by the Cotton Belt Rail Historical Society in the Pine Bluff, Arkansas, shop where she had been built in 1943. The 819 made a run to Tyler, Texas (opposite bottom), in November 1988.

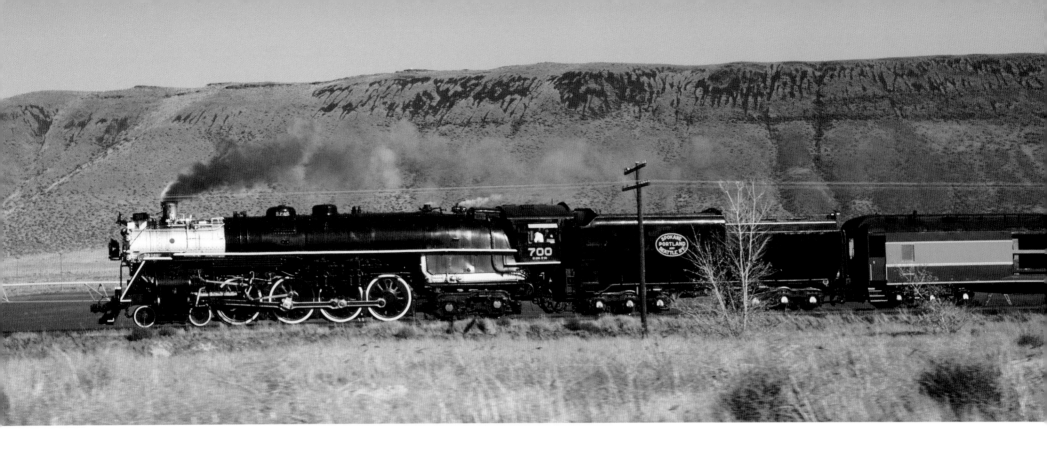

The Western Super Northerns

They were America's Super Northerns, and they had some pretty impressive specs in common: 80-inch drivers, 300-p.s.i. boiler pressure. Baldwin 3751 was the Santa Fe's very first 4-8-4 when it was built in May 1927 with 73-inch drivers and a 210 p.s.i. boiler, but it was rebuilt in August 1941 to Super standards. After years of display in San Bernardino, it was restored and returned to Cajon Pass (opposite) on December 27, 1991. Southern Pacific GS4 4449 was outshopped by Lima in May 1941 and restored for the *American Freedom Train* in 1975. It returned to full *Daylight* colors in 1981. For the July 1992 NRHS convention, the 4449 posed (below) at San Jose with the Golden Gate Museum's SP 4-6-2 2472. The Union Pacific's last new steam locomotive was 4-8-4 844, built by Alco in December 1944. In spite of being renumbered "8444" in 1963 to avoid conflict with a fleet of GP30s, it survives in the 21st century as the only steam locomotive in North America that has never been retired by its original owner. It was in passenger *Greyhound* colors (above) on Sherman Hill on October 3, 1967.

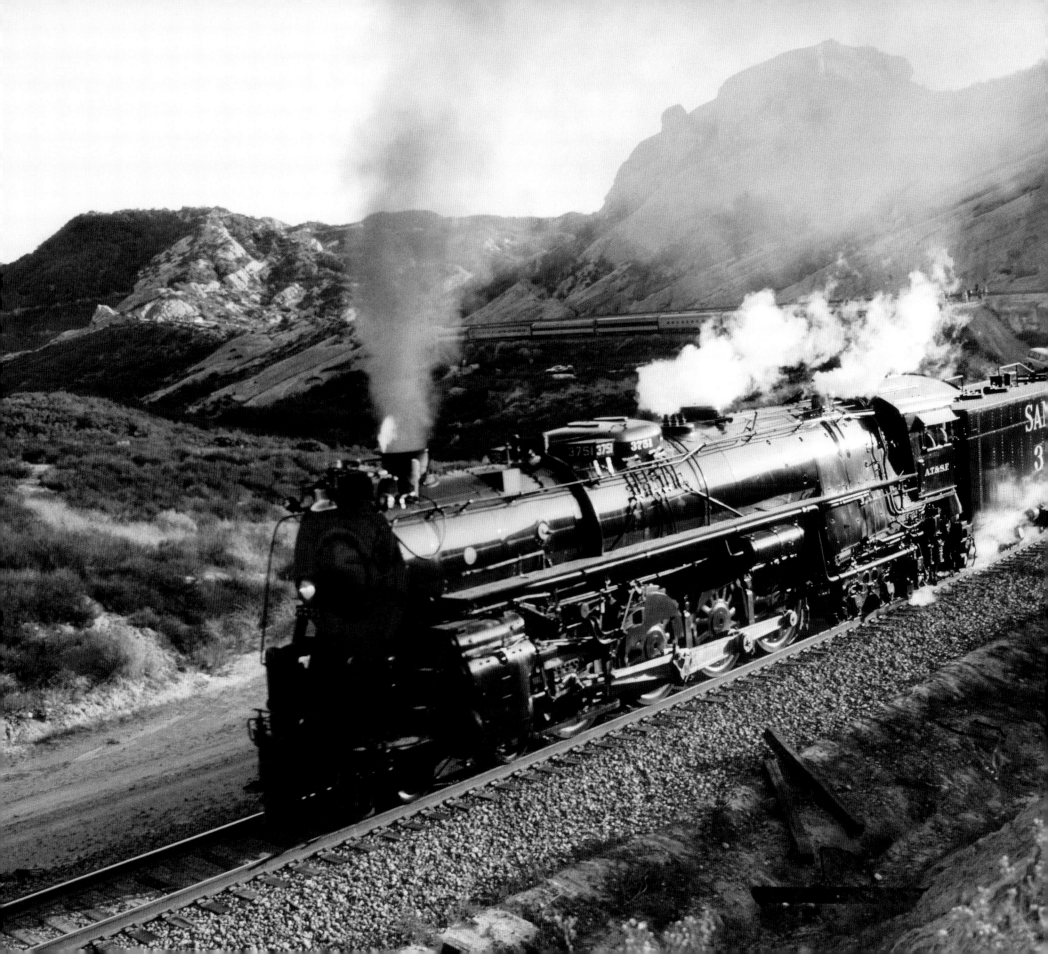

The World's Largest Operating Steam Locomotive

When I was thirteen and watching steam disappear, I could never have imagined what life had in store. On September 18, 1990, I found myself in the cab of Union Pacific 4-6-6-4 3985, the World's Largest Operating Steam Locomotive, eastbound out of Cheyenne, Wyoming, on a seventy-eight-car freight, about to ascend Archer Hill. I was on a first-name basis with engineer Steve Lee and fireman Lynn Nystrom and felt like a member of the crew for 125 miles to Lodgepole, Nebraska. We crested Archer Hill and cruised along at 70 miles per hour. Wildest dreams really can come true.

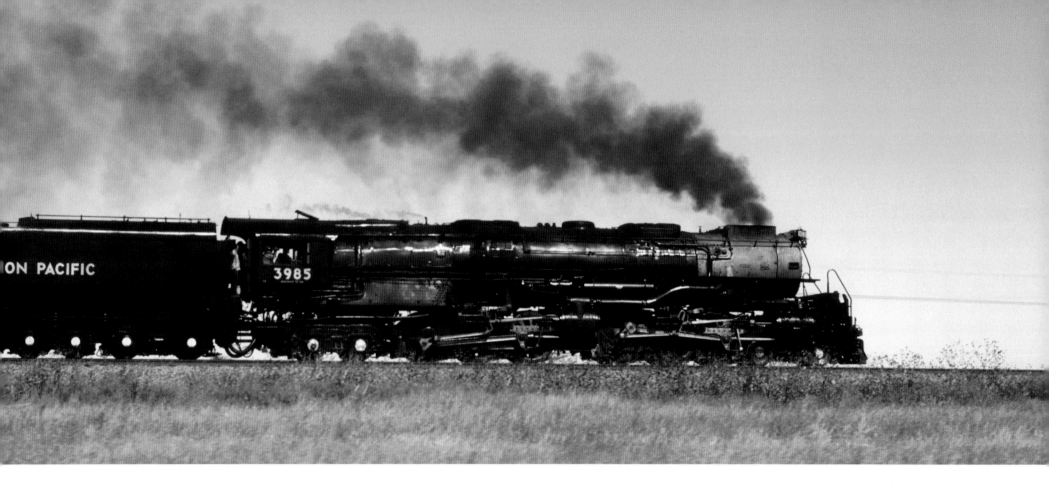

While the Challenger is today's World's Largest Operating Steam Locomotive (above, east of Lodgepole, Nebraska, on September 18, 1990), the undisputed World's Largest was the UP Big Boy. Alco built twenty-five of the 4-8-8-4s between September 1941 and November 1944, and eight were preserved at various museums. On Memorial Day 1999 (left) the 4012 was lit up for a night photo session with WWII reenactors at the Steamtown National Historic Site in Scranton, Pennsylvania. Will a Big Boy ever be restored to run again? Absolutely! Why? Because it's there.

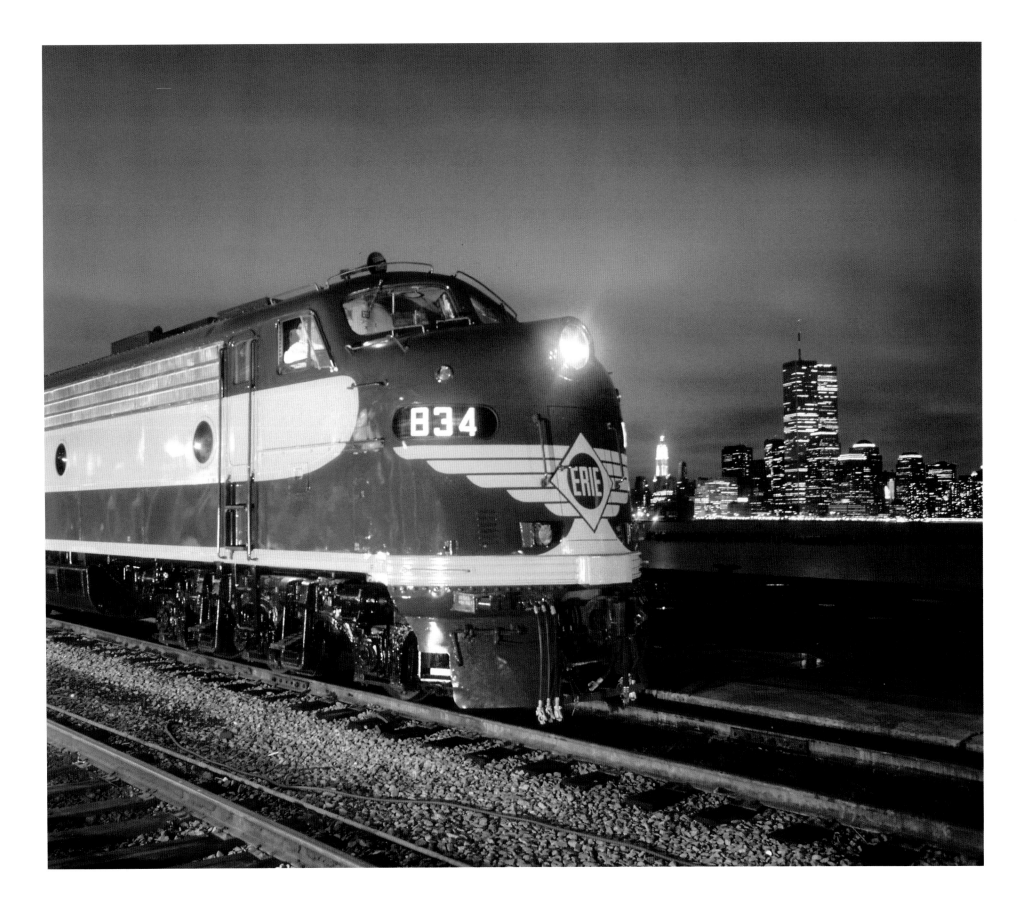

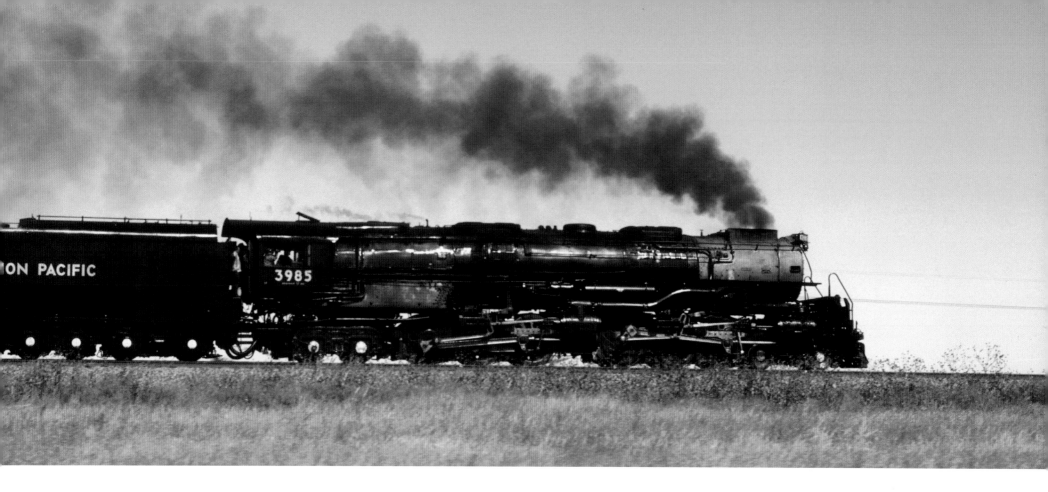

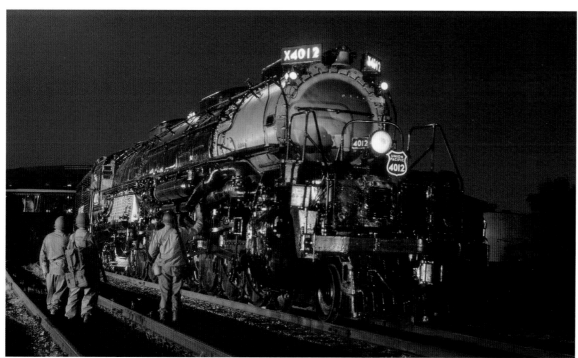

While the Challenger is today's World's Largest Operating Steam Locomotive (above, east of Lodgepole, Nebraska, on September 18, 1990), the undisputed World's Largest was the UP Big Boy. Alco built twenty-five of the 4-8-8-4s between September 1941 and November 1944, and eight were preserved at various museums. On Memorial Day 1999 (left) the 4012 was lit up for a night photo session with WWII reenactors at the Steamtown National Historic Site in Scranton, Pennsylvania. Will a Big Boy ever be restored to run again? Absolutely! Why? Because it's there.

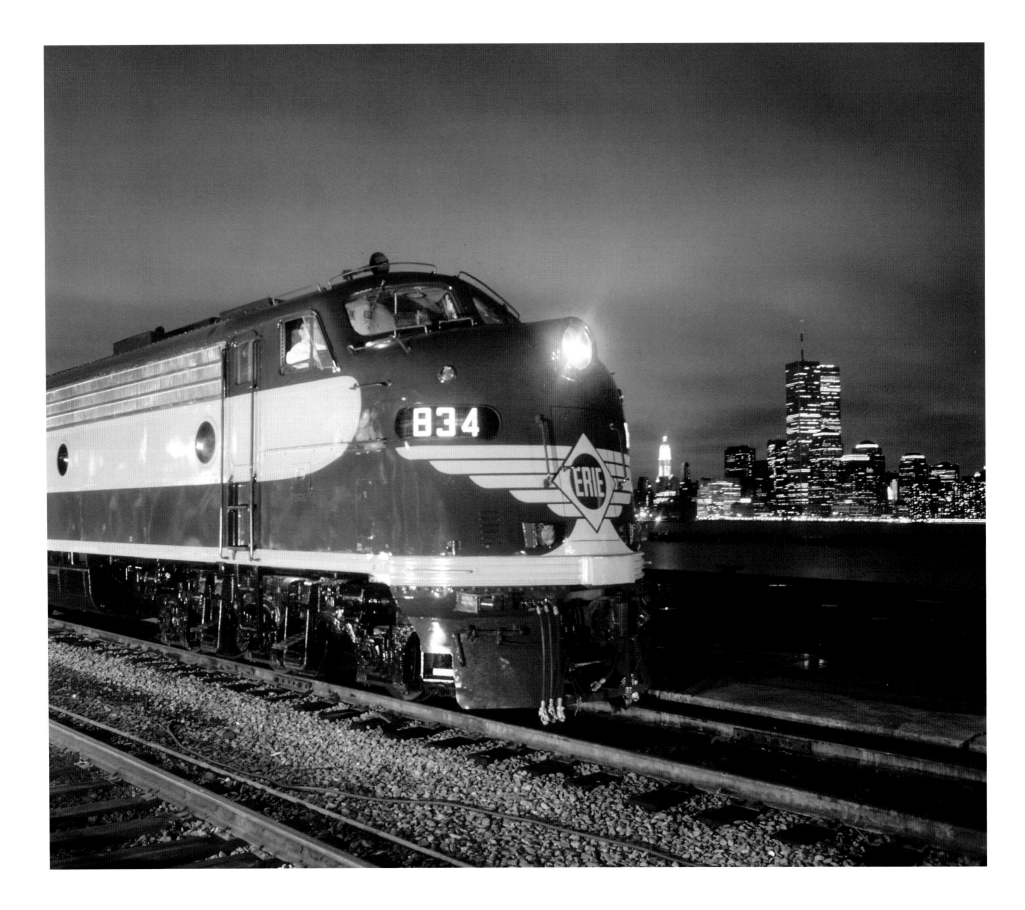

What we've saved and what we've lost.

In mid-1990 the United Railroad Historical Society of New Jersey repainted

two former New Jersey Transit E8s (originally NYC 4076 and PRR 5788)

as a matched set in Erie two-tone green. The fully serviceable and HEP-equipped

E8s are the crown jewels of the equipment fleet being gathered for a future

New Jersey State Transportation Museum. On November 17, 1990, the 834

posed at Hoboken Terminal, just across the Hudson River from the

New York City skyline. As amateur historians, we look at the scene and ponder

the changes the future will hold. What part of this scene will remain and what

part will vanish? The Erie E8? Hoboken Terminal? The New York City skyline?

In November 1990, we were so blissfully innocent.

INDEX